# SHIFTING WORLDS, SHAPING FIELDWORK

Reflecting on fieldwork for the twenty-first century, anthropologist and artist Susan Ossman invites readers on a journey across North Africa, Europe, the Middle East, and North America. She reveals that fieldwork today is not only about being immersed in a place or culture; instead, it is an active way of focusing attention and engendering encounters and experiences. She conceives a new kind of autoethnography, making art and ethnography equal partners to follow three "waves" of her research on media, globalization, and migration.

Ossman guides the reader through diverse settings, including a colonial villa in Casablanca, a Cairo beauty salon, a California mall-turned-gallery, the Berlin Wall, and Amsterdam's Hermitage museum. She delves into the entanglements of solitary research and collective action.

This book is a primer for current anthropology and an invitation to artists and scholars to work across boundaries. It vividly shows how fieldwork can shape scenes for experiments with multiple outcomes, from conceptual advances to artworks, performances to dialogue and community making.

**Susan Ossman** is Professor of Anthropology and Global Studies at the University of California, Riverside, USA.

# SHIFTING WORLDS, SHAPING FIELDWORK

## A Memoir of Anthropology and Art

Susan Ossman

LONDON AND NEW YORK

First published 2021
by Routledge
2 Park Square, Milton Park, Abingdon, Oxon OX14 4RN

and by Routledge
605 Third Avenue, New York, NY 10158

*Routledge is an imprint of the Taylor & Francis Group, an informa business*

© 2021 Susan Ossman

The right of Susan Ossman to be identified as author of this work
has been asserted by her in accordance with sections 77 and 78 of the
Copyright, Designs and Patents Act 1988.

All rights reserved. No part of this book may be reprinted or reproduced
or utilised in any form or by any electronic, mechanical, or other
means, now known or hereafter invented, including photocopying and
recording, or in any information storage or retrieval system, without
permission in writing from the publishers.

*Trademark notice*: Product or corporate names may be trademarks
or registered trademarks, and are used only for identification and
explanation without intent to infringe.

*British Library Cataloguing-in-Publication Data*
A catalogue record for this book is available from the British Library

*Library of Congress Cataloging-in-Publication Data*
Names: Ossman, Susan, author.
Title: Shifting worlds, shaping fieldwork: a memoir of
anthropology and art / Susan Ossman.
Description: Abingdon, Oxon; New York, NY: Routledge, 2021. |
Includes bibliographical references and index. |
Identifiers: LCCN 2020039906 | ISBN 9781350128101 (hardback) |
ISBN 9781350128095 (paperback) | ISBN 9781003086680 (ebook)
Subjects: LCSH: Ossman, Susan—Travel. | Anthropology—Fieldwork. |
Anthropology—Philosophy. | Art and anthropology. |
Anthropologists—United States—Biography.
Classification: LCC GN34.3.F53 O77 2021 | DDC 301.072/3—dc23
LC record available at https://lccn.loc.gov/2020039906

ISBN: 978-1-350-12810-1 (hbk)
ISBN: 978-1-350-12809-5 (pbk)
ISBN: 978-1-003-08668-0 (ebk)

Typeset in Bembo
by codeMantra

# CONTENTS

| | |
|---|---|
| *List of figures* | *vii* |
| *Acknowledgments* | *x* |
| *Prologue* | *xiv* |
| Introduction | 2 |
| **First wave** | **27** |
| 1 Gatherings | 29 |
| 2 Spinning | 44 |
| **Second wave** | **59** |
| 3 Call and response | 61 |
| 4 Vibrant circles | 83 |
| **Third wave** | **101** |
| 5 Moving subjects | 103 |
| 6 Concept to community | 120 |

**vi** Contents

Conclusion  140

*Notes*  *143*
*Bibliography*  *153*
*Index*  *164*

# FIGURES

| | | |
|---|---|---|
| I.1 | "Sources," 2017. Multimedia on silk organza, 70" × 180". Photograph by Nathaniel Goodwin | xx |
| I.2 | "Steeped in History, Knowledge, Place," 2017. Gauze, velum, ink, paper, string. Photograph by Claudia Egholm-Castrone | 8 |
| I.3 | Detail, "Steeped in History, Knowledge, Place." Photograph by Claudia Egholm-Castrone | 8 |
| I.4 | Detail, "Steeped in History, Knowledge, Place." Photograph by Claudia Egholm-Castrone | 11 |
| I.5 | "Cappuccino," 2016–17. Paper, coffee. glue, acrylic, 25.4" diameter. Photograph by Claudia Egholm-Castrone | 13 |
| I.6 | "Bibliography," 2017, 5" × 1/2 mile. Velum, ink, and scotch tape. Photograph by Claudia Egholm-Castrone | 16 |
| I.7 | Detail, "Bibliography." Photograph by Claudia Egholm-Castrone | 17 |
| I.8 | "Index Cards," 2016–17, 25 canvasses. Acrylic and ink on canvas, 5" × 7" each. Photograph by Claudia Egholm-Castrone | 20 |
| I.9 | "Index Cards," 2016–17. Acrylic and ink on canvas. Photograph by Claudia Egholm-Castrone | 21 |
| I.10 | The "Passport Window," detail of "Sources," 2017. Multimedia on silk organza, 70" × 180". Photograph by Nathaniel Goodwin | 25 |
| 1.1 | "Window # 1," 1991. Paper, pastel, and ink, 17" × 25". Photograph by Nigel Tribbeck | 28 |
| 2.1 | "Tables et Tabliers," 1992. Acrylic on paper, 19.5" × 26". Photograph by Nigel Tribbeck | 45 |
| 2.2 | "Table Tress," 1995. Acrylic on paper, 17.5" × 25". Photograph by Nigel Tribbeck | 46 |

**viii** Figures

3.1 "Hang Dry," 1994. Oil on canvas, 31" × 48". Photograph by Yvonne Polk Ocasio   61

3.2 "Gather Wood, Gather Words; *al-'Arousa*" (The Bride), 2012. Acrylic, ink and paper on canvas. Photograph by Nigel Tribbeck   66

3.3 "My Mother Your Mother, What Color?" Acrylic, ink, and paper on canvas. 36" × 96". Photograph by Nathaniel Goodwin   72

3.4 Detail, "My Mother Your Mother, What Color?" # 2, organza, paper, ink and acrylic. Photograph by Yvonne Polk Ocasio   73

3.5 Detail, "What Goes Unsaid." Photograph by Yvonne Polk Ocasio   79

3.6 "What Goes Unsaid," organza, paper, silk, 5 panels, 60" × 80" each. Photograph by Rayed Khedher   79

3.7 View of "The Second Look." Photograph by Yvonne Polk Ocasio   80

3.8 Beatriz Mejia-Krumbein performing "Of the Same Fabric." Photograph by Yvonne Polk Ocasio   81

4.1 "Chergui," Winds of Life Series. Oil on canvas, 36" × 60". Photograph by Nathaniel Goodwin   82

4.2 Visitors viewing Monica Landeros' "Heart Beats" at "Hanging Out." Photograph by Anh Ly   87

4.3 Dancers Samantha Carlso, Rebekah JoAnn Guerra, Valerie Mendez, Erica Johnson, and Lindsey Casco performing "Laundry Stories." Photograph by Anh Ly   90

4.4 Audience members gathering for a performance of "Hanging Out." Photograph by Anh Ly   91

4.5 "Pin the Wind," oil on canvas, 72" × 60". Photograph by Nathaniel Goodwin   93

4.6 "Untitled," 2016, by Danielle Giudici Wallis. Photograph by the author   95

4.7 Rebecca Guerrero setting up her "Postales de mis viajes/ Postcards from my Travels," 2016, at the Casa Blanca Library with the help of student Suzanna Vargas. Photograph by the author   97

5.1 "*Asharq al-awsat*," 2004. Acrylic, ink and paper on canvas, 13" × 22". Photograph by the author   105

5.2 Detail, "*Asharq al-awsat*." Photograph by the author   106

5.3 "Oil steal," 2004. Oil on canvas, 31" × 42". Photograph by the author   113

5.4 "Tragedy at the haj," 2006. Acrylic and newsprint on canvas, 31" × 42". Photograph by Ian Sam James   114

5.5 Detail, "International Life," 2009. Acrylic and newsprint on canvas, 5 panels, 10" × 30". Photograph by Ian Sam James   117

5.6 Detail, "International Life." Photograph by Ian Sam James   117

6.1 "MMTW Riverside Memory Book," 2015, by the author   121

6.2 "MMTW Clichy Memory Book," 2016, by Guillaume Lasserre   123

6.3 "MMTW Amsterdam Memory Book," 2015, by Blanca Casas Brullet   123

Figures   **ix**

| | | |
|---|---|---|
| 6.4 | Detail, "Sea Scroll," 2014. Photograph by Ian Sam James | 124 |
| 6.5 | "Gather Wood, Gather Words: What Goes Up in Smoke," 2014. Photograph by the author | 126 |
| 6.6 | Detail, "Sea Scroll # 2," 2015. Photograph by the author | 130 |
| 6.7 | MMTW discussion in Bucharest, with "Dans les bras de Morphée" and "Sea Scroll" in the background, 2015. Photograph by the author | 130 |
| 6.8 | "Mapquest," Bucharest, July 2015. Photograph by Guillaume Lasserre | 131 |
| 6.9 | "WALLS," MMTW performance, June–July 2017, *Kapelle Der Versöhnung*/Berlin Wall Monument. Photograph by Guillaume Lasserre | 135 |
| 6.10 | "Traverse Heritage," pre-performance filming at the Hermitage Museum, Amsterdam, May 17, 2018. Photograph by the author | 137 |
| 7.1 | Detail of "Conclusion." Photograph by Ian Sam James | 140 |
| 7.2 | Detail of "Conclusion." Photograph by Ian Sam James | 141 |
| 7.3 | "Conclusion," 2020. Acrylic, ink, and tissue paper on linen, 72" × 145". Photograph by Ian Sam James | 142 |

# ACKNOWLEDGMENTS

This book was composed under shifting circumstances. It began as a collaboration with Bloomsbury, where Miriam Cooke's interest in my initial project and the trust of four anonymous reviewers gave me momentum and motivation. When Miriam departed, Lucy Carroll and Lily McMahon offered critical support while I completed the manuscript. While three anonymous reviewers perceptively offered suggestions for improving the text, it followed Bloomsbury's anthropology collection to a new home at Routledge. Katherine Ong, Amy Doffegnies, and then Manikandan Kuppan and Anna Doyle shepherded the book through production. I am grateful to all of these people who ensured the book's publication in spite of these changes and in the midst of a global pandemic.

In the interval between project and manuscript, Genie Davis read each version of every chapter; a veritable *génie*. She and Michael Walker helped me to go with the flow of image to text. Casey Avaunt, Alexandru Balasescu, Barbara Bernardi, Blanca Casas Brullet, Helen Faller, Beatriz-Mejia-Krumbein, Dhiren Panikker, Katarzyna Puzon, Sue Roginski, Olga Sezneva, Priya Srinivasan, Dennis Thompson II, Uthra Vijay, and Natalie Zervou read sections related to the work we have done together. Collaborations with Juliann Allison, Claire Lambe and WESSIELING have been critical to shaping my experience of fieldwork and art. I am grateful to them and to all of the scholars, artists, and publics who have made collective programs key chapters in my life and in this memoir. Special thanks to Patrick Brien, Michel Camau, Abdou Filaly-Ansary, Luca Giuliani, Thomas Jeutner, Felip Marti Jufresa, Tonya Kennon, Guillaume Lasserre, Matthew McCray, Jan Willem Overdijk, Anne-Marie Planel, Lisa Strehmann, and Annemaire de Wildt for getting their institutions involved with the programs I write about.

Students who have taken my classes will be familiar with many of the themes of this book. Vianney Bernabe, Jordon Brown, Liam Espinoza-Zemlicka, Chari Hamratanaphon, Mingyue Huang, and Lawrence Ramirez offered helpful

Acknowledgments **xi**

comments and corrections on the penultimate draft in the Spring 2020 graduate fieldwork seminar at the University of California, Riverside (UC Riverside). Huang and Ramirez, along with former students Erin Gould, Kohanya Groff, Stephen James, and Shahab Malik, took part in some of the journeys across fieldwork and art I write about.

Peter Brown, Natalie Zemon Davis, James Faubion, Stephen Foster, Todd Gitlin, George Marcus, Lydia Nakashima-Dagarrod, Susan Slyomovics, and Susan Terrio gave me the courage to do the work I reflect on in this book, and the confidence to write and paint memoir. Thoughts I develop in the coming pages emerged during walks up Mt. Rubidoux with Sally Ness and Christina Schwenkel, over drinks in Anne Sutherland's pool, or at LA and Portland hotspots with Juliette Levy. They took form as I went gallery-hopping with Cindy Rinne, attended theater performances with Erith Jaffe-Berg or WR Duell, through conversations about anthropology and art with Debbora Battaglia and Roger Sansi, and critiques at Kristine Shoemaker's place at the Brewery in Los Angeles.

The work of memory was especially hastened and enlivened by visits to people and places that figure in the text. Lunch overlooking the Bou Regreg estuary with Amina Aoucher and a trip up the river basin with Souad Radi and Jean-Noel Ferrié; visits "f-rbat" with Bouchra Boulouiz, Jamaa Baida, and Mohammed Kenbib, and then to "dar el beïda" with Hassan Rachik could not have been more pleasurable and necessary for recollecting. In Dublin, Shana Cohen and Rupert Cox jogged my thoughts about text and image and activism. In the San Francisco Bay Area, my mother Camille Ossman and sisters Linda Crowson and Mary Martinez reminisced with me. I remembered how my father, Edward, listened carefully to my childhood musings, making me feel like I had a stake in science and philosophy. This intellectual encouragement and my mother's interests in design and talent for management influenced the kinds of work I have imagined and carried out.

In the Bay Area I also conjured memories from Paris and Berkeley with Marian Concus and met Charles Cavanagh, Johnny Garcia, Stacey Swanson, and Tania and Wally de Young who took part in the teenage "encounters" I reference in the coming pages. My friendship with Ann Henstrand began in California in the early 1970s, but most recently brought me back to Chicago, my birthplace. Heading to the Art Institute and the Field Museum, meeting up with Paul and Jill and Lu Radzicki, and then returning to Ann and Stephen Broadie's house in Oak Park to relax on the screened back patio in the wake of a thunderstorm, the scent of rich, dark soil rising on the still air at nightfall was the same as it had been 50 years before, when I spent summer evenings on the porch behind my grandparents' bungalow.

The voice of my grandmother, Bernice Wrobel Radzicki, often came back to me as I wrote. So did the Provençal accents of my son's great-grandmother on his father's side, Marie Turc Fajardo, an essential support on the home front during the early years of research. As I wrote in the calm of a world gone quiet because of the pandemic, I sometimes felt like my friend Nabiha Jerad was sat beside me.

**xii** Acknowledgments

I imagined sharing what I wrote with Andre Taieb, Mark Kuroczko, Marcel Allalof, and Yves Jeanneret. They all departed this world too soon.

My son Nathanael and his partner, Jade Juste, and their children, Swann and Lou, make Paris their home. They, and countless friends and colleagues, keep the city at the center of my life-wheel. In France, Antonella Casellato, Christian Dardonville, Hannah Davis-Taieb, Louise Dorent, Waddick Doyle, Deirdre Gilfedder, Jean-Claude Gicquel, Yves and Cécile Gonzales-Quijano, Ivan Jabolnka, Catherine Lheureux, Justin McGuinness, Alice Peinado, Caroline Pierce, Susan Perry, Marie-Pierre Ulloa, and Adeline Wrona have contributed to the work I reexamine here in many different ways over the years.

I have only spoken once about this project in its entirety, at the American University of Paris in May 2019. I have, however, presented aspects or parts of it at the *Institut d'études avancées* in Marseille, the Celsa-Université Paris IV, Sorbonne, the University of Newcastle, *L'Institut universitaire de recherche en sciences sociales* (IURSS, Rabat), Cornell University, the University of Amsterdam, the University of Chicago, the *Institut Français de Rome*, New York University, the *Wissenshaftskolleg zu Berlin*, *Arts of the Present*, The Transart Foundation (Houston), the Université Internationale de Rabat, and to the University of California, Riverside Global Studies Program and Anthropology Department lecture series as well as panels at the meetings of the American Anthropological Association, American Ethnological Association, and the Royal Anthropological Institute. I gave artist talks and gallery visits related to these projects at the Officina Collective Studio, Berlin, for CARMAH (Center for Anthropological Research on Museums and Heritage); at the Los Angeles Art Association; and at the Inland Empire Museum of Art. I am grateful to the organizers and participants of these events for their interest, attention, and feedback.

The College of Humanities and Social Sciences of the University of California, Riverside generously provided a grant to produce this book.

The following institutions made the work I write about possible: I list them chronologically according to the waves of work I study in the chapters.

*Wave One*: L' Institute de Recherche sur le Maghreb Contemporain (IRMC), the Centre National de Recherche Scientifique (CNRS), the Fondation du Roi Abdul-Aziz Al Saoud pour les études islamiques et les sciences humaines (Casablanca), the CDEG (Centre de Documentation Economique Egypte), and the American Institute of Maghrebi Studies (AIMS).

*Wave Two:* The Brandstater Gallery, La Sierra University, University of California Institute for the Arts (UCIRA), The Center for Ideas and Society (CIS), UC Riverside, the Graduate Students Union of UC Riverside, the Riverside Council on the Arts, the Riverside Public Library, and the US National Endowment for the Arts (NEA).

*Wave Three:* Grants and program support from the CERI (Centre d'Études et Recherches Internationale), Agnelli Foundation, Georgetown University, The British Academy, Pavillon Vendôme Centre d'art contemporain, the University of Amsterdam, the Allard Pierson Museum of Mediterranean Antiquities,

Typographia Gallery (Bucharest), The Culver Center for the Arts (UC Riverside), Center for Ideas and Society (CIS) (UC Riverside), The Norwegian Institute in Paris, The *Kapelle der Versöhnung*, Berlin Wall Monument, Protestant Dinary of Berlin (East), Santa Monica Art Center (Barcelona), French Embassy Cultural Services (Barcelona), The Museum of Amsterdam and Hermitage Museum (Amsterdam), and The John Simon Guggenheim Foundation.

The many home institutions of MMTW scholar-artists have also generously contributed funds to that program. I am especially grateful to the many anonymous individuals who have made generous donations to the MMTW.

# PROLOGUE

At the cusp of the nineteenth century, a movement toward "the field" brought scientists and artists out of the laboratory and the studio. Riding waves of discovery and conquest, European naturalists traveled to distant lands to collect, identify, and catalogue specimens of plants and animals. Writers entranced increasingly literate Western publics with both real and imaginary stories of distant, exotic lands. Painters exited their ateliers for the open air: Delacroix journeyed to Morocco; Gauguin to Tahiti. It seemed that everyone was on a voyage of discovery, some in search of themselves or many more in the service of God, profit, and power. Encounters with people with other ways of life awaited explorers, travelers, and immigrants. Yet, the branch of knowledge dedicated to the study of humanity in all of its incredible diversity dawdled when it came to getting caught up in the movement to field. Anthropologists mostly relied on information gathered by missionaries, traders, and colonial officials to study the varieties and development of human culture and society. Rather than seeking out face-to-face, on-the-ground observations and experiences, they theorized in the context of their own displacements between their desks and lecture halls, office armchairs, and men's clubs. That is, until a new generation came of age at the brink of the twentieth century. Swept up in the spirit of the times, when even some philosophers extolled the virtues experience, young anthropologists forsook their libraries to travel to the field to encounter their subjects. Significantly, they brought the leisurely lounge-chair habits of their discipline along with them, making prolonged fieldwork the signature research method of the discipline.

The patient, repetitive observations of anthropologists Franz Boas and Bronisław Malinowski resembled Monet's method of painting a single haystack at different times of day, in all kinds of weather. Like the artist, the fieldworker developed questions and techniques progressively, gaining confidence in their

own faculties as they learned the language and lifeways of "their" people. Ethnographers took copious notes, sometimes sketching and taking photographs, documenting what they observed, while also taking part in day-to-day life. This "participant observation" engaged the anthropologist's senses and emotions and intellect with the goal of developing a portrait of the society and culture under investigation. A year of immersive, on-site fieldwork became the norm in the profession; experiencing a yearly cycle of the seasons would presumably allow the fieldworker to observe typical patterns of transmigration and agriculture. One could, it was supposed, get a well rounded perspective on kinship, belief systems, ritual, and exchange – aspects of human life entangled in "culture."

Of course, the anthropologist had few ways of judging whether the seasons they spent in the field were ordinary or exceptional for their subjects. While recognizing that there were years of drought and flood, of peace and war, of abundance and famine, the timeframe of the researcher's sojourn set the boundaries of the knowable. How might anthropologists generalize about what they could not observe or be a part of? It was assumed that since many of the peoples they studied did not have written records, it would be impossible to historically situate the anthropologist's findings. Most researchers believed that any truths in oral histories must fade into imagination with passing generations. Besides, even when anthropologists did fieldwork among people who were a part of great historical civilizations with abundant written records, they often did not have the linguistic or archival skills to contextualize their work with regard to these histories. Thus, anthropology made method of necessity, inventing a methodological device called the "ethnographic present." This science-driven fiction extracted non-European peoples from history. It made the scholar's "time in the field" the framework for knowledge.[1]

Upon returning home, the researcher "wrote up" their findings in books and articles. Ethnographic description and analysis at the time followed a positivist urge to render observations in similar terms for all researchers. Uniform protocols for analysis and writing were deemed necessary to serve the aims of generalization, of theory. So although bodily and social embeddedness was considered essential to knowledge gained in the field, much of what one learned during the year of research could not be included in scientific publications.

Even as anthropologists abstracted the peoples they studied from history, so their own time in the field was set apart from the flow of their lives as usual and the histories of their own societies. The "year in the field" was fetishized by the profession. Yet examinations of how field experience actually led to understanding, and the way it affected the person doing the research could not be included in typical scholarly texts. Experiencing new ways of living, forms of consciousness, and intellection that could not be included in the "write-up," many anthropologists began to write fieldwork memoirs. Memoir thus emerged as a symptom of the classical fieldwork scene becoming science. Writing memoir, anthropologists could reflect on the remnants of their scholarly texts. They could share their stories with curious, enthusiastic publics beyond the academy. And

they could engage questions about larger historical forces that more academic anthropological literature pointedly avoided through its very methods.

Consider how the famous French anthropologist Claude Levi-Strauss began his *Tristes Tropiques*, published in 1955 to critical acclaim. Tongue in cheek, he wrote about how his first attempts to compose a memoir were thwarted because he could not stop himself from comparing his own travels to those of the Great Explorers, who encountered "virgin" land and "untouched" tribes. It was only once he considered how his journey in the 1930s would appear to anthropologists "a hundred years hence" that his prose flowed freely. Readers of his memoir would be in the same historical relation to him as he was to his predecessors.[2] They would envy his ability to encounter peoples who will have vanished by their time, he mused. Apparently aligning himself with the thrust of history, he picked up his pen and began to write his fieldwork story. Yet history itself seems to have intervened. Instead of commencing his account of fieldwork with his maiden voyage across the ocean, he wrote first of his second transatlantic crossing in flight from fascist Europe, just a few years after he returned from his first journey to Brazil. The penniless refugee on the run casts a shadow from the future on the figure of the energetic novice anthropologist, whose travails he recounts and remembers as his own. The life-defining voyage of return overlays the narrative of travel to the field and homecoming. Levi-Strauss twists the narrative of discovery to his reflexive ends. Using narrative methods akin to those of the then-emerging new-wave cinema, he invites the reader to contemplate connections between discovery, knowledge, and power.

I cannot say when I first traveled to the field. I do recall my first anthropological sojourn. That voyage began at the Des Plaines, Illinois public library. I must have been about ten when I discovered the anthropology shelf and began trying out the methods I read about to study the exotic habits of my family at holiday feasts and ritual celebrations.[3] The notes I wrote in a green velvet diary are long-lost. What I do have is a set of watercolor portraits I made based on black-and-white photographs in one of the books I found in the stacks.[4] A bright picture of a woman from "Tanganyika," now Tanzania, conjures words I wrote in the long-vanished notebook: about menfolk gathering to watch Sunday football, the symbolism of first-communion veils, and the ethnic and racial divides of Chicagoland as they took form on the schoolyard.

When I moved with my family to the San Francisco Bay Area in 1972, I added the experience of migration to my ad hoc training as an observant and engaged participant. I discovered that I enjoyed mathematics, especially setting out equations; I was not as interested in solutions. I developed philosophical, literary, and then political interests. But it was art that led me to Kroeber Hall, at UC Berkeley, to study painting with Elmer Bischoff and printmaking with Sylvia Lark. It was in a first-floor seminar room in the same building, named for the eminent anthropologist Kroeber, that I also staged a situationist-inspired performance in Martin Jay's history class on Western Marxism in 1978. The topic was the

student uprising just ten years before, in Paris, in May 1968. I graduated in March 1980 and set off to France.

As the first-born daughter of a large family, I had extensive childcare and housekeeping experience. That landed me a position as an *au pair* girl in Paris with a middle-class family of the 20th arrondissement. Next, I minded the daughter of a marquise in a spacious flat overlooking the Tuileries garden. Later I moved on to a waitress job at Hayne's soul food restaurant near Pigalle. On weekends, I distributed leaflets for François Mitterrand in my boyfriend's northern *banlieue*. Once Jean-Philippe and I were engaged and I obtained a *visa de fiancée*, I started a new position, explaining the intricacies of French national health insurance to students. The wedding was in December 1981: the night that General Jaruzelski imposed martial law on Poland to crush Solidarność. JP and I soon headed for Brooklyn to share a former spice factory loft with two artists; there was plenty of room to paint. But activism kept my then-husband looking toward France. I eventually followed him back to Paris, returned to the insurance job, and took up painting miniatures in the tiny flat we rented near the *Gare de l'Est*. Immersed in political milieu and making art, I was ambivalent about academia, but missed the focused intellectual exchanges of the university. I decided to expand my earlier interests to study of the introduction of new communications technologies and media in the French former colonies. I returned to the "fac" to study the way in which French colonialism shaped ideas about authenticity and cultural expression in North Africa.

Living in Paris in 1982, I missed seeing the wheat field that artist Agnes Denes planted in Manhattan that year. I read about her pathbreaking work, but I had no inkling of the influence her actions could have on me in the future. I was ensconced in exploring the history of the refractions the media projected across the Mediterranean. I went to Morocco to consult archives, and met some of the authors of the texts I sought out, still very much alive. I shifted my focus from the past to the present.

By that time in the mid-1980s, the ethnographic present had been resoundingly critiqued.[5] Anthropology's complicities with Empire and Orientalism had been laid bare. Reflections on anthropological connections with colonialism were steadily becoming more central to how research was being framed and conducted. From being a symptom or an afterword to research, elements of fieldwork experience formerly relegated to memoir were finding their way into doctoral dissertations. In that period of crumbling paradigms and changing canons, experience-near fieldwork methods seemed to offer new grounds for thought. The promise of shaping understanding through first-hand experience attracted new practitioners from across the academy and beyond, to the arts, creative writing, and journalism. I was among them.

Some people sought out ethnography as a way to seek out vibrant experiences that modernity had snuffed out. Not me. I came to anthropology a second time with the aim of studying how modernity's "fairy images" flowed from movie projectors and television screens to shape ways of life and forms of power.

**xviii** Prologue

I wanted to study images in motion as they composed Casablanca, a city known to the world because of a movie shot in Hollywood.

In Paris, I spoke with seasoned ethnographers about my ideas for research. They responded politely: how could I frame and pin down spectral images once they were released into a fluid landscape? How could I measure their effects? Casablanca is a sprawling, heterogeneous environment. How would I establish the boundaries of my study? Their words were polite, but their eyes looked at me as though I'd said I would become an anthropologist by sprinkling my wings with pixie dust. By then scholars in Britain were starting to do media ethnography. But I could not move to England. My son was born in 1984, and I needed the support of family in Paris or the Bay Area. Friends suggested that I contact Paul Rabinow at UC Berkeley. After publishing his *Reflections on Fieldwork in Morocco*, he was studying the building of colonial Casablanca. We met. He was interested in my project. It was time to return to fieldwork and anthropology and to Kroeber Hall: anthropology is just downstairs from the art department.

In the mid-1980s, Kroeber Hall was abuzz with discussions about representations, but artists and anthropologists kept a courteous if friendly distance in the hallways. It was conveyed to me that total immersion in "the discipline" was a necessary prelude to total immersion in "the field." I stored my portfolio under the bed in my rundown apartment in the married-student housing complex with a fabulous view of the Golden Gate bridge. I was not about to reveal the panoply of practices I engaged in to the public eye, especially since other aspects of my graduate career deviated from the norm. I was the only parent in my incoming class, one of only a couple in the entire program. And then there was the way I blurred lines between field and home.

Although by that time the ahistorical methods of classical fieldwork had been resoundingly rejected, the pattern of travel to the field for a year-long sojourn remained the norm. Even today, graduate students still typically take a couple of years of coursework, then exams, go to the field for a year, and then return to their universities to "write up" their research in dissertations. After landing an academic position, one publishes the "diss" and starts on a "second project." As for me, I took the required courses at Berkeley, and then headed back to Paris for a side research project on migration and the anti-racist organization S.O.S. Racisme. I began making regular journeys to Casablanca from there. By the time I took the examinations that had theoretically prepared me for a year of fieldwork, I'd been coming and going "to the field" for some time. When did I "come back" from the field? Perhaps I never did. Just as there was no clear point of departure, there was no single home to return to.

I stayed in Morocco for over seven years; my first academic job was as a research fellow and director at a French research institute in Rabat. That was followed by positions teaching media and communications and anthropology in Paris, then Arab studies, international media, anthropology, and global studies in Washington D.C., Houston, London, and California. Fieldwork, writing, and

making art were constants as I moved through disciplines and languages, shifting personal circumstances and jobs. As years passed, anthropologists became attuned to the rhythms of globalization and configurations of power and meaning across the world wide web. Fieldwork paradigms and practices have changed with the times. Like Agnes Denes's wheat fields in Manhattan, anthropology has come not only to reap observations by way of experience but also to sow fields in unlikely places. The cross-field currents that have long given my work momentum are increasingly designed to coming together in creative and meaningful ways. Feeling caught up with myself in this present moment, I have written this memoir on shaping fieldwork by way of art.

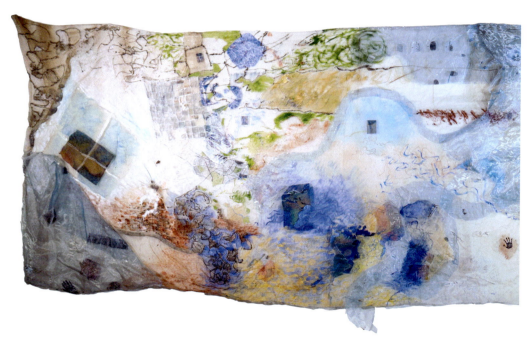

**FIGURE I.1** "Sources," 2017. Multimedia on silk organza, 70" × 180". Photograph by Nathaniel Goodwin.

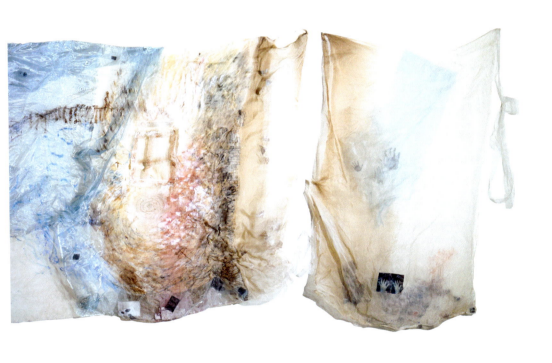

# INTRODUCTION

"Sources" gathers together evidence of my moves, returns, and shifts of direction. I made it for an exhibition on WALLS at the *Kapelle der Versöhnung*, the "Chapel of Reconciliation," at the Berlin Wall monument in June 2017.[1] The chapel rises on the same spot in the former no-man's land where a cathedral stood until GDR authorities demolished it for "security reasons" in 1985.[2] The curving clay inner wall of the *Kapelle* includes its detritus. Bits of bright tile peek out from the compressed earth. A path winds around the elliptical structure, bordered on the outside by wooden rails that let in light, wind, insects, and even small birds. This second wall offers a clear view of the park beyond. Yet not even the tiniest child can shimmy through its slats. The roof is poised over the parallel high walls; it protects the walkway between them and the inner sanctum, where daily services commemorate people who died trying to cross from East to West. I was haunted by one story in particular. A couple planned their escape in a hot-air balloon. On the appointed day and hour, the woman was detained: her husband had to choose between arrest and a solo departure. He alighted. They had calculated the flight path for two. Alone he flew too high, too far, too fast. He froze amid the clouds and plunged into a West Berlin backyard, a Cold War Icarus.

As I reflected on walls as boundaries, barriers, and lures, I imagined I was weaving a silk parachute to ease the descent of my East German contemporary.

Times change. Lines between East and West have shifted. Other walls have been erected. Some are as impermeable and physically imposing as the Berlin Wall once was. Many more are as transparent as the Iron Curtain that symbolically divided the world into two "blocks." Bricks, blocks, sticks and stones... .

Introduction    **3**

I returned to the *Kapelle*. Running my hand across the coarse earth wall conjured memories of the imposing mosques of Timbuktu. I visited the once-great city on my way to a Tuareg settlement in the pathless desert to the north. Some years before, the red clay bricks of the village school melted in a sudden storm. Earthen buildings are vulnerable. They require regular patching and renovation. The village was far from the river with its sources of clay, so the villagers invited architecture students Alpha Saloum, Harber, and my son, Nathanael, to rebuild it in "hur," a durable local stone. I was there in 2008 as they set the cornerstone for a cafeteria and a dormitory; the school was attracting students from around the region. Then war came. The buildings may still stand, but the village dissolved in the wake of murderous upheaval. Did still lively trans-Saharan networks of the Tuareg get those children to safety in Mauretania or Algeria? How many of them headed to Morocco or Libya to cast their lot with the capricious gods of the Mediterranean in hopes of reaching Europe? Pricking my fingertip on a glass shard in the clay wall, I thought of silk a second time. I envisioned a gauzy net stretched across the sea, catching people whose boats capsized.

Silk is remarkably resilient. Cloth woven of its threads keeps the body warm in winter and wicks sweat from the skin on a sultry summer day. It withstands water and wind and the work of time, and yet there is no finer fabric. I knew silk could weather the cold storms that visit Berlin even in the springtime.

It took many visits to fabric stores around the city to discover the right swath of cloth. Once I found the perfect, broad, translucent length of ivory organza, I rolled it out on the floor of my living room. I decided that the piece should veil, and then offer a glimpse of the field beyond the chapel, punctuating the act of viewing. I cut the organza into two unequal pieces to create a rhythm for the passing viewer, daaaaaaa—daa. The longer length would focus on issues of location, identification, individual signature, and circulation, the smaller on mark-makers across human history. Between the two, encased in a fold, there would be a wire mobile of my genealogy, composed of rows of triangles for males and circles for females in proper anthropological fashion. Border walls raise questions of history and nation, identity and surveillance; I collected my passports and social security numbers, voter cards, and credit cards. I photographed my fingerprints and irises. I considered issues of origin as I drew out my family tree and composed the mobile that joined my "sources" to those of others. I thought of the *Kapelle*'s inner wall and collected bits of brick and tiles that reminded me of my many homes. I added pockets of clay and painted with mortar. Remembering and writing every one of my addresses was not an easy task. I stitched long ribbons on the corners of the diptych, so I could tie it to the posts. I tucked pebbles into the corners of the hems to keep the gauzy panels from striking viewers when the wind came up.

I pinned the fabric on the wall or I stretched myself out on top of it on the floor to stitch and glue these relics onto the gauzy flux of the diaphanous

**4** Introduction

fabric. The filmy material brought to mind curtains. I took out photos of a series of drawings of windows I'd made years earlier, printed them as appliques in several sizes and ironed them on the fabric. I stapled the identity numbers onto the soft stuff and added a layer of blue organza over appliques of my identifying fingerprints and eyes. I colored the silk with paint and clay and poppy dust. *Aker Fasi* is made of dried, crushed poppy petals. If you mix it with oil and touch it to your lips, it draws your mouth in a scarlet streak. Spread on the skin, and then rinsed, it leaves a rosy glow. In Morocco, you can buy it from any spice vendor.[3]

Using this palpable synthesis of my paths as a touchstone for memory, I am reminded of what Claude Levi-Strauss wrote about his efforts to recollect for memoir:

> En roulant mes souvenirs dans son flux, l'oublie a fait plus que les user et les ensevelir. Le profond édifice qu'il a construit des ces fragments propose à mes pas un équilibre plus stable, un dessin plus clair à ma vue.
>
> Plunging my memories in this flux, forgetfulness has done more than wear them out or bury them. The meaningful edifice it has built of these fragments opens a steadier path for my feet and a clearer picture for my vision.[4]

When I strung "Sources" along the outer wall of the *Kapelle*, it billowed like a sail. Contemplating it, I could both imagine and observe

> Des évènements sans rapport apparent, provenant de périodes et de régions hétéroclites, glissent les uns sur les autres … Des formes évanescentes se précisent.
>
> Events without any discernible relation, from different periods and diverse regions gliding over each other … Evanescent shapes coming into focus.

The clay I had stitched into silk brought to mind the red-earth cities of Southern Morocco which the locals call *ksour*: "castles." Still, my memory work could never

> s'immobilisent dans un semblant de castel dont un architecte plus sage que mon histoire eût médité les plans.
>
> Stand[s] still to form a citadel whose architect, wiser than my life story, designed the plans.[5]

"Sources" presumes no such great architect. It flutters and evolves with its environment, never settling to become anything other than itself.

At the *Kapelle*, breezes animated the autographic work on view for tens of thousands of people. Storms mangled and partly decomposed the triangles and circles of the family tree. Yet the postcodes and ID numbers I stapled to the

precious fabric were unaffected by the weather. They can still be checked and verified. They will still provide me medical care or a pension. They will persist in identifying me when I pass on. "Sources" imbibed the scent of petrol, gathered dust and pollen; it gained weight in the course of the month-long exhibition. When I took it down on the first of July, the gauzy membrane had changed from pale ivory to the tawny beige of my summer skin.

While Levi-Strauss wrote how putting pen to paper cleared up the "murky" stream of his thoughts, the pockets of soil of my memory-work bled with the rain, blurring the letters I had traced on its sheer surface. It was not enduring constructs, identifications, or a collection of each remnant of my fieldwork experiences that were essential to pass on. What was important was to stitch red clay into pockets of silk and to let the rain seep in.

## Waves

My gauzy, sand-stained map dances with the wind, associating bits of who I am and where I have been in changing ways as it flickers and folds in on itself. It shows much that cannot be said outright. It opens a path for composing memoir in a way that eschews the sexy self-exposure of straight-up autobiography. Reflecting on the forms my fieldwork has taken by way of painted silk wafting in the wind, I have fashioned a text that includes deeply personal truths of a kind that true confessions obscure.[6] These may come out in a particular turn of phrase or a brushstroke, or in the form I have given my work and this memoir; all of these are examples and results of a particular way of moving through the world.

One critic writes that my work "has a strong sense of place, but at the same time ... a feeling of impermanence and shape-shifting evocative of transient lives where landscape, language and a sense of self are forever being renegotiated."[7] Another states, "The brush work has a linear quality which the artist moves across the picture plane as if waving a wand."[8] These negotiations suggest some coherent mode of action across multiple, moving worlds. This wand suggests a particular manner of giving shape and meaning to things. One might call it style.

Michael Wood has reflected on writing style as "not a meticulous control of a fictional world but a disciplined vulnerability to the shocks of a historical one." He noted, "Of course, the control and vulnerability are related to one another, the first presumably an answer to the second. When the answer is difficult, barely manageable, only style will allow the writer to continue to write."[9] Style is thus an always emergent, yet somehow inescapable aspect of one's work that is interwoven with oneself under specific circumstances.[10] The sense that one can sometimes have of not being able to do or make or be otherwise is a result of entanglements of fate and intention. I recorded a student's comments during a lecture in my diary: "You talk just like you write, in waterfalls."

**6** Introduction

Watching videos of myself, I observe how my hands move about like fluttering birds or butterflies. It is as though I want to leave the ground on the wings of the words coming off my lips. "Lyrical," "layered," "poetic," these are the words that others use to describe my writing and art.[11] Or they insist, "Please just spit it out, state your point! Why do you digress?" Or comment that "the writing is graceful, but doesn't it distract from the argument?" It was not just the argil wall of the *Kapelle* that compelled me to sew silk pockets for red earth to bleed on white cloth.

As I set out to make myself a malleable dependent variable to reflect on field-work, I keep in mind the pervasive contrasts of male abstraction, theory, and design to feminine connectivity, practice, and grace that I encountered every-where, and always. These operate within domains, and among them. With this in mind, I remember my efforts to cross that persistent border; I realize how those trangressions make it impossible to lay down a project-by-project account of my intellectual biography, as some important men have done.[12] Instead, I follow a selected number of fieldwork projects that took their form in larger waves of in-quiry on media and globalization, women's work, and migration. I reflect on how others made my work what it has been, and how the fields I devised put designs on me. I set out the terms of my analysis by way of art made in the field, with the aim of understanding scholarly habits, assumptions, and ways of life.

## Analytic

When I arrived at the *Wissenschaftskolleg zu Berlin* in late August 2016 on the trail of my then-partner, I had no intention of making the residential research institute an object of study. Yet, once immersed in the life of that bounded, semi-autonomous community, the purity of the classical anthropological scene was enticing. A society conjured into existence each year with the purpose of offering academics and artists time to work and exchange ideas, the institute of advanced research was like a utopian vision of the ethnographic present. As a scholar among scholars, I already had intimate knowledge of the mores of the population. The only problem was that surrounded by others of my kind, I had no ready point of comparison. There was no "home" or elsewhere to stimulate the research dialectic. What I could do to gain distance, however, was to mo-bilize my dual practice and identity as an artist-ethnographer. I turned to art to do fieldwork on scholarship.[13]

At the library, in my home office and at "Officina," a collective art studio in a yet to be gentrified part of the Neukölln quarter, the stuff of research became my preferred medium. I worked with lined paper and footnotes, formulas, paperclips, lists of statistics, and the coffee and tea so necessary to getting creative minds going in the morning. I attended research lectures, noting regularities in the shape of con-versation and forms of debate as well as attending to the subject matter.[14] I began to pay close notice to my own and others' habitual gestures as we read, took notes, or typed on keyboards. Making art the leading practice for fieldwork, I reflected

on the environment, project of community creation, and work being done at the institute. Shaping my artistic practice to fieldwork investigation, I became more aware of my own artistic penchants and references. Broadening the range of my habitual media within the framework of the fieldwork project, ethnography led me to work with a mind to a wide variety of artistic movements and traditions, past as well as present; from post-Dadist literalism I shifted to late-Romanticism, molding art practice to fieldwork rather than to my own inclinations or contemporary art world fashions.

Throughout the year, I worked toward a year-end, on-site exhibition with fellow resident and artist Claire Lambe. As our plans become widely known, many of the fellows seemed to forget that I had ever been a scholar or academic.[15] The way these people then spoke to me of their work, as an outsider, was also illuminating for the results of the research, and for the project that would become this book. Reflecting on the *Wissenschaftskolleg*'s project for scholarly community, displacing scholarly gestures with reference to art worlds and movements, I came to reconsider the interplay of site and practice and collective life in my own fieldwork, art, and writing. It is to selected works I made in Berlin that I thus turned to set out the analytic for the reflections I develop in this book.

## Environments

Whether or not the field is conceived as a particular place, scene, or state of being, some sense of the environment is implicated in a fieldwork project. Perhaps you see a space in your mind's eye: it may be limited by the horizon or the walls that encircle you or need to be framed for you to make anything of it. Sound and scent stretch the space, and its echoes differently, often beyond what the eye can perceive. Touch seems to narrow down to contact; vibrations set nerves on edge in ways that affect the way in which one moves through place and time. Textures can be similarly suggestive, whether they are conveyed in a landscape, soundscape, or language. The environment hugs your body. Yet anonymous systems and institutions and messages from afar also convene to create the field you sense, engage, live in, and investigate.

How you can move through and what you can make of environments is obviously determined not only by ideas, or visions, but by what you bring to them. This might be a facility for easy conversation, shyness, your beliefs, and theoretical and epistemological positions, or those you have previously embraced.[16] It could be knowledge and practice using particular methods and media. What environments make of you is also critical to how you can engage and know them. The inquirer you can be might influence not only where you go, but the objects you study and the social networks you engage.

To think about environments and how one might parse them, I will turn to an installation called "Steeped in History, Knowledge, Place." I made it to study and convey the aspects of the environment that coalesced to produce the seductively comfortable atmosphere of the *Wissenschaftskolleg*, which Berliners and residents called the "Wiko."

**8** Introduction

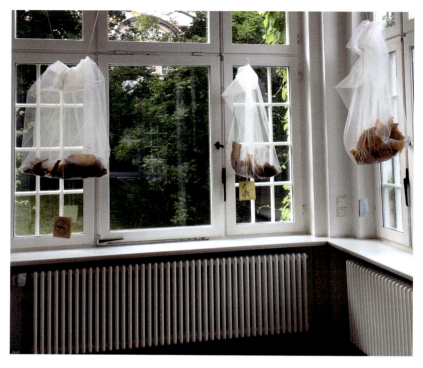

FIGURE I.2  "Steeped in History, Knowledge, Place," 2017. Gauze, velum, ink, paper, string. Photograph by Claudia Egholm-Castrone.

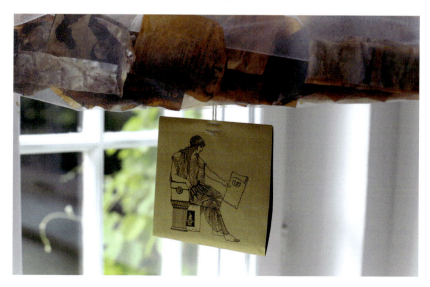

FIGURE I.3  Detail, "Steeped in History, Knowledge, Place." Photograph by Claudia Egholm-Castrone.

Any residency or fellowship is an idyll from life as usual. But at the Wiko, the buildings, grounds, and neighborhood are especially well appointed. The tranquil late turn-of-the-century buildings and expansive gardens with their ersatz Roman statues awed many of us initially. Very quickly, we became absorbed into our new life at the institute. This process echoed the ways that anthropologists write about becoming immersed in fields that present themselves as self-contained, bounded, walled, or socially well defined.

The filmy elegance of the deluxe teabags in the dining room captivated me. These minor luxuries seemed a particularly graceful distillation of the institute's environment, even as they evoked possibilities for critically apprehending the immersive promise of fieldwork in an engaged and sensual manner. It was easy to observe that tea was a daily accompaniment for scholarship for some resident scholars. It was also a potent medium to explore the very idea of immersion as an active principle.[17]

Of course, tea is activated only when it is associated with water and heat. Living in chilly Berlin led me to appreciate the hot water that coursed through the radiators across the campus. Central heating was a necessary condition for scholarship in that climate, but it was not sufficient to spark intellectual activity. For that, caffeine was almost always required. Scalding water added to Darjeeling leaves thaws cold hands as the cup heats up. The body warms next: it takes a few minutes for the hot brew to prod the mind into action. While the kettle revived some summer Chamomile blooms in the evenings, it was the stronger brews of English Breakfast or Green Gunpowder that were the chosen beverages of the genuine tea lovers who worked with their mugs steaming beside them during the daylight hours and into the long winter nights.

I tasted the varieties of tea on offer. I read up on the tea trade and history of the beverage. I began to think of how I might use tea in artworks to explore and convey the immersive experience of living and working at the institute. What did we take in as we drank tea in those spacious, well-lit rooms? Why did this particular setting make academics of a certain age and renown, from around the world, feel at ease? I began to consider the different "flavors" that infused the environment. I wondered: if the "tea leaves" of the institute were dried and bagged, how would they be labeled? I studied the grounds of the *kolleg*. I traversed the Grunewald neighborhood on foot, bus, and train. I read up on the history of the neighborhood and the city. I inquired about the history of the institute. And all along I experimented with dried or wet tea leaves in combination with various emulsions in the studio. I conceived an artwork to explore how three types of "tea" mingled to create the experience of the *Wissenschaftskolleg*.

First, there was a history. Discussions about the past were commonly prompted by visits to the deportation memorial at the Grunewald train station, or visits to the Berlin Wall Memorial; or simply the way the Nazi era and the fall of the Berlin Wall seemed to hang over contemporary Germany. Most fellows were middle-aged or older. Most were from Europe or North America. Their own or their parents' tales of the Second World War and the fall of the Berlin Wall

**10** Introduction

were closer to us in time and consciousness than some other historical facts. Still, residents would likely know about the 1919 revolution or the role of French Huguenot refugees in the early days of Berlin's expansion during the seventeenth century. Reading led me to understand that the longer history was important for understanding how so many of us found life at the *kolleg* so immediately attractive and easy.

I took up a magnifying glass to the institute itself. The publications of the fellows who had been at the institute since it began in 1980 are displayed class by class on tall bookshelves lining the walls of the public rooms. I looked through the rows and rows of books. I spoke with former residents and asked staff about their impressions of the collegium that convened each year. I conversed with the fellows and staff on site and during delightful walks around the neighborhood. I was interested in the dynamic that animated the project across time. Could all of this be taken in during a single year-long visit? I wondered. Regardless of the changes over the years, such as having more women fellows and wider geographic representation, the configuration of the intentional collective that the *Wissenschaftskolleg* created seemed fairly consistent since its founding.

As I studied what I called "Place" in the title of the teabag artwork, I focused on the resonance of the Wiko's design and style with academic lifestyles. Historian Marian Füssel has noted that the modern German academy, particularly in Prussia, was shaped in a particularly close relationship with the nobility and its courtly ideals.[18] German models of the university and professorate were also extremely influential in shaping the modern university around the world.[19] I thought about how these ideals and historically engineered commonplaces of academia influenced my own and others' sense of ease at the institute. I became attentive to how the buildings and grounds allied a certain "noble" elegance with a sense of late-bourgeois comfort, whose opaqueness Thomas Mann probed in his novels.[20] I became ever more aware of how ideas of a refined lifestyle distanced Wiko residents from the clock time of the industrial worker or the adjunct professor or even ourselves in our normal academic lives. Here, no one was summoned to render a progress report or account for the results of their research.

I do not draft an "outline" when I make art any more than when I write a book. I do sketch out diagrams and create gatherings of materials, an animating sense of the overall direction guides my brush, or pen. It is a practiced discipline, perfectly suited to the improvisations and opportunities that come up in ethnography, one encouraged by the expressionist training I'd received as an art student. At one point, I imagined hundreds of tiny teabags that contained much more discrete, specific elements. But like all Berlin, the institute's graceful life was characterized by major collective experiences. I wanted to underscore these. Although the deluxe teabags in the dining room were beautiful, I chose the classic "Lipton" teabag with its trapezoidal top as a model; there would be no ambiguity: this shape would be recognized by everyone. Thus, I repurposed the ordinary object to suggest processes and histories that helped me to understand the environment around me, with its many and often restless phantoms.

Introduction **11**

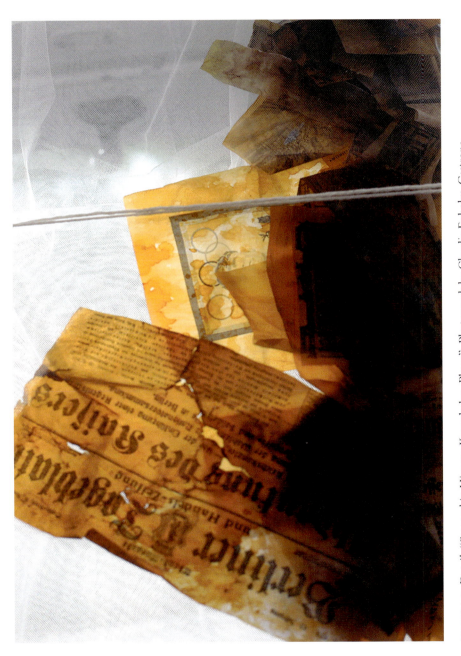

**FIGURE I.4** Detail, "Steeped in History, Knowledge, Place." Photograph by Claudia Egholm-Castrone

**12**  Introduction

Working on the elements of the environment at the Wiko with the exhibition on the horizon affected the progress of the research. It influenced how I worked to conceive this particular piece. I already had a space to hang it in mind when I made the tea bags: a gap where two windows meet in a corner of the large colloquium room. Hung in front of the windows, they would be illuminated from the back. The odd number would also create a triangular dynamic against the background of the double window frame. I sewed the three bags large enough to fit the windows, and so viewers could readily decipher their contents: "tea leaves" printed on velum. I printed texts or images on the paper using my computer printer. Next, I plunged the leaves into a tub of golden-brown ink, drying it, and then dipping it a second time into a vat with a deeper walnut shade. This made the "tea" glow to crystalline effect. For "History," I selected newspaper articles and archival images from the founding of Berlin to the nineteenth century, the World Wars, the fall of the Wall. I sought out recognizable images: the Olympic rings for the 1936 games, 1970s punk rockers in front of the Berlin Wall. I chose writings in a variety of languages with diverse ideological stances. For the "Knowledge" bag, I thought initially about working with journal articles of current residents. Instead, I foregrounded the Wiko as an institution, filling the bag with the names of all of the fellows since the institute was founded. For "Place," I worked with maps I collected and others I made. I included programs from the city's operas and monuments. I mingled recognizable tourist paraphernalia with ordinary scenes of streets and buildings and grocery store logos. The day before the exhibition, I tore the dried velum tea leaves with my hands, careful not to mingle the three sets. I filled each fabric bag, folded it, and attached the labels with staples and thick cotton string. I indicated the contents of each bag in the title of the work, "History, Knowledge, Place." I printed labels on shimmering metallic paper that seconded these words with icons: Clio for history, Berlin's Bear for place, and the ensign of the *Wissenschaftskolleg* for knowledge. I hung the installation on the corner windows as planned for the exhibition. The opening was on a glorious spring day: the leaves of paper glowed in the sun; the old stories were revived.[21]

Anthropologist Katarzyna Puzon wrote that

> Ossman's *Steeped in History, Knowledge, Place* invites viewers on a sensorial journey into the past of the institute and its surroundings. The work is composed literally and figuratively of the traces of Fellows' visits. Time and space, history and geography, are interwoven in its knowledge production/creation. Hanging in front of the two massive windows in Wiko's large colloquium room, three silk bags house three sequences referring to time, memory, and space. The bags contain ink-stained tea leaves one can touch, thus plunging us into the memories of the site. The tactile exploration of Wiko and its history is not organized in a linear manner, making this experience intersubjective and dialogical, as is often how memory works. This chimes with an understanding of history presented by Siegfried Kracauer, a cultural critic and film theorist exiled from his native Germany in

the 1930s. Kracauer saw history in terms of a specific "area of reality" that does not necessarily need to follow chronological time.[22]

As I set out to study how I have given form to other projects, I examine the way I parsed and presented the layers of the environment at the *Wissnschaftskolleg*. I will not assume the same divisions for other settings, being attentive to how coexisting strata or atmospheres shape what can be made of "the field." A field can be devised for experiment, or bordered in space and time by institutional calendars and practices, or set out by means of conventional borders of state or culture. Playing on the layering of these at the outset and in the course of the process of research can enable different ways of "being there." It can open opportunities for adjusting your work in the field like so many layers of gauzy fabric.[23]

Working with tea led me to become particularly attuned to subtle processes of absorption and enlivening in the environment. It enabled me to sort out an atmosphere of assumptions and suggestive, unspoken messages. It encouraged further scrutiny of how the institute worked with the environment, in the manner of an activist anthropologist/artist, creating an atmosphere to foster a temporary academic community each year. To study the particular rhythms of collective life of the actual people I lived with for a year in Berlin, I must turn to consider the work I did with another necessary research substance.

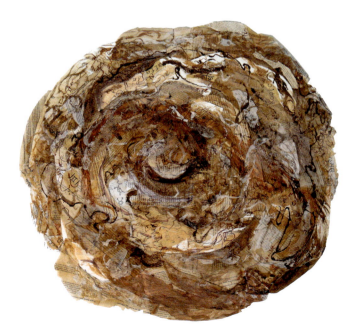

**FIGURE I.5** "Cappuccino," 2016–17. Paper, coffee, glue, acrylic, 25.4" diameter. Photograph by Claudia Egholm-Castrone.

**14** Introduction

## Collectives

Coffee was an ideal medium for exploring the collective aspects of research. This was not only because of the panic at the institute on the rare occasions when the espresso machine broke down. Nor was it based on the observation that coffee drinkers seemed more likely than tea enthusiasts to abandon the campus in search of the ambient noise of anonymous cafés. It was also because of the social and political connotations of the beverage for European history and philosophy. In Germany, it was difficult not to think of philosopher Jurgen Habermas's well-known account of the emergence of the democratic public sphere when mingling coffee and intellectual conversation.

Habermas makes London coffeehouses a prototypical democratic meeting ground, free to all, or, more precisely, for literate men.[24] Like his later theorization of "ideal speech situations" in which people take part in discussion as rational equals, he fails to notice how realities beyond the coffee shop might influence exchanges within them.[25] The stated mission and mode of operation of the *Wissenschaftskolleg* resonate with such Enlightened ideas. The *kolleg* aims to create a collective, global space for sustained interaction among intellectuals; a few writers, filmmakers, and a composer are added to a larger pool of scholars in the humanities and biological and social sciences. Communication across fields of activity and national academies and the potential for enriching the minds of each participant are indeed an intangible, yet most important, "outcome" for the institute, and others of its kind. This presupposes that brilliant people from different domains will find something to say to one another.

Fellows are not expected to quantify or concretize their activities while at the institute. They are utterly free to do as they like, work hard or not at all. The only requirement is to give a single talk about one's work at the weekly colloquium and attend a certain number of collective meals each week. Nonetheless, everyone submits a project as a key element of their fellowship application. I became quite interested in these declarations of intent, because of the vital role they played in spite of the director's continual insistence on the free play of the mind. In spite of the regularly repeated mantra that no one had to follow through on their proposals, I noticed that "project talk" was central to creating bonds among people with whom common belonging to global academia initially offered only a thin connection at the start of the year. Thinking and talking about one's project was also a reminder of the temporary nature of life as a Wiko fellow. It conjured the ordinary academic accounting beyond Berlin and the *Wissenschaftskolleg*. Residents inevitably measured their time in the academic paradise according to what they would bring back to the "publish or perish" realities of an increasingly accounting-oriented global academy.

In spite of the freedom it offered from the university as usual, the institute encouraged research-centric sociability simply by making the choice to invite high-performing scholars and artists to join a temporary collective experiment.

The academically saturated group encouraged a contagious mimetic project consciousness. Coffee was significant not only symbolically, to evoke egalitarian social relations and enlightenment, but as a necessary elixir for the highly productive mind. It helped to concentrate, to avoid being waylaid by the complexity and seductive leisure of the environment.

In the studio, I painted with espresso on paper. I sprinkled coffee grounds on glue. I worked coffee dregs into a variety of binders. The coffee filled the studio with ethers that kept everyone alert on dark winter afternoons. Meanwhile, at the office in Grunewald, I printed the fellows' projects on papers of varied weight and texture. I took some of these to the studio to soak in liquid coffee, or dust with grounds. Then, I methodically composed two circles, layer by layer. The first was made only with coffee-colored projects: it would become "Espresso." The second mingled mahogany-stained prints and frothy, lightweight cream-colored projects; voilà "Cappuccino."

Little by little, day by day, I pressed and pasted these two circles together into irregular, yet unified, spheres. It was like making layers of puff pastry. It was important to me that the projects be joined to one another rather than being attached to a ground that would suggest a common background or a shared set of references or assumptions. I sought to emphasize how the projects animated by the drink fed the collective life of the institute, as well as the individual feedback loop that brought each researcher back to their mug and their books each morning.

I drank many cups of coffee myself. I stood in the long lines at the coffee machine after meals. I asked people where and how they drank their Joe or *kahwa* or café. I traced the history and spread of coffee consumption and the growth of the global espresso industry. I recalled being initiated to the dark brew as a child by my grandmother, who allowed me to add just a tablespoon or two of the delicious potion to a cup of milk; she showed me how to grind the coffee finely to mix it with water and heat it in a small pan on the stovetop. Later, I would learn that this was how coffee is made in the Middle East; except that there, most people add sugar and sometimes cardamom to the mix.

Once each round of the twin espresso drinks was set, I painted them with espresso and drew on them with coffee grounds. I overwrote them with diagrams of the individual brain on caffeine and with the words for coffee in each of the fellows' mother tongues. The art is a reflection on the form of collective the institute sets out to create and about collective life and research in general. In the context of the present project, it taught me to distinguish between collectives and collaborations. Like the institute itself, the piece associates projects that act on one another, not by blending them into a unified ground, but by associating work that is individual and composed with diverse signs and symbols.

Making art with coffee led met to reflect and render the collective form the research institute created. This in turn encouraged me to take notice of the

arrangements of my collective engagements vis-à-vis fieldwork projects, solitary or otherwise. I began to perceive how essential collectives made up of people with whom I could communicate and from whom I got feedback have been to the shape and rhythm and results of my work. Collaboration has been a topic of sustained discussions in both anthropology and art. Still, there is a relative lack of attention paid to these groups of known others who contribute to one another's work in a manner that need not be collaborative.

The "collective" as I conceived it is composed of known-others who share an environment, topic, field, or activity. It can be short-term or involve lifelong attachments or commitments. It may be a loosely associated group of colleagues doing research in a single location, or a far-flung network of people with similar interests. It may be a cohort of students. Or, it may be a formal association with a specific aim or outcome. Its meeting places and modes of association may be similar to the coffeehouse or collective studio, or research institute, or quite differently configured. A collective need not have an institutional base, but it might be formed by a religious congregation, a political party, or people who share a neighborhood.

I have found it helpful to draw a line between collectives and references. While you can communicate with participants in a collective, and they can take your aims into account in these exchanges, references can't listen or talk back.

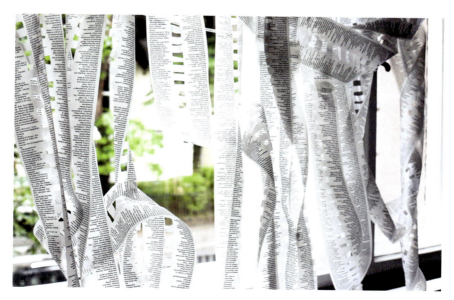

**FIGURE I.6** "Bibliography," 2017, 5" × 1/2 mile. Velum, ink, and scotch tape. Photograph by Claudia Egholm-Castrone.

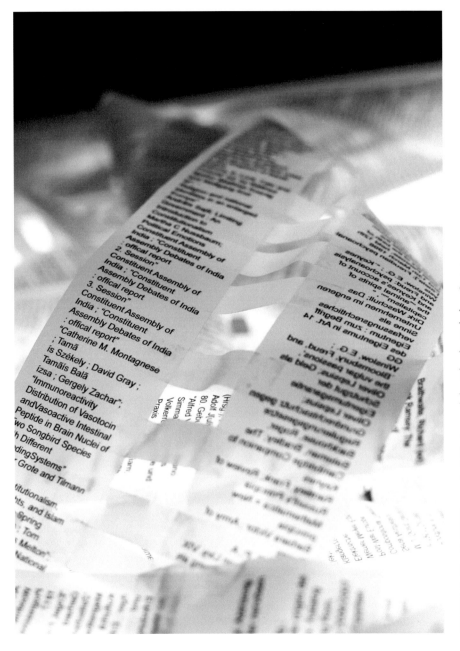

**FIGURE I.7** Detail, "Bibliography." Photograph by Claudia Egholm-Castrone.

**18** Introduction

## References

References to the work of people you could never meet, artworks you might never see firsthand, and cultural understandings you are barely aware of play an essential part in stirring research dynamics. Some writers separate scholarly influences from those of culture or history. While this may be an important distinction in composing the results of research, these diverse references work in the same way when it comes to fieldwork. Some references may be especially important in determining how you will design the field or envision your project's aims. They may make sense of its meaning in relation to a discipline or sphere of activity. However, they mingle in the fabric of fieldwork.

I made *Bibliography* with velum and scotch tape, using a computer program that merged the titles and authors of every text requested from the Wiko's library by the 40 fellows and their families during the first six months of our residency. It shows the extent to which we each carried on intense relationships with innumerable absent others even as we engaged one another face-to-face.

The librarians kindly provided me with the list of requests for articles and books they had received. They erased any mention of who borrowed what, and that removed the formatting of their ordering system. I then had to figure out how to reformat the lists in long bands that could be printed on extra-broad rolls of paper. Moving the data through different programs led to typographical errors and notable omissions: while I could correct the bizarre diacritical marks that computer databases spawned on the lists, I could not add in titles in languages that did not use Latin letters. Because of the limits of the computer, I was thus unable to call on the semiotic and aesthetic resources of mingling different scripts as I did in "Cappuccino" and many other artworks I'd composed over the years.

This limitation resonated with concerns about the way knowledge is formatted, whether by computer programs or by the hegemony of Western epistemologies.[16] Reading of the actual entries was testimony to the impressive linguistic versatility of so many of the scholars. It also proved the linguistic hierarchies that prevailed at the institute and, indeed, across the world. It is interesting that the overwhelming dominance of English in scholarship that counts is the topic of little genre-probing anthropological writing. And, however impressive its length and subject catalogue, it was also a reminder of bibliographies' always frustrated aim of being comprehensive.

Making this piece involved thinking out the steps I would follow and the procedures I would use to keep the work process orderly. I had the text printed on extra-wide sheets of velum several times before the printer get it all lined up correctly. Once it was right, I carefully cut the broad sheets of paper into strips. I attached one strand to another to form long streamers and wrapped them around cardboard tubes from discarded paper towels and toilette paper. I set these spools two by two, side by side on a long table. Then I unrolled the mile-long strips little by little, progressively joining them with a ladder rung of scotch tape. Cornstarch is not technically a material used for scholarship; I still used a small plate of the powder

to keep the now tape-studded ribbons from sticking to one another. I would later twist these doubled strands to evoke a double helix: a nod to the biologists and an evocation of how bibliographies are a kind of productive, genetic material for research. In addition, it was a sign that the project fulfilled the cross-disciplinary mission of the *kolleg*, as well as my own research goals.

Looking at the work, one might imagine a chorus of voices from the past filling the silent library. These individually heard melodies and suggestions come to each viewer quite differently than discussions around a coffee machine or cocktail table. They spur research and situate it, even as they veil the proximate world. They do this much as designs for fieldwork cast certain aspects of the environment into the shade to illuminate particular objects, and attend to and promote certain experiences related to them. For me, the lists of names and books also evoked long lineages of learning, chains (*silsilat*), that in Muslim scholarship include mentions of the personal qualities of those who hand down knowledge. This assures authenticity and veracity, a gesture toward the ethical valence of sources that is delegated in modern Western scholarship to format, citation and anonymous reviewers. Collected, the lists of books only touch the surface of the deep wells of knowledge scholars draw on to cultivate their thinking.

References might be to a political ideology, a sport, a type of music, a palette of tastes, or modes of politesse. The list is infinite. Whether they come into play will vary according to the object, method and research design. Indeed, fieldwork environments actively shape how the researcher or artist draws on and develops their references. Bibliographies may be shared. References are always intensely personal. Even in collaborative research, each individual is accompanied by different and evolving references that may surface as culturally specific habits or a particular interest in certain authors. "Bibliography" helped me to develop an experiment in how this happens.

When I strung the ribbons of references over a window in a reading room for the *Wissen/Schaffen* exhibition, they became a curtain that simultaneously focused and obscured the view of the street. Two years after the Berlin exhibition, I had the opportunity to hang the work differently at the Los Angeles Art Association's 825 Gallery for an exhibition called "Applied Science" curated by Marisa Caichiolo. This time I installed the long strands against a white wall, high above my head on a test-tube like plastic rod. Although each entry was more legible than when the piece was hung as a curtain, the long list of books in diverse languages became more mysterious because of the play of shadows created by the gallery lights. In California, the long ribbons no longer suggested lacey curtains. Instead, many viewers said they evoked celluloid film and the spectral images of the cinema. This suggests the way that references come into play in different field situations. The art object drew out and performed how references and meanings evolve in new environments for different projects.[26] Comparing "Bibliography" in the Berlin research institute to "Bibliography" in the Los Angeles art world helped me to visualize how references shift to make meaning for different disciplines as well as dissimilar environments.

20  Introduction

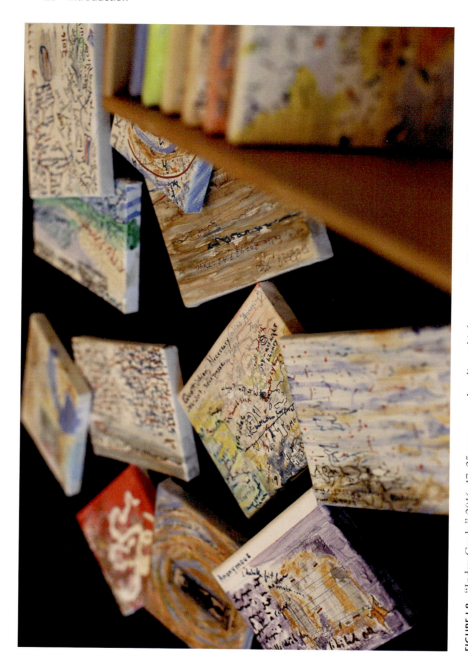

FIGURE I.8  "Index Cards," 2016–17, 25 canvasses. Acrylic and ink on canvas, 5" × 7" each. Photograph by Claudia Egholm-Castrone.

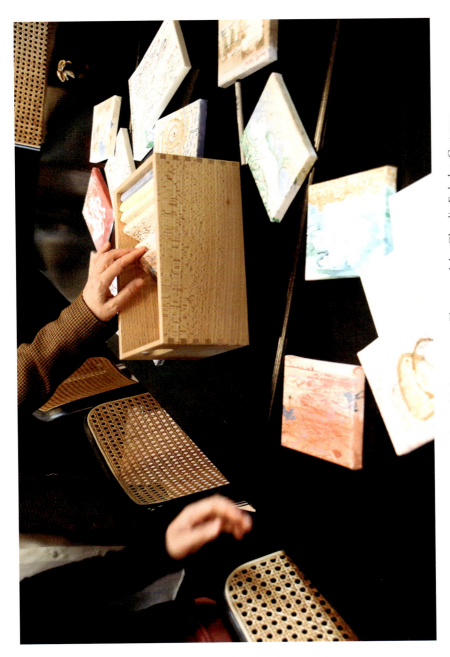

**FIGURE I.9** "Index Cards," 2016–17. Acrylic and ink on canvas. Photograph by Claudia Egholm-Castrone.

**22** Introduction

## Shifting genres

"Index Cards," another piece I made in Berlin, made it possible to explore a different kind of shifting, this time across genres.[27] In contrast to the netherworld of invisible and powerful references, these "cards" evoke past practices that still have meaning for middle-aged professors, and also present the shared experiences and lore of the institute's class of 2016–17.

In the days before the first personal computers, libraries had enormous rooms filled with row upon row of card catalogues. Students and researchers kept recorded notes about sources by hand on index cards. Recalling this now long-gone era, I remembered a past that resonated with the sumptuous yet somehow outdated setting of the *Wissenschaftskolleg*. I recalled that when index cards were essential to working in the library, canvases were synonymous with art in the studio. To think through this parallel, I drew blue and red lines across notecard-sized canvases and used them to make field sketches of fellows' lectures. I also recorded some of the topics that filled the air at fancy dinners, like the chatter of the birds we heard coming from the lake. What did the ducks eat? Where did the swans go when the ponds froze over? Specialists of ancient history and the rise of capitalism asked the ornithologists.[28]

The acrylic and pen on canvas cards were thus an index of how scholarly work has changed in the digital age. They were also interactive. At the exhibition, anyone could leaf through the "notes" and rearrange them in the wooden box, which resembled those where researchers kept their actual notes several decades earlier. They drew out residents' memories of their time in Berlin but also put these in contact with the distant past. The art encouraged the play of memory; for me, the musty, welcome scent of entering the library stacks; pushing a cart among seemingly endless rows of books when I worked at the UC Berkeley library as an undergraduate.

Studying scholarship through art, I could play on genre conventions much as I could work with style and form and alternative procedures. I could make what was often hidden in the footnotes or assumed to be known to all central.[29] Watching how people discussed, arranged, and rearranged the paintings/cards at the year-end exhibition, I saw how the art provoked discussions about the common pool of experiences and folklore that had developed over the course of the year, but also to a shared set of memories of libraries, projects, and student days. Making art an alternative system of documentation, I found ways of understanding how the past contributed to a present sense of comradery and commonality.[30] Watching people seeking out the cards where I "drew up" their talks as the results of my own research, I reflected on how like the anthropologist of old returning from the field, I would soon be leaving behind the double life I led at the institute and turning to new projects, notably this book.

## Waves

With these elements in mind, I have chosen to write about three waves of my work, setting other projects aside. Each of these currents involved multiple projects that explored diverse environments, and developed through exchanges with distinct sets of people and references. They all crossed solitary and collaborative fieldwork with art in different ways. I use the analytic I developed by studying scholarship to explore the divergent frequencies among the work-waves while remaining attentive to interferences and cross-currents.

The first wave of research I investigate emanated from my study of how global images were given body in the beauty salons of Casablanca, Paris, and Cairo between 1990 and 2001. This work evolved from my doctoral research on media, the city, and the politics of the Moroccan monarchy. I wanted to delve more specifically into the relationship of media to changing visions of self, to get at the embodied politics of globalization as it shaped new forms of diversity in the midst of uniformity. I devised a strategic "flipped" fieldwork design, beginning in marginal Casablanca, and moving to the centers of media and fashion, Paris and Cairo. Most important for this book was how that solitary fieldwork developed in counterpoint to other, collective programs and collaborations. The first chapter explores the interplay of my multi-site work and the multi-site collective I developed in relation to it while working at the *Institute de Recherche sur le Maghreb Contemporain* in Morocco. In Chapter 2, I follow the project to Paris and Cairo, to discussions of collaboration and issues of mimesis, the topic of a second large program I initiated in France. The progressive layering of sites and languages, academic communities and bibliographies that contributed to this wave offers clues to the role of images in research design. I use pastel collages as anchors for my backward-looking analysis; they bear witness to the way lines of art and science were drawn at the time, to the dominance of propositional forms of knowing, and to the linearity and monolingual prejudice of text. At the same time, they offer precious insights into how the practice of art, played an important role in shaping the fields I moved through, and lines of inquiry that were generative for others.

A painting I made in Rabat was at the origin of a second wave of work that made art its object. It started in 2008 when I hung "Hang Dry" on the wall of my home in California. The painting had traveled with me from Morocco to France, to Washington D.C., and on to London. It was only in California that it generated a project on laundry in all of its many meanings that created a context for experiment, reflection, and dialogue among artists, scholars, and people around the city of Riverside. In Chapter 3, I explain how I developed artistic research anthropologically and made the gallery a site for experiment between artists and anthropologists. Chapter 4 explores how contemporary forms of anthropological fieldwork design expanded the project further to generate a

**24** Introduction

widening circle of art with political and social resonance. From the gallery to the mall to the parks and sidewalks of the city, making current forms of fieldwork design central to curatorial practice and performance opened ways of thinking about the way fieldwork and art can come together to create meaningful forms of exchange in embodied ways to foster dialogical practices beyond the studio, library and gallery.

A third stream of inquiry emerged from a concept and a path. It began with reflections on the tug-of-war between home and host countries typical of immigrant experience, which I myself had lived through. It continued with a dialogue among writers and scholars who shared Morocco as one homeland about how the to and fro of immigration ceased or changed when the immigrant moved on to a third homeland, as I did when I moved to Casablanca. Reflecting on "serial migration" with friends and colleagues gave me the resources to do research among people who shared only a storyline of becoming immigrants and then migrating a second time. In Chapter 5, I delineate the concept of serial migration and how I moved from concepts to meeting serial migrants and gathering their stories. I notice what is left out of any step-by-step life story, explore the processes by which narratives shape particular kinds of subjects, and how art helped me to get at how repeated experiences of migration shape subjectivity in particular ways. In Chapter 6, I explain how the book I published on this work became the stepping-off point for *The Moving Matters Traveling Workshop (MMTW)*, an international collective of serial migrant artists and scholars that has grown by developing exhibitions, performances, and participatory events in one place after another. I trace the initial stages of the peripatetic "workshop." This leads to a discussion of how the concept of serial migration and the design for the MMTW project led from an initial attention to commonalities among participants to the creation of an "artificial," yet authentic, community.

Mysteries of the differences within what seems similar, questions of how repetition begets change and about the coherence of the self are among the themes that traverse all of these work waves. This brings me back to "Sources," that delicate veil I made to stretch across the open, yet impenetrable wall of the *Kapelle der Versöhnung*. My attention is drawn to the one clear view that opens to the park beyond. I remember cutting this mirador in the diaphanous cloth, framing it with a list of passports rated for their global mobility, and then adding the tiny curtain printed with the world map. The window invites reflection on liberty, movement, and privilege. It takes me back to Casablanca, where international visas are hard to come by.

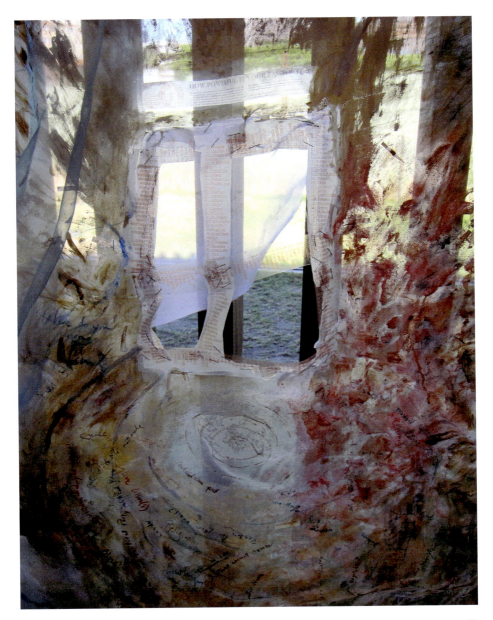

**FIGURE I.10** The "Passport Window," detail of "Sources," 2017. Multimedia on silk organza, 70" × 180". Photograph by Nathaniel Goodwin.

# First wave

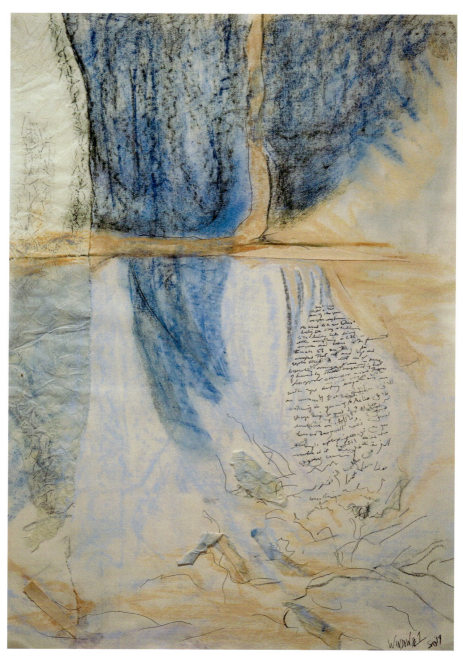

**FIGURE 1.1** "Window # 1," 1991. Paper, pastel, and ink, 17" × 25". Photograph by Nigel Tribbeck.

# 1

## GATHERINGS

It was a perfect spring afternoon. I was stretched out on the cool, smooth floor. The window was ajar. Sun streamed in. I watched dust particles appear and then vanish, as they passed through a ray of light. Bits of conversation and the mist of humming motors flowed into the room, teasing and testing the clear-cut lines of the window frame. I looked at the large, white sheet of paper in front of me. I reached for a second, cream-colored page, tore it, and adjusted it to fit a corner of the first sheet. I pasted it on, stretched to one side, and started to write. After a while, I rolled over the sheet of paper to write from the other direction. I turned a pastel stick on its side to draw a vertical streak, blew the excess powder into the air.

I made "Window # 1" in the ground floor living room of a colonial-era house in Casablanca. The home was built for a single family. By the time I lived there, it had been converted to a duplex. When I moved in, the house was on the "Rue Malherbe." A few months later, the street changed names. Now I lived on the "Zenqa Mustapha El Monfalouti." The shift from a sixteenth-century French writer to a modern Egyptian poet and playwright was meant to symbolically reposition the city in a new, post-colonial order. But mail sent to the outdated address kept arriving. No one paid attention to the shiny new street sign. Indeed, there were many people who could not read the plaque. Illiteracy was still wide-spread, especially among women and immigrants from the countryside. Some people could string together the letters of the bilingual sign from right to left in Arabic and left to right for the transcription of the poet's name in the Latin alphabet. Many people could read in only one direction. During the colonial period, Muslims of the "notable" class and Jewish children were educated in the language of the colonizer. After independence from France in 1956, Arabic be-came the national language. French remains the lingua franca of commerce and science; English gained importance in the twenty-first century.

**30** First wave

While Manfalouti's poems are on the literature program in Casablancan public high schools, in daily life, most Casablancans converse in "derija," the Moroccan dialect of Arabic.[1] Many also speak one of the languages descended from those spoken by the peoples of North Africa conquered by the Romans, *barberos*, the Romans called them. They called themselves *Imazigen*, free men. So, in Casablanca, conversations often hop from one language to another in a single sentence.[2] How could this creative mélange be conveyed in writing?

Clifford Geertz, famous for his fieldwork in Morocco, developed the technique of "thick description" to move from observations to interpretations of cultures, which he compared to texts.[3] Like many others, I also tried this evocative, experience-near prose technique. But rather than leading me to some sense of comprehensive cultural style, it encouraged me to notice tears in the idea that culture can be conceived as a whole cloth. Casablanca's layered languages did not fit neatly into any dictionary or grammar. What's more, the censors were also always hard at work. Words, scenes from films, not to mention people sometimes suddenly disappeared.[4] In the "Years of Lead" during the reign of Hassan II, the *mukhabarat*, police informers, were ubiquitous. One learned to fill in the blanks in books and conversations.[5] In this situation, I set aside Geertz and took Roland Barthes as a guide. The French writer and semiologist marked intellectual life in Morocco, where he taught at the university Mohammed V in the 1960s. But more than this influence, it was the voids and unsaid truths he layered and cut into his writing that felt much more true to what I was living and observing than the notion that culture was a "web of meaning" or a grammar-like system: a view taken by other semiologists, inspired by structuralist conceptions of language and communication that had also informed the work of anthropologists like Levi-Strauss. Some scholars critiqued Barthes for his less "rigorous" approach. But it was precisely the way his texts shift from sensitive description to pithy speculation to create suggestive intervals and gaps that I appreciated. I notice how the frame of "Window # 1" solidifies at certain points, then fades into a vague emptiness.[6]

Fieldwork in Casablanca at that time meant integrating the near-impossibility of working with recording devices. No one wanted their words to be preserved for the wrong ears. I typed notes up each evening into a desktop computer. No matter how messy my thoughts, how incomplete the information, the golden letters appeared steady and regular on the screen. After many years of playing the piano, composing on the keyboard felt natural to me. The percussive sounds of the work in process insinuated itself into the melodies of the city. Perhaps a score that transcribed the rhythms of the keyboard could be conceived to explore the style of a writer performing a text, upright in front of their instrument. At least, this is a possibility imaginable today, as I juxtapose typed-up notes and published texts to hand-written notebooks from the same period to remember.

Writing notes by hand, the pull of the nib of the pen creates friction on the page, slowing the writing process. A moment of distraction can turn a letter into a drawing of a face or a butterfly. A notebook hand can wander in all directions;

letters can move onto the page from different angles. My field notes are full of sketches and doodles and arrows pointing from one phrase to another. There are blank spaces; do they indicate a lull in conversation, or in my attention?

"Window # 1" is a reflection on writing, sound, and layered visions. English voices were rare in Casablanca. Still, words in that language scrawl into the picture from the left, as though jumping straight to the art from my notebook. They encounter Arabic script, coming from the right. It is not beautiful calligraphy: just ordinary writing.[7] Their encounter references the work of the anthropologist alongside the sensory qualities of that day, in that place, at that moment. I mingled words in a central cipher, evoking invisible meetings of message and sensuous consciousness.[8] The drawing/collage suggests how syllables compose a scene by insinuating themselves into the ear of the listener. Today, I can reanimate the artwork's floating embrace of words and sounds turned to script. I move my lips to make the air vibrate with the sounds recorded by my hand on that warm spring afternoon in Casablanca. My eye can follow the movements of the pen that coalesce in the letters and almost-written phrases as they become quivering lines, moving toward the edges of the paper. The work is an instantiation of a time now gone, but, to paraphrase René Magritte, "Ceci n'est pas une note de terrain."[9] No, "Window # 1" is decidedly not a field note. It was not simply the larger dimensions of the paper, or the media I used to make it that made it art. It was my intention that included the invitation to others to view the work that distinguish the artwork from the multilingual markings in my notebook, making it a rendering of the results of research. It was made to be publicly circulated, like an article or book. Like the texts in which I analyzed my research, the piece is the result of an accumulation of countless days spent researching how pictures and stories in the media created the city of Casablanca and figured the Moroccan nation. At the same time, the picture evokes the limits of academic prose for analysis as well as conveying atmospheres. The image offers modes of figuring situations and analysis in a glance that could be captured only sequentially by a text.[10] Pictures can layer scenes on scenes, meanings upon meanings. Through artistic practice, I could synthesize reflections I'd written down while sitting with a family watching home videos and interviewing journalists, and mix them with the acrid scent of the diesel exhaust of the buses I took across the city.[11]

Looking again at "Window # 1" suggests to me how a frame might focus or confine, while still conveying movement. I notice how some lines form legible words like *zenqa* (street), but others dissolve as though blown by the wind coming through the bit of velum/curtain that places the viewer inside, looking out. Looking out the window at the street in Casablanca, what did I perceive? Certainly not a free open space. On the boulevard or avenue or alleyway, the sounds that I heard in the living room participated in an urban tapestry woven to the rhythms of the glances and gazes of men of all walks of life. This made simply walking down the boulevard a challenge for women. Taking a seat on a bench in a public park, or at the terrace of a café, a woman was expected to expect men's

**32** First wave

advances and comments on her appearance. A bus ride required preparing one-self to respond to groping hands. In spite of the omnipresent eyes of *mukhabarat*, none of those actions were censured.[12] Working around town was essential to my research, which also took me to newsrooms and cafes and boardrooms, where I asked questions about sensitive political topics. I sought moments of respite with intimate circles of friends, or by leaving the city for treks in the mountains. But most important for my work on media and globalization, I found refuge from the street in beauty salons. In that feminine space where global fashions are given body, welcoming eyes greeted me as I crossed the threshold. Within, conversation flowed freely.

## Modern bodies

It was in beauty salons, under the cover of apparently frivolous preoccupations like fashion and grooming, that I discovered spaces of exception from politics as usual. It was not that conversations were mainly about public issues in these enclosed environments. The lather of talk encompassed every subject from television series and family, to romance and sex, world news and memories from childhood to just plain gossip. The politics was as much in how people sat together as in what was said.

Men often perceive salons as places women go to prepare to meet the public eye, that is, their own gazes. Women tend to know them as spaces of sociability, support, and self-making.[13] I became familiar with beauty shop routines long before I lived in Morocco. As a child, I dreamt of having long, luxuriant tresses; however, my fashion-conscious mother was practical: she had no time to untangle the hair of six little girls. So, I had my hair clipped in "Pixie," or the popular "Sassoon" at the beauty school where she went each Saturday to get an inexpensive "hairdo." I listened to her conversations with the "girls" who would soon be qualified beauticians.[14]

In Morocco, I learned to enjoy visits to the hammam, otherwise known as the Turkish bath, another place women gather to socialize in North Africa. The hammam is full of steam; it is an immersive experience. In contrast, salons are dry; water is applied to the body at precise places and moments. The hammam's mists thicken as temperatures rise from room to room, embracing the whole body to achieve détente. The salon is a targeted bodily experience. Baths may be decorated with beautiful mosaics, but there are no windows, photographs, paintings, or televisions. Meanwhile, salons are image-filled. They mingle photos from magazines, television screens, and posters of actresses and models with reflections of actual people in their mirrors. The hammam treats the whole body at once: the salon works on it piecemeal and charges for each action, body part by body part. I wrote about these contrasts in an article for a special dossier on "New Cultures in the Arab World" I edited with Yves Gonzalez-Quijano for *Les Cahiers de l'Orient*. I thought it would be a one-off piece. I was proved wrong.

The article was an unexpected hit.[15] The journal sold out quickly. Copies were still on library shelves, I heard. But the pages where the study of beauty shops should have been were missing in library after library. In those days of overpriced photocopies, some students carefully hid razor blades in their briefcases or handbags. When they came upon an article they wanted to keep, they surreptitiously slit the book at the bindings and removed it. Colleagues wrote to me from France and America to send copies. Strangers at conferences started asking me for beauty tips.

With my dissertation completed, I began spending time in salons across Casablanca. I noticed the provenance and subject matter of the images that shaped these semi-public, feminine-gendered spaces. From my notes:

> In Halima's salon, the television is always on: I watch a Moroccan cooking show in French about how to make *vol au vent* pastry with mushrooms, followed by an Egyptian soap opera. I leaf through magazines. *Sayidati* then *Femme Actuelle*: they illustrate the everywoman aspect of Arab and French Fashion. Just as Arabic and French mingle in speech, so the models of fashion and beauty that matter here emanate from Cairo and from Paris, the capital of the former colonial power. These are not simply images and messages that speak to fashion, but signs of interwoven and sometimes competing cultural practices that are part of everyday life. Global currents feed into regional eddies.

Generally, the study of globalization and media influence was focused on the movement of influential models and processes from global centers to peripheries. What did it mean to be in the center? How did global flows shape difference among people in a single city? Anthropologists in the 1990s were becoming attentive to how "local" scenes reworked global models. They and media scholars who practiced ethnography often observed that people developed "active" reinterpretations of those models creating new, hybrid versions.[16] That was the view from any given "reception" site, but what if one dove into the media flows to gain a closer understanding of those streams? I wondered. By conceiving a moving field to swim against the current, I thought I might gain a better understanding of general processes by which global media shaped not just fashion but culture and people's ideas about themselves more generally. I would begin in Casablanca. From there, I would navigate two media streams: one that flowed from Paris and the other from Cairo. Moving out of Casablancan salons, I would weave a research triangle. Salons had spread to every neighborhood of the three cities by the 1990s. By spinning the field by way of these feminine sites, I could work beyond the bounds of an assumed unitary local culture. I could turn my thoughts to how processes of globalization generated differences and disparities in as well as across cultures and nations.

**34** First wave

Already, I had started to notice disparities among Casablancan salons that did not simply correlate with differences of education or social class. Women often changed beauty shops for specific services or occasions. What did this indicate about the circulation of models of style? How did the process of shaping one's body by way of fashion relate to subjectivity? I decided upon studying these and related questions equally in the three cities, making Casablanca the point from which I would develop my fieldwork and, thus, hypotheses.

A game of fieldwork hopscotch might be a way to get a feel for this project's shape and evolving script. To play the game, try following these instructions:

> Take a piece of chalk. Go to a paved driveway, patio or playground. Find the point from which you have the broadest view, or the one where the wind blows most strongly. Draw a circle around yourself. Inspect the cracks or stains that extend out over the concrete. Notice two points where they intersect with other marks. Draw circles around these as well. Then, connect the points with lines. Return to point A; see how being in those other circles affected your view on what the line you drew encompasses.
>
> Walk around the circle several times: try leaping, walking or skipping between them in different ways. Increase your speed until you are dizzy: the borders of the rings may blur and you might step out of bounds. This means you are playing the game properly. At this point, when the shapes merge into a single plane, stop. Sit down in the center of the triangle. Take off your shoes and feel the rough surface beneath your toes. Note how some stones or combinations of pebbles and leaves and dust tickle or scratch your feet. Study these differences as they relate to the history of this span of cement. Does each association of pebbles encourage you to jump, or dance, or sit down and bask in the sun? Invite a friend to join in and see how the other's presence, movements or voice alters your own progress and sensations.

By the end of 1991, I was back in Paris. The relationship that had kept me in Morocco had ended. I began to apply for jobs, my "beauty project" in hand. Finding an academic position in a mid-sized country where local affiliations and powerful patrons dominated the academic world was not easy. Research topics and methods like mine were of interest to scholars of my generation. But it would still be a few years before well-known Professor Marc Augé would publish *Pour une anthropologie des mondes contemporains* [For an Anthropology of Contemporary Worlds].[17] In France, connections to North Africa and with the United States are numerous, complex, and often conflicted, if for utterly different reasons. I sometimes felt like I myself became a problem because I engaged both; neither quite neatly enough. I recall a conversation that took place among a jury assembled to select a candidate for a job. One member began to ask me if I "really spoke Arabic," while a second defended me, "but can't you hear her voice! Can't you hear her Moroccan accent?" At a second interview, it was my American training and background that led the jury to inquire about why anyone would be

interested in self-reflexive writing: it was not the trend in French anthropology.[18] Of course, the name printed on my CV may also have dissuaded some employers from extending invitations to interviews. In France, mention of ethnicity and origin is barred from resumes, a formal nod to ideas of equal access. But applicants with names deemed to be "Muslim" are very often set aside in the selection process.[19]

Said aloud, my name can suggest that I am part of the Alsatian family of the Baron Haussmann, who redesigned Paris as a modern, organized, and thoroughly policed city in the nineteenth century. (In fact, some former colleagues in Paris still playfully call me "the baroness.") However, in writing, the initial "O" suggests a Middle Eastern provenance. Police at the frontiers of Muslim countries tend to assume my father is North African, or that I was from one of the local families with Anatolian or Andalusian roots who often have light eyes and hair that is blonde by local reckoning. I was otherwise assumed to have a North African husband because of my name, which is the one on my birth certificate.[20] More imaginative people have told me that my blue eyes and some-say "Byzantine" features led them to imagine me as a descendent of some janissary, or of a Circassian married into the Turkish Osmanli dynasty.

Eventually, I landed a job where my ambiguous status and Maghrebi and US connections were perceived as an advantage. I was offered a three-year contract with the French foreign ministry as a research fellow at a research center in Rabat: l'Institut de Recherche sur le Maghreb Contemporain (IRMC). I had never heard of the institute: that was because it would be my job to create it.

## Institution building

The Rabat center of the IRMC was then the newest in the global network of French research institutions. One particularity of the IRMC was its regional ambitions. I would work under political scientist Michel Camau, who was based in the IRMC's Tunis office. The project was initially to also have an institute in Algiers: but that was put off due to the tense political situation, and then civil war in the country during the 1990s. The IRMC's transnationalism vexed both the Moroccan government – *the makhzen*, that functions through and also behind and interwoven with the administration – and some bureaucrats in the French Embassy.

The first French cultural attaché during my tenure was welcoming and enthusiastic about anthropological research. A second became hostile when I presented my newly published *Picturing Casablanca* and he realized it was in English. As far as I knew, I was the only woman to head one of the institutes or centers at that time. I am certain I was the only one born in the United States. Some important men expressed irritation: the IRMC was headquartered in Tunisia and headed by a distinguished professor while Rabat got me, a young, binational divorcee with leftish leanings, who, what's more, was studying a topic as ridiculous as beauty shops. I particularly recall one older, high-ranking Moroccan bureaucrat who

**36** First wave

never hid his displeasure at having to be in the same room as I was. On one occasion, place cards obliged him to sit beside me at an official dinner. He spent the entire evening obviously trying to provoke me by singing the praises of Augusto Pinochet. Fatima Bellaoui was the administrative assistant in the Rabat center. She reminded me years later of how often I failed to come to the office after those official dinners. She admitted that she secretly built those absences into the schedule of meetings she set for me.

In Morocco at the time, foreign cultural centers and institutes were havens for the relatively free exchange of ideas. Organizations that facilitated international exchange, such as the Fulbright commission, or provided grants like the German foundations were important to the dynamic of research, which was otherwise much more limited than it is today. Many academics found the prospect of trans-Maghreb research that the IRMC proposed to be alluring. Others avoided institutions associated with the former colonial power. Some particular visitors surely reported on our activities to various ministries. Others occasionally stepped beyond the tacit understanding of the limits of what might be said in public about the nation or king. I had to work with all of them. It was exciting but taxing. I looked forward to vacations with my son, dinners with old friends, and occasional nights out at a club with great music frequented by West African students: I knew I wouldn't run into the official crowd there. Most of all, I counted on the support of friends and colleagues who like me studied day-to-day life to understand big questions.

There was no lack of interest among intellectuals for my idea of studying global issues from the perspective of the beauty salon. Michel de Certeau's work on the practice of everyday life was globally influential.[21] Le Seuil, in Paris, had just completed publication of the *History of Every Day Life*. And in Morocco, much like me, other researchers had turned to "minor" practices and marginal places to get at what was important.[22] The interest in the quotidian was certainly, like elsewhere, related to feminist calls to note the political in the personal. It was also related to the particular conditions of research and the history of fieldwork in Morocco.

In the 1990s, experience-distant data-driven approaches were fast gaining ground in the Anglophone social sciences. Field research might be honored as a source of "impressionistic" or "ground knowledge," but it could not hold its own against the firm conceit of those who worked with hard data and statistics. However, in Morocco, fieldwork was still practiced across disciplinary divides. Keep in mind that surveys were still illegal in Morocco then. Numerical data that was available was often diversely compiled year to year. Statistics of consumer behavior might count the number of bars of soap sold in the country, measure sales of deodorant use two years later, and then shampoo after six years.[23] Although there were no departments of anthropology in the country, the government was generally welcoming to foreign fieldworkers. A long line of Western researchers stretched back to Edvard Westermark's fieldwork begun in 1898. It included illustrious scholars like Jacques Berque during the colonial period; then Ernest

Gellner, Geertz, and his students post-Independence. What's more, an entire generation of Moroccan scholars trained in fieldwork methods with sociologist Paul Pascon in the 1970s at the *Institut agronimique* in Rabat. All of this made fieldwork a high-profile activity in the country.

It was easy to explain why the monthly seminar on fieldwork I started at the IRMC was attractive.[24] But my job description stated that besides organizing meetings where people would talk about their existing projects, I would develop a collective program for which they would launch new ones. What would motivate accomplished researchers from across the region to develop new work for a program on themes related to *my* research, under my direction? Again I turn to "Window # 1" to investigate and convey how my thinking at the time led me to take up this challenge.

## Abstractions for others

"Window # 1" reflects on meeting points and thresholds and flows of communication. It suggests a gathering, or a hanging point. It offers a loose frame, but designates no specific location. It sums up how I thought about the encounters of media flows and places of sociability for the proposal I made for the IRMC program. The scale of inquiry is left open. Each researcher would adjust the frame to explore a particular site and mesh of media and social life. We would each examine what flowed in and out or remained in each milieu, rather like the sounds–words–lines of flight in the artwork.

I did not actually send out photos of the picture: yet the image suggests how I winnowed down my own salon project to its essential starting point, to propose an abstract form that others might use to conceive or reframe their work in the field or the archive. Just as phantom influences and models for living can be revealed by a hairstyle, they can also come out in songs, ways of dancing and manners of walking. They may be conjured by forces that are readily visualized in posters, on screens, or in publications. Or they may hide in conversations. Anthropologists and geographers, sociologists and semioticians could find them via research in and on cafes and living rooms. I outlined the proposal in an introductory text for the IRMC newsletter. Each participant would use their own expertise and methods to fill in the contours of a particular space as a dream catcher of the quotidian, it explained. Meanwhile, I needed to imagine how I would develop scenes for our encounters in Rabat and Tunis; I needed to devise a script for the program.

Anthropology had taught me to attend to alterity and to reflect on power differentials both in the field and in writing.[25] It made me mindful that my hair was bobbed, straight, and blonde in Casablanca, and long, wavy, and dull chestnut in need of lightening up in Paris; clearly personal characteristics and local categories affected what one might hope to accomplish in field research. At Berkeley, my mentors expected fieldwork to be a self-reflexive process. They did not rule out playfulness or experiment. They encouraged me in my multi-sited

**38** First wave

field designs.[26] However, professors of anthropology, like those that taught art and history, assumed their students would work alone. In France, this was also the case, but this individual work is generally carried out in relation to a "laboratory" external to the university, according to their research interests.[27] Those graduates hired in research positions work within these institutions long-term. Many others teach at universities and take part in a "labo" outside the context of their usual duties; this was the situation of most researchers who joined IRMC programs. With this in mind, I wonder now if the jury that appointed me realized my utter lack of preparation for taking on the direction of a transnational collective. They were well aware of my engagement with networks of Moroccan scholars and knowledge of the country. I was French enough to be hired, and worked easily enough in the tongue of Voltaire: I was comfortable working in the "human sciences" rather than the humanities.[28] They may have overlooked my ignorance of models for conceiving and leading a multi-site international research initiative because they took it for granted that I had at least some inkling of collective programs during graduate school. Or perhaps some of them knew me enough to imagine that I would be able to count on experiences and references outside the academic realm to respond to the task at hand.

A collective often grows organically from informal associations of the kind I had with other researchers and other graduate students, while I was doing my first fieldwork. The collective I convened at the IRMC would be, on the other hand, intentional. The picture of the topic was clear in my mind, even drawn in color on heavy cotton rag paper. I could count on the IRMC team to organize meetings in Tunis and Rabat. I was in the enviable situation of having plentiful public funding. Participants could expect travel funds. Books would be made available in both libraries. These material aids and structures did not alone make a good program. Colleagues were sending in proposals from across North Africa, Europe, and beyond. How would I actually conceive a plan so we could work together? I knew something about what outcomes I did not want to encourage.

In North Africa at the time academic conferences were often solemn, stiff affairs. My experience of American academic events was limited: what I did know was that people tended to read pre-prepared papers word for word. I felt more comfortable in the spontaneous, oral style more current in France, but I also realized that I needed to reflect on how spontaneity could evolve over the long-haul for a dispersed group. We would have to direct and channel our energies. To keep a program going and maintain enthusiasm between meetings, setting a pace and tempo and keeping everyone to them would be essential. The process was more akin to associating scenes in a play improvised over several years than it was to doing anthropology in the way I had studied the subject. Yet, fieldwork experience led me to think carefully about varying the forms of presentation and interaction to encourage the group research dynamic. Similar to the process of individual fieldwork, there needed to be an overall, if evolving design so these scenes and scripts could accommodate new discoveries and shifts in direction. Just as the proposal for individual research needed to be framed, yet

leave openings and gaps for experiment, so the program would have to be both defined enough to maintain its momentum and malleable enough to accommodate swells of exchange and shifts of direction.

## Encounters

What prepared me to think about the social arrangements, timing, and style of the program in the making? Nothing at the university. On the other hand, home life in a large family was a lesson in leadership, group management, and the politics of the everyday. Being raised in the 1960s and 1970s meant I was familiar with forms of collective action, like demonstrations and sit-ins, and art "happenings." My teenage friends and I called our get togethers "encounters" instead of "parties." I wrote the required senior high school research paper on the organizing methods of the Students for a Democratic Society (SDS). Little did I know that media sociologist and former SDS president Todd Gitlin would become a professor and friend; one of the more exciting moments of the IRMC program was when he visited and gave a lecture.

In Paris in the early 1980s, I was close to the founders of *SOS Racisme*, an anti-racist organization known for pioneering newly artistic and experiential forms of political protest. I had traveled to Marrakech with the organization's leader Harlem Désir as a kind of adviser.[29] I arranged a meeting for the famous sociologist Pierre Bourdieu to meet the group's leaders. My first published article was a Bourdieusan analysis of the movement. I was more a thoughtful friend or go-between than a leader; yet the organizing strategies of that association and experience of friends who were professional politicians and activists fed my thinking on flexible long-term strategies.

For the program, I decided to distinguish several types of involvement and activities. There was the group of dedicated, core participants. I held introductory meetings with them in Rabat and Tunis. This led to initial research, to sharing references and key concepts; an inherently interdisciplinary and multilingual undertaking given the settings and participants who were anthropologists and historians, philosophers, linguists and communications scholars, sociologists, historians, and specialists of literature. What was a subject, or a self? How had the concept of civil society developed and how did it relate to notions of the public? I compiled bibliographies and ordered books for us to circulate on these and many other topics of common interest. I distributed articles by post. We thus progressively built up a set of common references to which we could turn in discussion, and in more focused meetings among groups whose projects involved similar sites and methods of research. To these, I added a series of open discussions about specific methods and current debates related to the program at each of the institute's locations. Thus were set the conditions for improvisatory moments, which required a common set of references and a certain level of trust.

When guest speakers came, everyone was invited. The presence of members of the collective at these public events created a strongly engaged and

**40** First wave

knowledgeable section in the audience. It kept things moving in a direction that fed the work of the core group. Researchers who lived in Algeria, France, or the United States were not able to attend all of these events. So, there were variances of collective experience between those who came together for the more focused meetings. Keeping regular contact also contributed to the liveliness and momentum with which we pursued our individual research. I attended every meeting, so I both appreciated these variations and reported on them in regular letters to the group.

How did I prepare and plan? Like a producer getting ready for a concert, I carefully researched the venue of each event. I considered the audience, or lack thereof. I set out the expectations and set up rooms in different configurations to encourage unexpected interactions. I composed a "score" for each meeting and considered not only what would be discussed, but how to alternate themes of discussion and manners of approaching them. How might the program be oriented to draw out certain questions or to accentuate particular voices? What needed to be done to keep certain more confident speakers from dominating conversations? It was interesting to test whether and how the shared form for our work could produce harmonies among apparently dissimilar topics, productive dissonances on related themes, or that used similar methodologies. Sometimes a guest speaker led the work of the group. Sometimes I divvied out changing roles to avoid disciplinary or topical groupings. I came to think about the program as a whole as an evolving and flexible composition, a bit like a field site except here, I had to direct the action as well as conceive an appropriate horizon. Each encounter set up a new way of working together to encourage new ideas and connections among the projects. Lectures, break out meetings, a game of presenting one another's work: I delighted in how discovering others' work spurred mimetic energies within and beyond the circle of participants.

We learned that it was important to reduce and focus references that would enter into a discussion, to encourage free, roaming ideas and make improvisation possible. We were schooled in how number influences affect, and how group feeling can encompass zones of incomprehension that would later bear fruit in vibrant exchanges. Many of the habits and procedures that enhanced continuity resulted from the institute's taken-for-granted expectations. For instance, there was the writing I was expected to do as part of my job. Naturally, training in fieldwork led me to take copious notes at meetings; these included numerous sketches, doodles, and diagrams. I added to them and analyzed them after everyone departed, and I sent out a post-meeting write-up to participants by letter. At the same time, I wrote a summary, just as I prepared an argued proposal for each new meeting. Our engagements with others' projects and methods grew as I developed ethnographic as well as conceptual analysis of our progress.

I gradually became practiced in establishing research rhythms. Enough time had to elapse between meetings so we could work on our projects and read

books or articles others had suggested. These meetings could not be too distant in time: we might lose momentum. Those of us who lived close to one another could meet informally between events. Remember, there was no email. International telephone calls were costly. The sense of "being there" at our meetings was perhaps heightened by the contrast of the thinness of communication among us on a daily basis. The double grounding of the IRMC for the years I was there meant that some would always be hosts, and others visitors. Off-site visits and shared meals especially encouraged a sense of camaraderie. In Tunis, we often drove from the institute in the city to the port of La Goulette for grilled fish and freshly prepared *harissa*. Thanks to Mina, the housekeeper, when impromptu guests showed from Casa or Oran, Tunis or Europe, I was always prepared on the home front. There was always one a delicious *tajine* on hand for guests. Whether at lunch or dinner, or the wee hours of the morning, I was always ready to spread a cloth on the low Moroccan table in the living room, or high European-style table in the dining room. There were late-night dances and moments of quiet one-on-one intimacy. And there were moments of magic: like a dialogue on death between anthropologists Abderrahmane Moussaoui and Marie Virolles-Souibes while we walked through the Sidi Bou Said graveyard by the light of a midnight moon.

## Field weaving

As I took the one-hour train ride to Casablanca or carefully prepared a visit to Cairo for fieldwork, the collective played into my solitary research. On the one hand, others' projects contributed to my understanding of the context: Amina Aouchar's study of dress; Habib Belaid's explorations of colonial history and the athletic male body; the projects Jamaa Baida and Mohammed Kenbib developed on Tangiers and the media as an intermediary space; Omar Carlier's work on the hammam, for instance. Other projects on gyms (Hadj Miliani), fast food restaurants (Hannah Davis-Taieb), and living rooms (Rabia Bekkar and Laarbi Chouikha) often came into my mind as points of comparison as I explored beauty salons. Even as the common frame of the program added clarity to the shape of my field, the work of others, and reporting on my fieldwork to them influenced how I experienced getting my legs waxed, or the kinds of attention I brought to conversations with beauticians. When I visited a salon, I naturally engaged conversations with authors that had shaped my thinking over the years, but added to these, I was trailed by references that were fundamental for my colleagues. The sociologist Irving Goffman, best known for his work on the performance of self, and the current of work called ethnomethodology that is ultra-attentive to the minutest social interactions were key references for several people in the group.[30] Seminar debates about notions of self in the West and in the Maghreb, discussions of individualism and epistemology, or notes on Foucault's writings about the making of one's self by way of texts and self-to-self conversations in

**42** First wave

late antiquity mixed with the voices of people I met in the course of research. These all moved with me from salon to salon.

Being the one who set out and animated the program, that practice of shaping the collective also influenced my solitary research. My work of arranging of rooms and coordinating of activities, of keeping to budgets and welcoming of visitors led me to pay closer attention to the way the four walls of the shops did not limit the geographic reach of the social terrain each salon presupposed. It made me ever more attentive to salons as organized sites of encounter. Now, when I looked into the mirror of a salon, I was alert to what the reflected gazes I met there showed about the relationships among those around me. I began to perceive more precisely how, behind the uniformity of the salon form, its well-rehearsed routines could be interpreted according to several social and cultural arrangements. The body might be cut up in the same way everywhere. The styles might be the same. Yet what took place in salons differed. And this had consequences less for the "look" one adopted, than for the kind of subject someone could be in each different milieu, and for my understanding of globalization. It was not the style but the way it was embodied and enacted that was essential.

I experienced how some salons were focal points for circles of neighborhood information and gossip. It took time to become a part of these circles, but once I did, it was easier to establish contact with people I hadn't met who came into the shop. Women came in mainly from the surrounding quarters, often by foot. So I called these places "proximate" or neighborhood salons. It could have been tempting to make the neighborhood out as context for the study and get to know every in and out of one or two of these salons: but given that other shops did not at all correspond to this configuration, that would have been a very limited study. It would not have spurred me to make the kinds of discoveries that the triangular field I was weaving promised.

I began to perceive how a second type of salon organized interactions around the client/beautician duo. These were often mirror-filled, with large windows that let in natural light. Looking in the mirror at oneself was expected: eye contact with other clients or hairdressers who were not serving you was not. When I explained my project, some of the clients were willing to exchange thoughts in the salon, but everything discouraged it. I could work with beauty professionals in the salon, or around it, but clients did not hang out once they got a haircut on their lunch break. I often met them in their homes or tea rooms or offices to discuss their beauty practices. In this type of salon, I was usually offered a glossy, standardized menu with photos of haircuts to choose from: no. 23? Natasha or Roxane? That is why I began to call them "fast" salons.

The salon took on yet a different form in beauty shops where the client was approached as a work of art by a usually male coiffeur, often named Mario or Jean-Jacques or Alexandre. People came these salons' clients from far and wide. It was often by word of mouth that I came to them when friends or acquaintances learned of the project: I myself would not have gone there otherwise. Like some of the women I interviewed about their choices of salons, I was a bit intimidated

by the individualized attention they offered; the custom-made hairstyles and facial regimes conceived the client as special, or as a work of art with an aura. These celebrity salons were instructive in thinking about charisma; they linked everyday experiences of it with those on larger scales. Their geographic reach was wide: I have already mentioned wealthy women who changed countries for their haircuts. The hairdresser-artists also served school teachers and office workers who saved up to visit them for particular services or special occasions.

When I arrived at the IRMC in 1993, colleagues from Oran could get in their car at daybreak, drive across an open border, and arrive in Rabat for dinner. Three years later, the border was closed, and Algeria was descending into civil war. Our Algerian colleagues were not allowed to board the plane to attend the final conference of the "Pratiques Culturelles" program. Many of them fled to France, America, or Tunisia, where then-President Ben Ali's grip on Tunisian freedom of expression and intellectual exchange was ever-tightening. The IRMC would eventually relinquish its regional aspirations and stick to working in Tunis. The center where I worked would be renamed "*Le Centre Jacques Berque.*" It became an independent, bi-lateral entity. And my fieldwork was leading me to attend to the power of such binary oppositions and the meaningful differences they conceal. By the time I returned to Paris at the tail-end of 1996, the Casablanca-centric, three-world model was ready for export.

# 2

## SPINNING

I arrived in Paris with heavy cartons of brittle old literary reviews and shiny fashion magazines, reams of field notes, and kilos of photocopied articles. There were shoeboxes full of cassette tapes and numbered floppy discs with transcriptions of interviews. Spiral notebooks with information on salon budgets, sketches of supply networks and the floor plans of dozens of beauty establishments were piled high on the dining table. Field notes and books seemed to multiply as I arranged them on shelves that soon heaved under their weight. My formerly insubstantial belongings had multiplied in Rabat: this included new paintings for my walls and in my portfolio. Two of these are particularly helpful in reflecting on how fieldwork was going. I made "Tables et Tabliers" in 1991 while living on rue Malherbe/Mafalouti. I made "Table Tress" in Rabat in 1995. Together, they present fitting "before and after" pictures of what had changed since I had left Paris for Morocco a second time, three years earlier.

*Before*. "Tables et Tabliers" traces a circular motion inspired by the low, round Moroccan table, the *mida* where families and guests gather in a tight circle for meals. The title encourages the viewers to see such a table, or perhaps an apron or maybe a skirt. Whatever it "is" the central form seems to float in a pool of light. Elliptical lines smooth out the composition toward triangular pressure-points. Were these inspired by the diadem that gathered Berber cloaks together at the shoulder?[1] The rounded ample form of a comfortably seated, female body? They are calm, yet not immobile. The work witnesses a sensitivity to light and movement that is similar to "Window #1."

This piece is one of a series of paintings focused on the circles and cycles of domestic labor. Cook and serve and wash up. Repeat. Like the tables and other coverings and jewels the picture might bring to mind, the image could be related to my experience of feminine-gendered spaces as a refuges from the pressures of the street.

**FIGURE 2.1** "Tables et Tabliers," 1992. Acrylic on paper, 19.5" × 26". Photograph by Nigel Tribbeck.

That was a time when I was just imagining the salon project. If the lines in this piece might be related to the flows I would investigate, the atmospheres and colors they traverse are tranquil, dreamy, pleasant to the point where some critics might judge this work might be overly aesthetic, an art-world echo of how ethnographic texts that are beautiful are often viewed with suspicion by theorists.

*After.* The title of the second piece clearly indicates that I intended it as a follow-up to or commentary on the earlier painting. "Table Tress" is composed of two layers. The ground is painted in translucent peach and beige tones. A second layer made of thinner paper is thick with paint in deep, dramatic colors. I can still hear the crisp sound of the stiff paper splitting as I sliced it, laid it on top of the diaphanous transparency reminiscent of "Tabliers et Tabliers," and then carefully separated the strips, as if combing a mane of long wavy hair. Colors and lines peek through the "tresses" from the background, suggesting lively movements. I recall thinking about motions of bleaching, dying and braiding, curling, combing, and teasing as I worked with paper and paint and scissors. Is the small straight horizontal strip along the bottom a comb, or a ruler? Or a tool of the anthropologist who calculates and counts by way of her sketchbook and intuition? The clipping of hair and paper, the calculated layering of strands: was I taking on the role of hairdresser? One might imagine that I was trying out the motions in media familiar to me, rather than risking what might have happened had I used my untrained hands to cut actual hair. Like the piece made several years before, this second painting/collage sends the eyes down a curved path.

**FIGURE 2.2** "Table Tress," 1995. Acrylic on paper, 17.5" × 25". Photograph by Nigel Tribbeck.

While the first work is a kind of landscape table, I would call this one a portrait. The figure fills the circular void of the "landscape," evoking the earlier painting. The title encourages connections of the abstract tangle with hair: rhetoricians might see the work as a "synecdoche" when a part of something stands in for the whole. Hair/Woman? Or Hair/Table?

I never told myself "I'll cut paper like a hairdresser clips hair," but this happened by way of example. The art suggests a mimetic chain at work.

*Mimesis* is the Greek word at the root of "imitation." While this last might have a negative connotation when it is taken to mean simply a production of the same, at least where and when innovation is prized, mimesis does not imply simple copying. The origins of the word go back to dance, to the "following" that is key to learning by way of example. Each new dancer and renewed gesture adds something to even the most set forms and routines. In ethnography experiences calculated to produce insights and analysis emerge not simply from being there, from immersive sensations and reflecting on these, but from engaging in an active process of following and learning. Fieldwork in salons both sharpened how I "saw" salons and how I could make something of them, whether for art or social theory. As I visited one salon after another, I found myself comparing the way I moved, felt, and acted in each of them. Focused and repeated attention led me to engage each salon in an ongoing movement of meeting to meeting, gesture on gesture. The evolving and layered nature of this attention helped me comb out the differences among salons in ways that crossed geography and

fields of activity. Sometimes I awkwardly imported a particular attitude or idea of expected ways of engaging others from one type of salon into another. If I used the "self as art" approach to selecting my style in a local salon, it distanced me from the warm circle of neighborliness. In a "fast" salon, attempts to engage conversation with other clients lined up along the same long mirror, quickly fell flat. No one sought the warm embrace of the neighborhood circle in those places, even though they often shared intimacies with their personal beautician. Conversations with a coiffeur-artist often permitted exchanges with others in the room, but these tended to move in an expansive direction, for instance, attending to trends in high fashion that only a very few of the clients actually wore or could afford.

Moving from salon to salon, I engaged in a kind of self-following, a self-mimesis. Who could I be in the circle of the neighborhood salon? What new thing might I become when I entered into the specific interpretation of the beauty-shop routine when Georgio coiffed me? How did me as a subject of art differ from me remade following a step-by-step haircut a beautician had learned to create in a franchise beauty school? While my friends were always curious about how I would look after my many visits to salons, I resisted offers to create a photographic record of myself. While I had followed the flow of images of cinema or music stars in reverse to set out the field, once entered into that terrain, it was the social and embodied meanings that took precedence.

With this in mind, and with the experience gained in Rabat on my resume, I imagined adding further voices and references into the experience of fieldwork. I found a new job in Paris and proposed launching a new collective program called "Mimesis and Mediations."

## Mimesis

In Paris, I joined the CNRS *Laboratoire Communication et Politique*. This group of media studies and literary scholars, sociologists, philosophers, historians, semioticians, and specialists of science and technology studies led by Dominique Wolton became an intellectual home and source of support. There were no research positions available in the "Labo." However, friends from the group told me about a job opening at the CELSA, the communications institute of the Université Paris IV–Sorbonne. I got the job and initiated "Mimesis and Mediations" in the context of the new part-time position, which focused on enhancing the research profile of the CELSA through a collaboration between the two institutions.[2]

The program in Paris was less organizationally demanding that the IRMC project had been. It brought people to Paris. There was no multi-site design to come up with. Outside of teaching at the CELSA and running the research program, I taught occasional classes at "Sciences Po" and the American University of Paris, a liberal arts college where I'd eventually became a permanent faculty member. It was not easy to make ends meet in France. So I

**48** First wave

also took the train to Belgium to fill in for a colleague on sabbatical in Liège, and then another in Louvain. I made trips to Tunis to work on an edited book based on the earlier IRMC program.[3] And, naturally, I traversed Paris and traveled to Cairo to pursue fieldwork in salons.

In Paris, life as an underpaid and at first untenured academic made it easy to shed Romantic or superior notions of Parisian style current in fashion magazines. Some salons were extraordinarily chic and alluring. Many others not so much. Most were efficient; work-wise, or simply comfortable. The hardest part of research was paying the bill at the more expensive salons; I learned to have my bangs trimmed, or just get a "brushing" (blow dry). I had the leisure to drop in at salons between classes. I could readily take the metro to *coiffeurs* across town. My friend Martine, who had worked as an aesthetician for many years in many different countries, was especially helpful in cueing me in to aspects of hairdresser's work and lives in the French capital. I could count on friends with divergent tastes and beauty practices, living in different quarters to tell me about particularly interesting or unusual beauty shops. Research in Cairo was an entirely different matter.

I made my first visit to Egypt in 1995, when I was still based in Rabat. I recall arriving at the Cairo airport and hopping into taxi. My lack of practical knowledge about Egypt became apparent immediately. At first, I thought the chauffeur couldn't understand me. He seemed distracted and unresponsive to my casual conversation. I was attentively articulating my words, using the standard Arabic I'd learned at university; the language used on television and in newspapers. Beyond the Maghreb, the Moroccan dialect is generally deemed incomprehensible; a fact related to the very flows of media I had reversed to braid the field I was investigating. However, I soon realized the driver's lack of conversation had nothing to do with my pronunciation or word choice. It was my left knee, not my words, that interested him: it was peeking out from what in Rabat was a modest length skirt. The driver was absorbed in the scene that he followed with the rearview mirror cocked to the back seat. He was the first man I saw doing this in Egypt, but far from the last.

I arrived in Cairo with a fair knowledge of Egyptian cinema and music, literature and scholarship. I had watched hours of soap operas made in Cairo over many Ramadan *futur*, the meals that break the fast when the sun goes down.[4] However, I would never move to Egypt with the expectation of staying on, as I had to France and Morocco. I had to be much more attentive to timing in Cairo than I was in the other cities. Even before arriving there, I had to coordinate fieldwork with my teaching schedules, school vacations, and summer camp. In Cairo, I worked intermittently and intensely, never settling into a routine. Each visit was entirely out of the ordinary and entirely devoted to advancing the project. Perhaps, for the first time, I experienced fieldwork as "a total experience, demanding all of the anthropologist's resources, intellectual, physical, emotional, political and intuitive."[5] Cairo required all of my energies. Indeed, fieldwork in Egypt made me a person in need of assistance.

## Collaboration

In Casablanca and Paris, I had assistants who collaborated on the project. An art student, Fedwa Lamzal, helped me do interviews and shared her perspectives on the salon of her home city of Casablanca. In Paris, Malgorzata Domogała, a Polish student making her life in that city, did the same. They each drew on our common pool of notes and interviews for their school and university projects. That their accents, looks, and ages differed from mine helped me to gain perspective on which specifics about me influenced interactions in salons, and how I interpreted them. Still, because I knew both of those cities intimately, their work was a compliment to mine rather than a necessity.

In Cairo, I was lucky to have friends to stay with who could guide me. I met Jean-Noël Ferrié, a political scientist, at Aix-en Provence when we were both students. It was not long before he introduced me to his partner, Souad Radi, a medical anthropologist. We all started off our careers with fieldwork in Morocco. By the mid-1990s, they had shifted their research to Egypt, where they worked at an institute in the same network as the IRMC, the CEDEJ (Centre d'Études et de Documentation Économiques, Juridiques et Sociales). At the time, the CEDEJ was a well-funded, large laboratory. It offered me intellectual and some financial support. Yet, it was the home of my friends that was the vibrant social and intellectual center for each Cairene sojourn. Thanks to them, my experience was not simply one of "being there" for fieldwork, but of having them and their circle of colleagues and friends "be there" for me.

Interestingly, what Souad recalled when we spoke about those years recently was how *I* had cared for *her*. She had taken penicillin. She did realize that she was allergic to the drug. I watched as her face swelled; a few moments later, we were out the door, rushing to the hospital. I held her tightly and dove into the traffic that ebbs and flows without stopping at any light or obstacle as though it were a single living organism. Souad remembered sensing both my urge to protect her and my absolute panic. My field notes mention the emergency room visit and relief that a simple jab from a kind nurse stopped the allergic reaction in its tracks. But by far the longest passages are about how Souad helped me during my stays in Cairo.

I trailed her as she went about her daily tasks, discussing hairstyles and fashion and salons as we met a seamstress, a retail clerk, a baker. She and Jean-Noël encouraged other people in their circle to introduce me to their favorite beauty shops. Some of my friends' associates were social scientists who read about my research and made strategic suggestions about unusual salons I should know about. Many of these friends and colleagues were willing to be interviewed. Some accompanied me to visit their favorite beauty salons.

One notable visit was with Jean-Noël to a mixed-gender salon located in a fancy international hotel in the center of the city. When we met in Rabat in 2019, we found we both still had clear memories of that day two decades before when a beautician spontaneously set about trimming the edges of his beard

**50** First wave

using the "threading" method of hair removal. Performing the role of a good re-
search subject, he said nothing in spite of the sudden, unexpected pain. I saw red
blotches spreading across his cheeks. I can still vividly call up the shade of shock
and fear in his eyes as the beautician approached him time and again, twirling
two strings together to pluck out each wayward hair from its follicle. Today that
scene brings to mind another one several years later. I was giving a talk about
my salon research at UC Berkeley, in Kroeber Hall. A man in the audience asked
why I had focused more on sociability than on the pain women endure to make
themselves beautiful. I cannot recall my answer, but I do know it was the look
on Jean-Noël's face that popped into my mind's eye.

My hosts introduced me to Aicha Chillali. A research librarian by profes-
sion, she sorted through articles in contemporary fashion magazines and the
archives in the CEDEG library to prepare for my intensive visits. She sched-
uled meetings with hairdressers across the city. And she simply wandered with
me, from central neighborhoods to elite suburbs, on to poorer quarters where
the researchers of the institute rarely ventured. Born in Algeria, Aicha had
lived in Cairo for a decade by the time I met her. She was an ideal translator
among dialects of Arabic. What's more, like the majority of those in the col-
laborative collective that formed a circle around me during each stay, she had a
deeply personal and embodied understanding of the counter-current direction
of the project. In different ways, at different moments, we had all come to
Cairo by way of the Maghreb, a Maghreb triangulated by French institutions
and language.

In Cairo, my fellow researchers shared a direction that kept me steadfast.
Their similar angles of approach to the city facilitated addressing the sometimes-
overwhelming symbolic weight of the Egyptian capital. The magnetism of the
city's history and Egypt's central position in Middle Eastern studies were miti-
gated by the shared path we had all followed there, in one way or another. The
complicities of our common movement intensified and proved critical to main-
taining the momentum and direction of "coming from Casablanca" field weav-
ing. This was especially important to me, since unlike them, I had no day-to-day
Cairo to match my ordinary Paris.

There was time to reflect and layer Cairene salon visits with those in Paris and
Casablanca. My friends thought about salons in my absence. Each time I returned
to Egypt, I found they had prepared for me, while having their hair trimmed, or
reading newly published articles in the library. Eventually, the research began to
reveal facets and facts that were obscure even to those who pointed me to one or
another beauty shop. "Mohamed" called himself Georges to conceal that he was
Muslim. There was a second salon for *muhajibat*, women who wore veils for reli-
gious reasons, and who favored single-sex salons, tucked behind a mixed-gender
salon in the center of town. I met a genial hairdresser in a poor quarter that
worked without running water and with only a make-shift plug; laughing and
joking, he made Aicha and me comfortable, following the usual greeting, wash
cut, dry, style routine to a tee, even with minimal props.[6]

In Cairo, I thus relied on friends and collaborators who lived in the city to correct some first impressions, even as I reframed salons in the "center" of Arab media by way of the layered research in the doubly peripheral port city. Comparing a version of a haircut in Casablanca based on the style of an Egyptian singer to one in Cairo set in motion a mimetic whirl of references and questions. What was Samira Said, from Morocco and who sang in Egyptian dialect and whose records were produced in Cairo? What about me, born in the United States, entangled in French research networks, with research anchored in Casablanca? As I had my hair pulled and curled, colored and bobbed. I came to realize that to be fashionable meant *manifesting* one's self-transformations. Curly hair straightened, thin hair thickened with extensions, eyebrows tinted: it might be deemed to be in pursuit of the "natural." However, chic required *showing* how one worked on oneself while tending to one's body and image. Issues of shaping one's body and self as a modern subject came to be more important in my work than issues of the origins and passages of particular styles. The strategic reversal of media flows that shaped the project led me to these new questions and discoveries, even as it led me to engage how these flows required me to become increasingly aware of the work on scholarly and cultural references that this triangular field motivated.

## Scholarly terrains

In the last chapter, I remarked on the unevenness of statistics in Morocco. Now I faced an even less even-handed accounting of consumption added to asymetrical scholarly references. The history of film and song in Egypt has predictably produced a wealth of scholarship. The work published on French fashion, cinema, and beauty technologies was overwhelming. Surveying the literature on "Casablanca," I found many more articles on the Hollywood film than on the African port city of three or four million people; statistics varied even on that count. The difficulties I set myself up for by moving from Casablanca toward Paris, the world capital of fashion, and Cairo, the "mother" of the Arab world, made it purposefully difficult to smooth findings into neat cultural or political boxes. Casablanca was good to think from.

Then there was my engagement with the English-speaking world and academy. While living in Casablanca and Rabat, I had experienced something of a distancing from the anglosphere. When I traveled to conferences in the US or UK, I found that the audience took "French theory" to be some kind of unified front, whereas I was ensconced in francophone networks. I also dialogued with the works in English that referenced French thinkers like Foucault or Barthes. I was influenced by the work of scholars in these languages of less international renown, or whose global notoriety would come later, once their works were translated. Sometimes this meant I was "behind" the times; I recall being asked in the early 1990s if I was "actually" an anthropologist or had wandered into the forest of cultural studies. I wasn't really able to answer the question because I did not entirely grasp what constituted this new discipline.

**52** First wave

Living in Morocco before the internet went global, I was able to catch up on English-language sources when I visited my parents and sisters in California on holiday. It was when I moved back to Paris that I was able to access "Anglo-Saxon" scholarship and catch up on popular television in the United States and Britain thanks to the introduction of cable TV channels. I once again subscribed to *The New Yorker* and *Art Forum*. All of this made me perceive how my references to my "own" Anglo-American culture had become more bookish than quotidian. While my colleagues in Europe and around the Mediterranean were much more likely to read works written in English than were my American colleagues to read works in other languages, this did not necessarily translate into making these readings part of the general intellectual conversation. The slippages of language and temporality among the scholarly milieu I engaged made colleagues at the CEDEJ, the media and communications "laboratory," and at the American University of Paris who also shifted among multiple versions of their disciplines all the more essential to me. They provided a sense of direction and continuity and support that no discipline could match. As I wrote about the salon research, each word I set down was shadowed or blurred by the echoes of other languages and discussions, much like the far-flung salons that layered one on the other to shape my analysis. It was sometimes only at the drawing table that I could bring everything together in a way that could involve as well as reflect on every world this fieldwork implicated.

## Analysis

The field I devised against the flow of the media was designed to test dualistic oppositions of global to local cultures that combed the world into local or national cultural styles. The beauties I encountered were not spun of global exchanges, then rewoven of national threads as arguments that contrasted local and global tended to assume. It was because I worked broadly in carefully framed settings that I could not only understand this but propose alternatives to the dominant models of how culture and global forces met. The simultaneous testing of the salon form and layering of one salon on another in my experience and in my body led me to conceive of the processes of embodiment in ways that could expose difference in what appeared similar when studied either from a distance, or so close up that one had to assume rather than tease out the context of one's observations. The way I wove three cities together beginning in Casablanca led me to notice how specific forms of the salon shaped different ways of bringing people together. Each encouraged a distinct understanding of society. I have explained how I came to distinguish between several salon types. As I worked with the model I developed in Casablanca, I could now begin to thicken my descriptions, thus adding to the texture of my understanding of how each salon was a learning ground in what it meant to be a person, community member, and political subject.

Some salons were as much neighborhood conversation circles as places of grooming. Others sought ready to wear style and efficient production: no

hanging out just to chat. Others were more like art studios, where the hairdresser was a medium who helped you to develop a unique, custom-designed style all your own. The conversation-circle type of salon I thought of as the proximate salon – its context being usually referred to as a *hay*, a *derb*, or a *quartier*; a roughly defined neighborhood. Women's movements toward these salons were frequent and inscribed in a relatively small radius – usually their homes were within walking distance. This kind of salon, while known to all, tended to be most visually closed off from the street. People stopped by to just sit and chat, so it was important to have a couch, magazines, and, if possible, a TV around. Images from the media animated the salon; their pictures of beauty were adapted or rejected depending on how "people in the neighborhood" might perceive the person who adopted them.

The second type of salon centers on a hairdresser, often a man. He proposes to make clients into works of art. The geographic reach of this salon is broad: the space is not cozy; it is intimate. One has the impression that it gives access to experiences lit up by the bright lights. People come from far and wide to be treated in this kind of salon, which reaches far beyond its walls, both because the celebrity hair stylist who attends to the stars in their villas, and because clients come from far and wide to be treated as *objets d'art*. The social life of the salon extends to the lavish wedding of a singer, or the birthday party of a government minister; it also includes styling for the wedding of a young school teacher who has spent her hard-earned wages to have the celebrity stylist do her hair and make-up for the special day.

The third type of salon, the menu-driven fast salon, is all about efficiency and professionalism. This type of salon keeps to the rules set by its image, and, sometimes, by the franchise. Its mirrors often cover the walls – what they reflect are one-on-one exchanges between a beauty professional and a client. In these salons, you chose a haircut based on a named or numbered model. Indeed, the "model" as guide is critical. Stylist skill is measured by accuracy with respect to images. If you have your hair and waxing done regularly, you may come to know the hairdresser or the aesthetician. Conversations with other clients, or across the salon with other professionals, are quite infrequent.

The three salons types suggested divergent ways of apprehending and embodying images and the places they are given body. These disparities were meaningful not only for beauty, but for the varied settings where people learn how to be themselves, by being together in a specific manner. I found that subjectivity shaped in one or another salon would not posit an ideology; rather, it intimated a way of coming into and comprehending one's social worlds and oneself. This is an approach that puts the emphasis on the subject as social. Subjectivity can be layered, because the types of salon are not exclusive. Crossing from one salon to the next is a movement between distinct manners of judging oneself and others. Being "educated" in all three of them gave people not only flexibility in thinking about their own actions and dealing with others, but was tightly correlated with greater mobility, both geographic and social.

**54** First wave

So it was not simply where one went or who one frequented that was important: not simply a question of connectivity and networks and nodes. It was important not only who or what one encountered in a place like a salon. It was *how* people engaged one another in each setting that was critical. The way people sat or joked or gossiped together, or not, implied a particular way of including free-floating images of beauty. The three interpretations of the single salon-form had distinct effects on perceiving, processing, embodying universal styles. Each also gave access to broader worlds and worldviews. To learn to be at home in one or another salon, café, school, or business setting was to gain access to a way of thinking and being in relationships to others and the globe. It is in the play between these "worlds" that the character of an individual, the unique feeling of a city, or the particular style of a beauty salon is created. The different measure of types of salons in Casablanca, Paris, and Cairo was itself a social fact worthy of investigation. The conditions for movement across the city or world implied reflected political choices; promoting one or another type of meeting place encouraged possible social, cultural, and political imaginations.

Thus, the difference in salons in spite of the homogeneity of the body they assume suggests more general processes by which diversity is produced. Globally distributed spaces like salons offer informal training in how to be in the world, and how to adjust to its varied social terrains. Was it the kind of hands-on reflection I used to develop the program at the IRMC that led me to be so attentive to social formations? Or was it a preexisting sensitivity to these forms developed as a child in a large family, or deep reading of social theory that led me to notice these social worlds across the counter-current field I had spun?

## Shadowing

Today, it seems obvious to me that speculation that is reflexive is not simply about relationships between fieldworker and interlocutor but also about these other forms of togetherness that contribute to "being in" the field. As I went from salon to salon, I encountered hairdressers, clients, managers, shop owners, and representatives for beauty product companies. I also introduced the questions and the voices of my colleagues into my fieldwork perceptions, even when they themselves were absent. The prospect of the next meeting of the IRMC program, or the need to type up a report on a newly published book about mimesis for a meeting of the CNRS/CELSA group urged me to work, and to work with impending collective activities in mind. Indeed, because of my lack of formal preparation for collective aspects of research at first, these institutional expectations were always highlighted to me. Being cast, *malgré moi*, into a leadership position, creating collectives, heightened my alertness to the way others composed scenes for sociability toward different ends. Working through beauty salons with reference to varied academic worlds, I often found myself on view academically in ways that reminded me of how my friends in Cairo inspected me

each night to study how fieldwork altered my hair style and cosmetics. Working on feminine spaces and using flowing, expressive gestures in masculine worlds of diplomacy and academia was a reaction, but a constructive one. Setting fields on edge in soft yet consistent lines of practice, reshaping theoretical assumptions forward by way of gentle but repeated provocations and writing across art and anthropology to develop abstract models was a strategic way of working out my own historical vulnerabilities.

The salons I visited were places where people learned to be together. By entering new kinds of salons with their singular social relationships and modes of evaluation and becoming conversant with them, one learned to how to be and see and become more or other. Salons could be scenes of conflicts related to social class, for instance. I explored relationships between owners and workers, and noted the patronizing some beauty school directors have toward their less financially and educationally privileged students. Still, hundreds of visits also showed me that strategies of social mobility or influence might be best understood as resulting from being able to readily settle into more than one salon form and the world it assumed and daily recreated. My research made me wary of arranging salons into a hierarchy based on price or social position that fit their owners, workers, or clients into class categories.[7] I was interested in understanding that physical mobility and social mobility were linked through experience of social life. I sought to get at how differences were engendered through experience; the social imagination I began my work with was inherently dynamic.[8]

Making graceful moves among worlds was at the crux of ethical reflection for those subjects privileged enough to be able to move amongst worlds. Being educated in each milieu, one could move amongst ways of being oneself, and relating to others. The "three worlds" that I discovered in salons pointed to a kind of pedagogical disparity that cannot be detected only by studying schools or measuring literacy. It gets at differences in how people learn "their" culture. Salons and many other places of social life collectively shape subjects who are not simply consumers or producers, but likewise citizens, workers, parents, or friends. Making oneself in a salon, one learns a way of being together. Having the opportunity to pass from one kind of salon to another, a person learns to navigate social worlds that extend across the globe, in different measure. Access to each world, and the way law and custom associate them are eminently political questions. Issues of transparency and corruption, competence and public appeal, and also of community and alienation can be read through this model in ways that help to clarify a wide range of questions. In the future, it would also help me to reflect on the way I would devise collective and collaborative work to expand my own and others' learning and understanding.

## Channeling

"Windows # 1," "Table Tresses," "Tables et Tabliers"; these and many other artworks captured problems, thinking processes, and atmospheres as an integral aspect of research. I have evoked how, making art, the shifting and layering, the

**56** First wave

attention to regularities of interaction produced a mimetic trailing with paper and scissors and paint. On paper or stretched canvas, I could include the divergent scripts and directions of the languages around me, and that by then worked on my thoughts. Letters and words that cannot join in sentences can become cryptograms for what could not be spoken in any tongue. Almost-formed syllables in a summer breeze themselves offer poetic possibilities for thought. And yet, some of the aims of my work were best served by adding word to word in exposition, joining description to argument.

A decade after I first wrote about salons for the *Cahiers de l'Orient*, I realized that fieldwork kept leading me to the same conclusions. It was time to stop. Somehow, in the midst of classes, helping my son study Latin and Greek and German, meetings of the "labo," and taking the train to lecture on Habermas and theories of publicity at the Université Catholique de Louvain so we could take a summer holiday in California, I found time to write. I settled into a corner desk in my bedroom overlooking an inner courtyard, surrounded by fieldnotes and books, often with a cup of coffee. The metro line 7 runs under the rue Monge, where we were living at the time. I felt the rumble of the train as I assembled notes and imagined shapes of book chapters. Once I dove into writing, the world around me faded. I became a medium shaped by the shifting, spinning, embodied project I had lived with and within for so long.

I set out the table of contents. I thought about the main points I wanted to touch on in a chapter and wrote them by hand on a piece of paper. From these marks, ideas and words flowed as I typed: at the keyboard, sound and rhythm were critical to my work as they would be for a musician. Once a framework was laid out, I set about writing. I explored how my triangulations revealed how power worked on bodies and social life in the *métropole* as well as the colonies. I drew out enduring Mediterranean faults of city and country and the way that orientalist tropes and racial divisions tangled and pulled hair straight and smooth across the research triangle. I delved into descriptions of salons and presented the model, and then explored how it might lead to a new approach to conceiving of significant social rifts that were not simply a matter of birth or wealth, but of access to learning about ways to think and relate to the world in the company of others. I combed out the sections of the manuscript, trimmed the edges, and clipped some words like an expert hairdresser. *Three Faces of Beauty: Casablanca, Paris, Cairo* makes abundant use of metaphors of dancing. The field I frequented for a decade did not quite set me waltzing: but its abstract, evolving movement was certainly well represented by that dance.

A perceptive and sympathetic reviewer would write that what I'd done was both something more and also something less than an "ethnography."[9] I concur that my objectives and the results of the research differed from monographs that seek to introduce the reader to a subject or place or people from every angle in the holistic tradition of fieldwork monographs. My dedication to "the field" had been total. But I had not tried to tell the "whole" story of any salon in particular. It was how this work was set up to problematize the familiar to notice

divergences within similarity that it met the aim of exploring the forces and process assembled in the word "globalization." These differences were not readily perceptible if one stuck to exclusively to style, national or otherwise, or. a deep and sensitive description of the day-to-day life of any particular salon or city or network or field of activity.

Since I came up with it, I've used the "three-world" model to explore other types of gathering places, like restaurants. I have worked with it to interpret political action. I have called on its intuitions to think about education and notions of equality in which each individual has a vote, and social distinctions based on star-studded constellations or the prejudices and warmth of the inner circle: be they of kin or mafias. I have used it to reflect on how people on the move seek out ways to feel at home in new places. Try it out yourself sometime.

It was perhaps strange for some readers to find a model maker in an anthropologist. Or an ethnographer who engaged in the kinds of abstractions I included in my research design and methods. Often, realist aesthetics are taken at face value as most apt to convey the truths of experience, and experience-based research in the social sciences. But realism has its own conventions. And there are forms of sensory experience that might be best explored and conveyed not in a poem, or even a painting, but through processes of generalization turned to form – through the abstraction of theory, or concretely, by making art.

When I completed *Three Faces of Beauty: Casablanca, Paris, Cairo* in 2001, I wanted to put "Table Tress" on the cover. The editor declined my request. It seemed that readers would expect illustrations, not abstract art "made in the field" by an anthropologist. He had his finger on the pulse of academia. He would surely have been right, for that time.

It is time to fast-forward to a decade later, when looking at a painting I made in Rabat created the momentum for the second wave of research I will remember.

# Second wave

# 3
# CALL AND RESPONSE

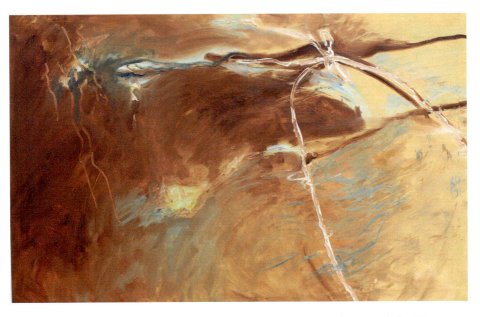

FIGURE 3.1  "Hang Dry," 1994. Oil on canvas, 31" × 48". Photograph by Yvonne Polk Ocasio.

**62** Second wave

The late-morning sun is pale, like the paint I spread over a canvas propped on a chair in my dining room. *Beeya, beeya* … the words of a passing street vendor set a meditative rhythm for my brush. *Shari'a, zenqa* … syllables of words inscribed into other paintings come to mind, quieting the traffic din from the open window.[1] I paint lines as though I might begin to write them down, then rub them out with my hand. I lose myself in the sweep of air coming up from the Bou Regreg River that meets the ocean in a briny gap between Rabat, the capital, and Sale, her sister city to the north.

The estuary mingles turquoise sea salt and brackish brown algae. It tames Atlantic currents from the Americas when they reach the edge of Africa. Wisps of conversation from a neighbor's roof terrace draw my gaze to the clotheslines that stretch an air-scape from the balcony. Tracing these on canvas connects eye and hand in a single stroke, a following and joining of laundry lines, electric cables, telephone wires, broad boulevards, and tiny alleys. I follow a couple of these stripes, and then cut a lunging pink band across the Naples yellow and mahogany on the canvas. I retrace the line with a thick streak of white directly from the tube, and then repeat that action. As I trace a finger through the viscous medium, glints of color seep through at the edges. Tying light to shadow, I knot the cord I have drawn, as though to hold on to this moment and this atmosphere amid the shifting momentum of the winds of the world.

"Hang Dry" followed me from Rabat to Paris, to Washington D.C. and on to London, bringing the light and fragrant scents of the Moroccan breeze into dark, cold winter rooms. When I moved to Riverside, California, in 2007, I stored it in a closet. Perhaps I didn't need it in that sunny place. Or perhaps the cords cast across the Atlantic could not reach the Pacific Rim.

Yet, when, by chance, I did take out the painting, it suggested to me that lines and networks, or currents and circulations, might not be the only way to conceive connections. Set beside a window in my home office that looks out at the rocky slopes of Mt. Rubidoux, the frame of the painting seemed to melt as the Moroccan colors blended the art into its new surroundings. Or was it the view of the mountain and cloudless sky that poured itself into the painting? Art unexpectedly offered the true illusion of my lifescapes. Even as I write, "Hang Dry's" cerulean blue and burnt umber perfume the workspace with a mélange of diesel dust and orange flower.

To envisage the start of this wave of work, imagine casting "Hang Dry" into a calm pool of water on a sunny day. Picture the colorful reflections and refractions on the water as it melts into the expanding wave it has created.

## Disappearing practices

The first circle of activity that "Hang Dry" set in motion occurred in the office and in my mind. The second happened in my garden. The work from Rabat inspired me to take new notice of the clothesline strung across the patio behind

the mid-century ranch house. I found motivation for painting in the way breezes use the laundry to make the yard into an ever-changing diorama. Painting on the patio inspired by skirts, socks, and towels, I could feel one with the life space that the old artwork opened to me.

Not so my neighbors.

John didn't find me when he rang the doorbell, so he walked to the back; there is no gate or fence. I was painting, but he took little notice of the canvas on the easel. In fact, he seemed to have forgotten what brought him to my home in the first place. Instead, he stared at the sheets and pillowcases strung across the driveway. Was it because I had "been away for so long?" he wondered aloud. "In Africa, one must imagine they have no modern conveniences. But Europe? Didn't you move here from London?"

Further encounters in the garden with neighbors, the mailman, the woman who read the gas meter, and kids selling lottery tickets led me to see how odd an ordinary practice appeared to everyone. A UPS delivery woman, the entomology student who checks citrus for pests, and a family of Jehovah's witnesses promising salvation: each of them seemed compelled to comment on my exotic custom.

Observing my dresses drying in the hot sun, one uninvited visitor wondered, "Didn't modern conveniences like the dryer lighten women's work?" Another reminisced, "My mother did that, and it smelled so wonderful!" They saw the ordinary work I did as marvelously out of place, "When we visited Rome with all of those clotheslines; so colorful, exotic." An eco-conscious colleague said she hung her family's laundry when she could. "I know dryers are such an energy-sink" she said with a guilty expression. I did not blame her for using a dryer. I simply didn't want to use one myself.

Informal interviews and random comments about my dresses drying in the sunshine rapidly confirmed that laundry lines are considered unsightly in the United States. Many cities and housing developments in California restricted outdoor clotheslines. In the States, hanging laundry outdoors connotes poverty and immigration; I was a white, educated, middle-class woman who could speak fluent English. Was there something I was hiding? Or was I an inadvertent performer/activist in my own backyard? Who would freely exhibit their underwear in the open air?

Some young people admitted that their mothers hung hand-washed items over the bathtub or in the shower stall. One teenager said he had "only seen it done in the movies." A more-worldly student explained that he had learned to dry his clothes outdoors during a year abroad in Costa Rica. Several others frowned with disgust when I talked about my strange habit. "Imagine how the air must make the clothes dirty!" Was "Hang Dry" really a depiction of a yellow-tinged Santa Ana wind fusing with the dusty Saharan Chergui?

"Hang Dry" was a relic of another time. It preserved and evoked the memory of squeezing Naples yellow onto a plate, of the scent of turpentine and linseed oil and the feeling of paint on my finger; of drawing and retracing the connecting

line with zinc white until it revealed the layer of color beneath it. The indentation and flecks of color remain as witnesses to my persistence. Art and work in the home: I remembered that Morocco was the only place I've lived where someone else did my laundry. Perhaps it was because Mina hung out my sheets while I rushed off to the office that I began to really take notice of that domestic task. While the maintenance work of women in their own homes or those of others are often overlooked, laundry hung out to dry advertises this labor. The attention I gave sheets on the line by painting them may also reflect how my work separated me from the daily pleasures of household and family while I worked at the IRMC.[2] This was not simply a landscape composed by referencing clothesline geometries; this blending of life's geographies fused worlds of my day-to-day, across time. It focused on simple gestures that gave continuity to my experience. It became a knot to tie together art and anthropology.

"Hang Dry" and the encounters I had with people in my California garden led me to become attentive to laundry practices as they crossed geography and time. I studied the history of soap and modern "labor-saving" devices. I sought out images of laundresses in art. I collected pop culture: from "La pince à linge" (The Clothespin) sung by Francis Blanche to the tune of Beethoven's 9th symphony to Lebanese pop star Nancy Ajram's video for the hit song "Ah W Noss" in which she flirts with the laundry as much as she does with her would-be boyfriend. I traced the development of the clothespin since pre-history and reread Zola's "Assomoir," a portrait of working-class struggles in nineteenth-century Paris through the life of Gervaise, who works as a laundress. Reading about washing and drying clothes awakened the bodily sensations of reaching down into a basket, and then stretching to hand my grandmother sheets or socks to pin on the laundry line. Painting to reflect on clotheslines also revived the memory of my first whiff of oil paint. My mother had inherited an unfinished paint by numbers canvas from my aunt. The scent of the linseed oil and turpentine enchanted me. It was even more thrilling to see how smoothly the paint my mother applied so gingerly became a Parisian street scene. I wanted desperately to try the paints, but my mother warned us girls: stay back. She explained that these colors were permanent. They could not be washed off if you got them on your clothes. She was right. The linen dress I wore as I painted laundry-inspired canvases in California decades later became so indelibly smudged and splattered that it became not just an artefact of my research, but an artwork in its own right.

By then I had met Beatriz Mejia-Krumbein, an artist, professor, and then director of the Brandstater Gallery, at La Sierra University. She told me about her fieldwork with circus performers. She showed me the art she developed through interviews and observations. I suggested she take part in the graduate seminar on art and anthropology I was preparing at UC Riverside. I showed her the work I was making for the laundry project, and she invited me to develop a solo exhibition at the gallery. I proposed a plan for "On the Line" that would include an experiment. After viewing my work, artists, anthropologists,

and graduate students would fashion a critical response with their own art and a remake of the original exhibition, "On the Line: A Second Look." Beatriz was enthusiastic. We began to envision the prospects that would unfold through our collaboration in the winter and spring of 2013. But first, I had to go to London, where fashion scholar/artist Wessie Ling/WESSIELING and I were about to make our duet exhibition at the Brunei Gallery into a terrain for an ethnographic experiment.

## Fieldwork in the gallery

In April 2012, I made my way through airport security in Los Angeles on Delta Airlines with a large portfolio. The agent took a quick look at "Window # 1" and five other works on paper, and passed me through with a wave of his hand. Throughout the flight, I worried about the roll of canvases I'd checked in as oversized luggage.[3] "Hang Dry" was among them; the others were more recent. Rather than art "made in the field," they presented my efforts to further develop the aesthetic research I'd begun in Casablanca.

By the time I headed to London, I had spoken and written about painting an abstract landscape inspired by the red-and-white aprons of working women in Northern Morocco. The bright garments encouraged me to stretch bold strokes of red and white paint across the three long, narrow canvases that form the triptych. Painting, I reimagined the stripes of their skirts as fundamental connections. The red and white lines I traced with a brush traversed green and blue washes that suggested hills, sky, and the Mediterranean Sea. The work showed the women's work as creating the land.[4]

As I prepared new art that built on that old painting, I thought about how even as some women till the earth, others in the Moroccan countryside forage for branches to light their cook stoves; a thankless, never-ending labor fortune has not required of me. Did their work encourage the forest to wither, making their treks for wood ever longer? Geographers and climate specialists debate this question as the Sahara expands and the globe warms because of humans burning wood, coal, and petrol. I thought of the heavy bundles of branches. Wood led to paper led to writing in my mind. Of all of the words I had gathered in years of fieldwork, how many had I bundled into an article or book? I began to write: "gather wood, gather words." I repeated that action. I typed the phrase in different languages. I printed it on heavy cotton paper, all the while reflecting on invisible labor and what never seemed to change. Thinking about work and words, texts and women doing fieldwork, I took out my old notes and artworks and considered the scissor strokes I'd used to cut strands of paper like hair. I cut paper into strips and lashed them together, gathering them on the canvas.

Then, I read a tragic news story from the Northern Moroccan city of Larache, not far from the fields that inspired me to paint two decades earlier. Teenager Amina Al Filali committed suicide there after being forced to marry

**66** Second wave

**FIGURE 3.2** "Gather Wood, Gather Words; *al-'Arousa*" (The Bride), 2012. Acrylic, ink, and paper on canvas. Photograph by Nigel Tribbeck.

the old man who had raped her. Reading about this tragedy, I reflected on the shape I had fashioned of the strips of paper on the canvas. The "branches" bundled at its center suggested a bundle of wheat or wood, or a female form. Research showed me that the shape had a symbolic male counterpart: the *fasces* is made of sheaves of grain gathered at the center with axe heads attached to each end of the bundle. Also known as a *bipennis*, it is a symbol of power that goes back to the Etruscans. In Rome, it symbolized the power of the magistrate. The name of Mussolini's "fascists" derives from it. It is displayed behind the podium of the US House of Representatives.

I read another article about Amina Al Filali and the protests her death had sparked. I thought of the judge who based his decision to let her aggressor/ husband go free based on written laws, with the imprimatur of state and religion.[5] Some words go up in smoke, and others write the law. I began to paint red lines around the "waist" of the bundle, recalling the skirts that shaped the Mediterranean triptych. This time, they became a crimson bridal belt. Was it an actual line of blood I suggested with the paint, or a comment on patriarchal bloodlines? Is that other bit of paper to the side of the bundle a measuring stick? The sharp sliver of the judge's voice pronouncing the innocence of the rapist?

The bundle/figure in "Gather Wood, Gather Words; *al-'Arousa* (The Bride)" is a portrait and an account of an event, a reflection on what never changes, on rape and exploitation and bondage, but also an appeal to notice the skirt strings that make the world. It is all of this and something else. The work of art creates an imaginative object that is new. It resists efforts to establish a one-on-one correspondence between it and something "in the world." The work is not conceived as an ideal-type or a generalization of my findings in the field. It is not typical, but composite: perhaps similar to a poem that condenses meanings in syllables by stringing one word to another, allowing a particular play among the letters.

Set beside "Window # 1," "Tables et Tabliers," and other early works on paper for "The Fabric of Fieldwork" at the Brunei gallery at the School of Oriental and African Studies (SOAS), the connections to the earlier works on paper became visible.[6] The old and new drawings, paintings, and collages offered sometimes complimentary, sometimes dissimilar, illustrations of the evolution of my artmaking in relation to fieldwork. It opened up further avenues for exploring and attending to these.

My work was supposed to develop an exchange with WESSIELING's work to reimagine the gallery as a field site. By bringing together art we made in the course of a study of fashion and labor in Asia (Wessie) and research on domestic work in Morocco (me) we sought to "offer a glimpse into the process by which aesthetic creation can participate in the making of knowledge in the field of research." We stated that "the activity of the artist/

ethnographer emerges in works of art not simply as a participant in an already constituted site, but as a place maker." We proposed an experiment to a group of anthropologists, artists, and critics. The day after the opening would be a "field day." To prepare for that day we did nothing to alter the exhibition, but simply renamed it a field site. We asked them to approach the gallery as they might any fieldwork situation. We were, on hand, throughout the day to answer questions about our work in and beyond the gallery. On day three, we held a seminar to compare field notes.[7]

We assumed that nearly ten years after the trailblazing *Fieldworks across Anthropology and Art* conference Arnd Schenider and Chris Wright organized at the Tate Modern Museum in 2003, some of the tensions and turf wars between our twin disciplines would have dissipated. We expected that the dialogue they encouraged would allow those for whom we had become informants to focus on our work in order to enhance collective discussions. One review by an artist Natalia Zagorska Thomas suggests that this was not the case.

> It is interesting that although much of ethnographic and anthropological research involves the study of material culture, there was a real difficulty in finding common language to discuss visual material and a marked resistance to the notion of an artwork as a complete outcome in itself. Perhaps part of the problem encountered here is the popular perception that the creative process is mysterious and messy … What was interesting is the repeated implication that artists and their work are a subject of study, not partners in discussion. The seminar revealed a fundamental lack of understanding, among some of the academics present, of the mechanisms by which visual art is created and a confusion about the purpose of the outcome.[8]

Some of the anthropologists thought the opposite: it was the artists who knew nothing about recent developments in reflexive and critical ethnography. They were stuck with the image of a discipline focused on the exotic, the other, the Orientalized and reified. During the seminar, an art critic told me that works like "Window # 1" were "so dated." They were indeed produced 20 years earlier, so I think she simply meant she did not like them.[9] Could art be subordinated to fieldwork and still be good? I wondered. Could it be of interest without direct reference to prevailing trends? I thought so.

Such questions lurked in the way some of the critics approached the exhibition and the anthropologist's approach to it. Generally, what art might be in the context of fieldwork, or how field design might sharpen the lines of artistic production remained a question.

Anna Laine's exhibition of her *Kolam* art/anthropology research was on view in a different room in the gallery at the same time as ours. She attended the seminar and later read Zagorska's review, and also commented on some of the sources

of misunderstanding between our two disciplines. She noted particularly that Zagorska wrote about how

> collaboration between artists and physical and natural sciences seems more productive than that between artists and scholars within the humanities and social sciences and she ascribes this notion to a need within the latter field, present at the seminar, to counteract criticisms by popular culture and the 'hard sciences' for lack of scientific rigour and therefore approach artists and artworks as subjects of study rather than research partners. While this might be the opinion of some, it is also possible that artists hold that associations with the 'hard sciences' are more prestigious and enhance their possibility to be publically legitimated as researchers.[10]

Where we had hoped to present the exhibition as a post-disciplinary terrain, the result was mired in a progressive subsidence of the blended field we sought to create in the gallery. Would it have changed had the seminar been held in the gallery rather than held off-site? There our work might have evoked common questions to fill in some of these deeply entrenched reactions. It seemed that keeping to the subject matter, creating, and dwelling in a shared space with stakes beyond comparing some reified notion of this or that discipline might be a way forward. As I reflected on these difficulties that other anthropologist-artists were also encountering, I wondered if we might have developed the exhibition in a way that would have made conversations less predictable. Could field design methods be employed to craft a more compelling terrain for dialogue? It seemed that fieldwork's special resources for observing and analyzing scenes and situations could be turned to creating spaces and occasions where both anthropological and art world discourses might be productively displaced, or fruitfully intermingle.[11]

Perhaps the goals of the project in London had been too diverse or woven of too broad a cloth. The texts that explained the exhibition in the gallery, invitations, and announcements in the invitation described the exhibition as a meeting of Asia and North Africa through art that was composed through fieldwork. They had not evolved as the art had progressed since we had conceived the exhibition proposal. WESSIELING had not presented the work developed through the fieldwork she had originally proposed but instead substituted new work composed of texts of English-language advertisements for items of clothing and shoes. Artists often shift out work as they hang an exhibition. However, this confused the people we asked to study the gallery as a fieldwork exercise. Instead of focusing dialogue on the exhibition as it was announced, participants were left to their own devices and disciplinary reflexes. This made me realize that to fashion a gallery/field as a cross-disciplinary terrain, the elements and the methods needed to be more clearly set out, even if that meant abandoning some curatorial flexibility. As I set about shaping a new collective experiment, I thought back on

**70** Second wave

all of this to ponder ways of producing more concrete, exhibition-focused kinds of research and dialogue.

## Back to the washboard

While "The Fabric of Fieldwork" was a double glance toward the past, "On the Line" was conceived to generate new work. It would move forward step by step beginning with my solo exhibition of the art I had made on my patio. Using that exhibition as a basis, I would then have artists and anthropologists work together to respond by making their own "laundry" art in response to it. I reasoned that the experience of working to make art and remake the exhibition would lead people to set aside worries about disciplinary boundaries. With a task to accomplish together and using the exhibition as a shared point of reference, the stage would be set for cooperation in a third stage of fieldwork when we might move beyond the gallery and the university together. Working slowly, in a progressive, recurrent, ethnographically informed way had worked for the Rabat interdisciplinary collective. In California, the project should similarly allow time to accumulate common references and possibilities for collaborative or counter punctual practices.

From the start, the project was tightly knotted around the practice of washing and hanging laundry. Focusing on this topic, I tried different frames, scales, and materials to work out the different aspects of the project I set out for myself and then, for the others. Anywhere someone washed and clipped a sheet to the line, my field site was activated. This attention to gesture and practice harkened back to anthropological classics and work I'd done in Morocco, but also drew on newer ideas; I think of how Yves Jeanneret was conceptualizing "triviality" at the time.[12] I further explored gestures of washing, bending, hanging, and folding, going back to notions of body techniques I explored in beauty salons, but also taking the idea of painting as "old art" to heart. "Old" art seemed appropriate to study a disappearing practice. With nimble, lingering, passionate hands, painters in the European tradition had often chosen to demonstrate their dexterity and skills of observation by painting the luscious, sensual, thick, or filmy clothes of wealthy clients or the modest home environments they took as their subjects.[13] I thought about the weight of folds of fresh smelling sheets: I noticed how the laundry lines framed the changing sky. I created large multi-panel paintings using the classical techniques; they offered me an immersive experience as I painted. That experience provoked other kinds of memory work and art in other media.

"What Goes Unsaid" is an installation composed of five large organza bags filled with texts and pictures cut in ribbons and tatters. It exposes my field notes and sketches, unpublished articles or unsent letters, photographs and interviews to view, while also veiling them. There are few complete sentences in the mix. Still, the contents of the large envelopes are legible to anyone who could decipher my handwriting or read the languages of the printed texts.

For the first exhibition, the bags were hung in a straight line, with space to walk between them. Considering the biographic nature of the work, a viewer might have imagined the regular spaces between them as temporal intervals. But the remnants in the bags were not collected following a time-line. The aim was not to reconstruct my story in a biographical way, but to propose this collection that was entirely mine as a generalized reflection on remnants and remainders and what is not rendered public. These remainders invited reflection on "hanging out one's dirty laundry." They asked: What is worth keeping? What is dirty and what is clean? What did it mean to show but also conceal?[14]

I probed issues of gender and labor and studied the social life around washing days. In California, one might feel nostalgia for the work of washing and hanging clothes on the line. But folklore also conjured other ideas about how that form of remembrance can obscure the hard labor it celebrates. Where and when does your laundry get washed? By whom?[15] Washing clothes and hanging them to dry in the open air can be romanticized. But it is also a task that brings out issues of gender and class. And laundry day may not have always been a happy occasion. Consider the way that color takes on racial overtones in this jump rope song:

> My mother and your mother were hanging up clothes.
> My mother punched your mother right in the nose.
> What color blood came out?
> Blue, Red, Yellow, Green…
>
> The colors are repeated until a child steps on the rope, determining the color of the mother's blood.

I took the child's perspective to study social gatherings around work. In contrast to other works prompted by laundry blowing in the wind, for which I'd carefully mixed luscious, complex, subtle colors on my palette, I used primary colors for this part of the project. Associations of baskets of wet clothes with gossip exchanged around the line arose in my memory. Using acrylic paint and markers, I sought to capture the buzz of talk that laboring alongside others tends to produce. I worked with blue, red, yellow, and green to reference the color-conveyed hostility I recalled from my youth and observed in the present-day. I scattered paper clothespins across the picture to suggest a moment of conflict or a strong wind.

Then I worked with organza. This time, I printed and wrote out snippets of talk around the themes of borders and blood, and instead of letting them move freely, I fused the back and front of two envelope/sheets, fixing the words between them. Clothespins extend beyond the edges of each of them: hung on a line with real clothespins, they point menacing fingers at one another.

**72** Second wave

**FIGURE 3.3** "My Mother Your Mother, What Color?" Acrylic, ink, and paper on canvas. 36" × 96". Photograph by Nathaniel Goodwin.

**FIGURE 3.4** Detail, "My Mother Your Mother, What Color?" # 2, organza, paper, ink and acrylic. Photograph by Yvonne Polk Ocasio.

## Exhibition as proposal

The project of making art the main method and outcome of research and the exhibition in the gallery its mode of publication was still new to me. Experimenting with bringing art and anthropology together in "On the Line" was exciting, but I was also doubly vulnerable. Which standards would artist, critics and scholars apply to this work? As I developed the exhibition, I thought about how to offer different ways of moving through the gallery, while maintaining a sense of the multiple yet related aspects of the project, and clotheslines. I knew that the people who would see the exhibition at this well-appointed campus venue would be comfortable with the conventions of both gallery exhibitions and academia. I also kept in mind that while some of those engaged in the experiment would be artists, many others were more predisposed to formulating wordy arguments than to using color and flowing lines to work out their ideas and feelings. I conceived the texts I wrote for the exhibition as signposts for myself, for viewers, and for future collaborators alike. I wrote the texts that set out the different sections of the exhibition in the form of a poetic grant proposal.

I introduced the concept:

> In this exhibition, I contemplate clotheslines to investigate lines of all kinds. Miming the hanging of laundry in painted gestures, I catch the words of women who exchange gossip on terraces or tell secrets across backyard fences as they hang their clothes to dry. Sheets in the breeze are like sails; they catch the wind and find direction through what tethers

**74** Second wave

them. Ropes, ties, knots, and belts are points of connection. They conjure other lines: of thought, action and performance.

I set out the argument:

> Anthropologists often associate body techniques with particular cultures or epochs while situating human universals at a deeper level associated with biological and cognitive processes. This work considers continuities of bodily experience and sensuous imagination that are so widespread and banal as to escape notice by those seeking significance, and too concrete to be considered by those seeking humanity's fundamental dispositions. This is not work that requires special skills or training; yet I find in the remnants of a once nearly universal chore a way of working on memory, time, and reproduction.

I explained why I was qualified to undertake this work and the evolution of the project:

> This project started in Morocco in the 1990s. It evolved as I lived, worked, and carried out research on media and politics, gender, and aesthetics in North Africa, Europe, and North America. "On the Line" registers my own experience of seeing a practice I took for granted in my other homelands interpreted as a survival from the past when I moved to Southern California.

And I clarified its relevance:

> Paintings poetically turn mountains and deserts into bits of cloth hung out to dry against the relentless blue sky of Southern California, subordinating the land to lines that evoke but challenge the grounded flux of freeways, aqueducts, or shadows cast by airline routes.
>
> Some people persist in this outdated practice for reasons of energy efficiency or ecology. The exhibition registers this appeal to reason, but suggests that it is not just energy that is lost when we fail to use the natural heat of the desert to dry our clothes.
>
> Some works evoke notions of purity and intimacy, family and propriety by reference to the metaphorical uses of laundry talk to wonder which social bindings are loosened when we dry clothes in the secrecy of our homes.[16]

With its movable walls and distinct zones, the gallery allowed me to group the work according to the themes I had enumerated.

## Viewing

In her review of the exhibition, poet and critic Jacqueline Balderama wrote:

> The size of several of these painting was thrilling. The largest ran about 10-feet long and nine-feet tall. It also seemed a popular approach for a single

work to be composed of multiple canvases. This was the case for "Caught In The Sheets" (2012), an oil on canvas piece with massive pink, yellow and brown spaces unraveled by blue and chaotic pink lines. It is composed of six large canvases—three long and two wide—resting side by side. This method did not interrupt the work, but rather seemed to speak to the idea of clothes coming off lines just as paintings are hung and removed from walls. Placing several canvases beside one another was used again for the second largest work, "Winter Wash," oil on four large canvases. Cold blues and black lines ebb from white sail-like shapes held in place by dashes of color representing clothespins. Here, a lot of energy spurts from the rubbing of yellow and blue, suggesting outside forces are commanding these forms, perhaps something more than wind and weather.[17]

Focusing on the paint, and working on a large scale, particularly in the section of the exhibition focused on memory, led to a certain abstraction. To view the whole required stepping back. Details drew one to approach and details required you to move close, as though to immerse yourself in the flux. Sometimes it was the "feeling" of the laundry that came through first.

This was especially the case for those who wanted to view the art before reading the texts that accompanied the exhibition. From my notes from the exhibition opening:

> A stylish, raven-haired woman walks quickly into the gallery to meet a group of three people. I am one of them. Her eyes move from one face to another, greeting each with her eyes. We say hello but everyone is distracted, immersed in the color and line of the paintings that surround us. "What marvelous, exciting colors and flowing lines, the movement whirls you around; kind of a thrill," the chic newcomer says, moving her hands from her left shoulder to her right hip, following a line that crosses the several canvases that compose one painting. Her hands, then her arms chased one another, on the trail of the brush strokes; "beautiful, who is the artist?" I introduced myself. She quickly glanced at another work, congratulated me on the exhibition, and then stopped abruptly, "Laundry! Oh, my God this is all laundry! It's alive; moving in the wind. It takes me back to my childhood in Buenos Aires."

The focusing power of the words in a title became apparent to me when I noticed an elderly man who had paused in front of "Winter Wash," rubbing his hands together. He told me how his mother's hands became red and bled when she did laundry as winter approached in New England. She had to break the ice on the barrel of water. Then, she scrubbed the clothes on the washboard. The dry clothes crackled when he helped her to fold them. Was it October? November? Whatever month, it was time to begin hanging laundry in the cellar, forsaking the fresh scent of the open air for the musty damp of winter.

**76** Second wave

Art openings produce talk in ways as patterned and sometimes predictable as the project talk of scholars. But the presence of the art offers unique opportunities to look at one's work alongside one's audience. This looking together is emotionally powerful. The immediacy of the art in its materiality calls forth a potential for shared feeling as well as conversation. This intensity is ephemeral, yet often lasting in the artist's consciousness and practice. An exhibition might be critiqued, prolonging its effects and adding to the feedback that might generate further work. Individual viewings follow the sociability of the opening. A catalogue might document an exhibition. Or it might even travel. But the exhibition remains a time-sensitive performance. It is time to move on to consider how the exhibition lived on in new ways with the "Second Look."

## Not being there

In London, for "The Fabric of Fieldwork," Ling and I invited artists and anthropologists to make the gallery and exhibition a field for a day. We made ourselves available for questions: like the art, we were subjects to be studied. For "The Second Look," those who responded to my work did not make my fieldwork trajectory or me in the gallery an object of investigation. Instead, they pursued work on the same subject I had. They had the task of responding to my proposal, of making something new of it and exhibiting it. They had the support of the collective to take on this task, which was daunting for many of them.

In the graduate seminar on campus, we read about anthropologists who work through art, and artists who do ethnography. Tim Ingold has written about how he alternates lecture and hands-on exercises in knotting or walking, for instance, to develop "understanding in practice" with his anthropology students.[18] I devised similar alternatives in the seminar, asking each person to explore practices that were new to them.[19] The alternation of seminar and studio formats, drawing and reading, mingling of practice and theory set the stage for exploring emerging ways of construing exhibitions and collaborative programs that associated or blended the two disciplines.[20] More specifically, we studied how patterns of call and response and mimesis traverse both scholarly and artistic practices. As Mejia-Krumbein wrote to me later, the

> multi-disciplinary collaboration enriched the collaborators in each discipline and enhanced the communication by the use and understanding of the diverse disciplines vocabulary. Also, it opened a dialogue questioning the roles of the disciplines in the project, the hierarchy and the roles they play, and the integrity of the art as collaborator versus a visual mediator to convey the findings of the research … In my role of artist-communicator, my horizon expanded, I felt comfortable dealing with such collaborations and looking forward to continue searching in this direction.[21]

What would this call and response method produce? As the mimetic process of developing "The Second Look" began, I was naturally extremely curious, but I had to step aside.[22] I had made my proposal. I busied myself with invitations for the seminar that would follow the second opening, and conclude this stage of the project. Beatriz became the key consultant and go-to person for the students as they began to work with the four artists and the anthropology, sociology, and history professors who joined the experiment.[23] Working with someone they had gotten to know and trust assuaged students' reservations about modifying the exhibition of their professor.[24] Besides, given Mejia-Krumbein's long experience in teaching art and curating, and as gallerist, this was entirely fitting.

As for me, I shifted from being a teacher and coordinator and the proposer of the exhibition, to being the author of something more like a score or an equation. I absented myself from the space I had made. But I remained as the creator of the field that generated the theme and rhythm of the work of the artists and students. My work had to speak for itself in my absence, within the possibilities for work in common the particular parameters of the experiment.

I had set out these parameters, the theme, made the art, and brought it together in the exhibition as a proposal. I rightly felt responsible for what would happen in my absence.

## Moments of publication

When I entered the gallery to view "The Second Look," I was elated, proud, and satisfied. Perhaps the mingled emotions were similar to the way architects might feel when they observe people furnishing and decorating a home they have designed. Except that few builders would revel in having the walls they drew removed, and their carefully thought-out floor plans redrawn, which is what happened to my exhibition. As for me, I felt privileged by the opportunity the artists and students gave me to reconsider and review my own work. The generative capacity of the topic, the work, or both, was apparent in most of the individual pieces. The movements and themes of my work-as-proposal were amplified and rendered more complex by the diversity of artists and the way the group had created a consistent, focused new arrangement. The coherence of the new layout spoke to the efficacy of the way the students had thought about the gallery as a field site, including for pursuing further research that would inform further iterations of the project.

Artist Duncan Simcoe's bold sculptures suggesting enormous dryer drums added a sense of rotation to the main exhibition space. Their dynamism and evocations of energy and machines were reflected in Shahab Malik's video "Power Lines." Malik, who was writing a dissertation on the training of American Imam's in Egypt, used my painting "Christo's laundry" as a screen to project scenes of women hanging laundry and working in the fields with the churning image of the agitator of a mechanical washer. The video

**78** Second wave

images set the painting in motion, melding the moving image and the brush strokes to affect a swaying of sheets in the wind. It evoked hard labor in the past or in present far-off fields, contrasting the frenetic, unvarying pace of machine-driven life. Jared Katz, an archeologist who studies ancient Mayan music, layered Malik's work with a musical composition. One flute followed the other like twin birds flying along the lines of the painting. The notes were like the brush strokes and like one sheet blowing over another in the wind. The two men said they'd worked separately. The composite work had not been planned. It was only in the process of developing the exhibition that it "all came together." Yet it perfectly illustrated the potential for collaborative, multimodal work fostered by a project that made experimenting productive by tightly weaving the project around a single topic. The subject matter had to be rich enough to allow for this: as our work proceeded, it became abundantly clear that laundry was such a subject. Indeed, it presented opportunities to explore so many strands of social and cultural life that it could be considered what anthropologist Marcel Mauss called a "total social fact."

## Intimacy

In "The Second Look," the interplay of making and showing individual artworks and working as a group created instances for shared emotions. This was palpable throughout, but perhaps the strongest and most poignant moment came when fabric artist Monica Landeros explained her installation/reaction to my organza memory collection.[25] At the artist walk-through before the final seminar, she told us why the delicate electrocardiograms embroidered across the hearts of hand-made cream-colored children's clothes became straight and black across the smallest dress.[26] She had lost a child. She could barely talk about her art. But the work itself was extraordinarily powerful and spoke for in itself. Everyone in the room wept as we listened to her attempt to describe the pain that led her to make such delicate clothes with such precise stitches.

Two other new works added to and altered my gauzy memory envelopes quite directly. At the first opening, I saw that the "do not touch" associated with art as precious dissuaded all but the most experienced art aficionados from actually reading the texts. Now, artist Tim Musso added arrows to the floor to invite people to walk between the organza panels and to touch them. As viewers walked through the bags, they rustled as they passed, suggested the wind in the sheets or whispered secrets. And, as they moved to the far side, they met the cutout of a child created by archeologist German Loffler. From the child's perspective, the work seemed even larger and more immersive than to an adult. She was a playful interloper – tying together the child's perspective I'd developed in bright primary colors with the more graceful reflections of the work on respectability and revelation – in a game of hide-and-seek.

Call and response **79**

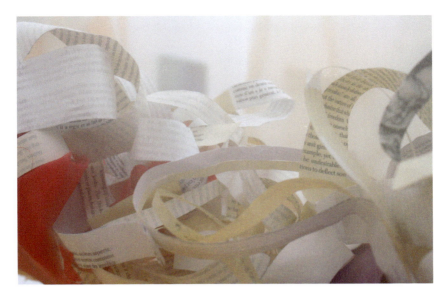

**FIGURE 3.5** Detail, "What Goes Unsaid." Photograph by Yvonne Polk Ocasio.

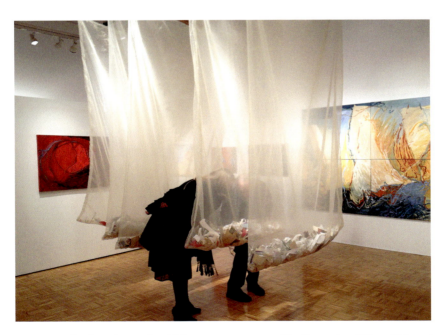

**FIGURE 3.6** "What Goes Unsaid," organza, paper, silk, 5 panels, 60" × 80" each. Photograph by Rayed Khedher.

**80** Second wave

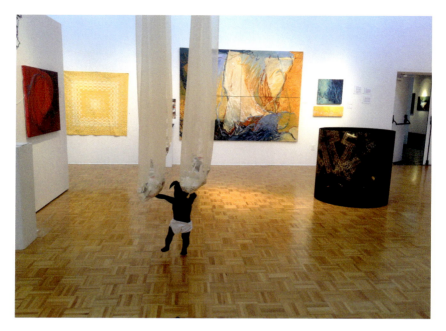

**FIGURE 3.7** View of "The Second Look." Photograph by Yvonne Polk Ocasio.

The Second Look artists and the audiences added to the collective momentum of the project. And then there was our artist/ethnographer/gallerist/advisor, Beatriz. She did not add a painting or drawing to the exhibition, but instead staged a performance to end this first stage of the program.

## Circular motion

At the very end of the seminar that concluded "The Second Look," all of the participants and the public gathered in the gallery one last time. Mejia-Krumbein left for a moment, and then reappeared in a white dress. It looked like it had feathers or petals attached to it; was she to become an exotic bird or a rare flower? She walked slowly to the center of the room and began to make the gestures of hanging clothes on the line. Conversation halted. She started speaking "Wishy washy, wishy washy, up and down, up and down," and her movements followed her song as it became a chant. She told a story about moving from Columbia to Germany, where her neighbor insisted on giving her "laundry lessons" so that she could pin her invisible sheets to the clothesline as one ought to do. We gathered around her as she ran between the "sheets" she made of thin air. She let us know they were suspended on a roof terrace. It was night in Medellin, where she was born. The stern voice of her aunt, a nun, rang out: "God will strike you children down if you soil the pure, newly washed sheets!"

FIGURE 3.8  Beatriz Mejia–Krumbein performing "Of the Same Fabric." Photograph by Yvonne Polk Ocasio.

As the artist performed bits of laundry stories from her life, she circled the audience and then moved close to one person after another. To each, she offered one of the detachable fluffy scarves that adorned her dress. When everyone had one, she asked us to join hands to form a circle. And then she led us in reciting the words inscribed on every one of them: "Of the same fabric," we read in unison. She had become the living thread to which we could all pin our laundry recollections and our untold stories.

I felt a weight fall off my shoulders. The experiment I had configured had worked; this was no longer my project alone. What might happen if the movement started by "Hang Dry" now rippled out to beyond the gallery, and the university, into new fields for broader publics? I contemplated how to channel the circular momentum of Beatriz's performance to respond to these questions, already envisioning a response to her performance.

When I worked amid salons, I followed existing flows of style and fashion and practice even if I swam upstream, against the cultural currents emanating from the cultural centers of Paris and Cairo. *On the Line* needed to generate movement where there was none. From "Hang Dry" to "On the Line" and then "On the Line: A Second Look," we knit a tight circle of transdisciplinary practice and relationships. We forged the methods and created the momentum to forward our experiment and expand the circle beyond the university and the art world.

**FIGURE 4.1** "Chergui," Winds of Life Series. Oil on canvas, 36" × 60". Photograph by Nathaniel Goodwin.

# 4

# VIBRANT CIRCLES

Layering "On the Line" with "The Second Look" created a storyline. What next? I wondered. Others asked me, too.

I thought more about the way art creates narratives. There are artworks that include written or recorded stories. Others use the gallery as a frame for marking the passage of time, using materials that shift, decompose, or even come alive. Then there are stories of artists working together to make a single piece, and the public co-composing work in or out of the gallery. Every exhibition had many stories to tell: how it was made or how it traveled from museum to museum.

As I contemplated this next stage, I kept painting on the patio. When violent Santa Ana winds whipped up the laundry on the line, I extended the movements of the desert's airstream to the paint brush in a gesture; an inquiry into how invisible forces and bodily sensations can become visible. Making "Santa Ana" revived memories of the hot, enervating Chergui that whips across Morocco from the Sahara. I painted that wind, too. A third painting followed the whirl of the Mistral as it rushes up the Rhone valley. As I worked, time fell away as the brush seemed to find its own direction and momentum. These excited moments of sensorial biography were forgetful of history. Was it the wind I painted, or the accumulated energy of shifts from one wind-swept afternoon or country to another? What would be the best way to move with the momentum created by the first chapters of *On the Line*?

I had the good fortune to meet Sue Roginski. The choreographer was already well known for her ability to facilitate dance performances in unlikely spaces from parks to cafes to trolley cars around the Inland Empire, the sprawling region just east of Los Angeles where Riverside is located. She and Casey Avaunt, a scholar-dancer working on a PhD at UC Riverside, were both interested in collaborating with visual artists and anthropologists. I was thrilled when Patrick

**84** Second wave

Brien, the director of the Riverside Arts council, called to offer the use of the "AfterImage Gallery" for February and March of 2014. In fact, the "gallery" was a vacant commercial space set between a threading salon and a Vietnamese restaurant in an outdoor mall. Management was letting the Arts Council use it until they found a new renter.

As the objective of redefining the empty shop as a hub for art took shape I began to look back at "The Second Look" as a warm-up for this new endeavor. It would be called "Hanging Out," a gesture to the idea of ethnography as "deep hanging out," and a description of what we intended to actually do.[1] The well-appointed university gallery had been a safe space for the cross-disciplinary experiment across anthropology and art. It had shown how anthropological lines of inquiry can focus artistic work and given the anthropologists a hands-on experience of art-making and insights into curating (in fact, some would go on to museum careers). The experiment had grown from an individual proposal to a collective response in a simple movement. A more complex design would be needed to engage exhibition with performance and to transform the empty store into a gallery/stage that could draw people in and encourage them to share their laundry stories. To associate these different goals for this stage of the cross-disciplinary experiment required an evolving script, with a design that would foster a productive counterpoint among these different practices and potential voices, to stimulate dialogues.[2]

Imagining what we could do in the ephemeral gallery, a space that could later become a sushi-to-go restaurant, or an ice cream parlor, my mind naturally turned to my earlier research. I thought of salons and what they had taught me about the configurations that bring people together: how these generate possibilities for sociability and self-fashioning. I thought back to how I had animated and led the IRMC in Rabat and to the activist and artistic models for gatherings that had inspired me. The first stages of the laundry project had focused on working on anthropological themes through art. That had led to further research not only in the studio, but also across Riverside and far beyond. Expanding the circle by turning the vacant shop into a space for art would require new on-site ethnographic research and art making, and further questioning of how the project could not just introduce "new publics" to our art, but engender dialogues that fed aesthetic and social experiments simultaneously.

Anthropologist and critical dance scholar Sally Ness has written about how semiological and structuralist ideas have too often "stilled" the ability of scholars to attend to the liveliness of things. She writes of this "liveliness" as an "unfolding, 'passing-on-ness' or temporal 'forward-ness'" and how it leads not only to new performances, but to becoming new kinds of performers.[3] The Second Look with its call and response had been a testing ground for such new performances. Now, "forward-ness" would require us to shape the places and times and forms of our work with greater attention to the environment. Issues of project design and projective ethnography would have to play a more prominent role.

## Guiding images

Anthropologist Keith Murphy writes that design has four features in common: "form, order, planning and intention."[4] As I imagined the overall shape of *On the Line*, I saw it as an animated target whose circular lines rippled outward from "Hang Dry." The centrifugal expansion would not be uniform: its rhythm would be punctuated by intervals of reflection, making, and research. With each event, the outward waves would become denser and more colorful as the circle widened to bring in new artists, practices, and publics.

Order and planning and improvisation would have to be tightly intermeshed to keep the revolving energy of call and response going, and to encourage feedback between art and performance and their diverse and shifting ways of engaging equally changing publics. The circle of the project could then be experienced in critical contrast to the typical movements of the mall, conventions of the gallery, and the flow of life as usual.

The task of setting up a program that would expand the circle was not one delineated by existing anthropological fieldwork manuals. Murphy goes on to write specifically about fieldwork designs, noting that "in anthropology two 'broadly distinct' senses of design have emerged." One associates design with static shapes or geometries; the other envisages "a complex domain of dynamic practice like the work of urban designers."[5] The image I had of the program was form-forward, but dynamic. How could it be otherwise for someone had dedicated years to studying movements and flows? The first exercise of making the shop into a gallery/magnet was indeed something like a project of urban planning, but it was more a rezoning or imaginative renovation than a new construction. Making the shop into a vibrant hub meant contending with the existing urban forms and the habits and forms of association they both assumed and engendered.

Everyone knows that in Southern California, life revolves around the automobile. The geography is vast and sprawling. Many people say that the horizontal expanse gives them a sense of freedom, but the freeways and broad boulevards are also objectively confining, and not only because of terrible congestion. They take most of the population along habitual paths. Work, school, the supermarket, and trips to the gas pump are separated by intervals of alone-time in the car. Driving, one city blends seamlessly into another. Still, highways and avenues cut lines across neighborhoods that largely follow census categories of race, ethnicity, and income level. So the sprawl is divided; no-go districts and comfort zones differ depending on a person's race, gender, and ethnicity. In California, shifts in neighborhoods are also overwritten by the border with Mexico. That line is present not simply on the map, but also in daily interactions between individuals and with institutions, not least among them ICE (Immigration and Customs Enforcement).

There are a few places where people of different backgrounds and classes cross paths. Malls can be one of these; public colleges and universities are others. As its

**86** Second wave

name suggests, the University Village Mall is frequented by students from UC Riverside; local residents also go there for a haircut or to see a movie or the bank. It offers many services but no supermarkets, drug stores, or discount stores: those can be found a few blocks away. Neither does it include clothing or shoe shops, or department stores. It is not a shopping destination. People sometimes sit down to eat, but besides a few students studying at a Starbucks, it is a place of quick comings and goings. The mall is a crossroads, but never for very long. Our aim would be to get *some* people to stop, come in, and play a part in making the empty shop a magnet. As with most ethnography, our goal was not to amass a huge crowd, or a representative cross section of the population, but the more modest aspiration of getting some people whose paths would not otherwise have crossed to dialogue through our laundry-centered art. We would curate the exhibition with this in mind.

I initiated a new seminar/studio. This time, everyone tried media and genres new to them in class, but specialized groups prepared the terrain for "Hanging Out." We put out a call for art and curated the exhibition in relation to the work of the "ethnography team," who analyzed the circulations and schedules, and gathering points of the mall. An "events" group set the dates and times for performances and participatory activities in collaboration with the ethnographers. A closing/conference would bring artists and scholars to the exhibition to experience it and some of the performances. These performances in turn drew on the two earlier exhibitions and the ethnographic work to continue the *On the Line* research and its unfolding narrative.[6]

## The art scene

The presence of the researchers around the mall ignited curiosity among employees in the shops. As the date of the opening drew close, the event team sent out invitations and flyers and posted announcements. When we taped the exhibition poster face-out on the window of the former store, passersby stopped to read it and peered in to see what we were up to. A cashier, a student, and a baker knocked on the door while we were stringing installations from the ceiling; we asked them to come back once we finished. When they returned, they saw the same poster hung in a line with the posters from the previous exhibitions. Then came the original painting "Hang Dry." These were accompanied by texts that traced the development of the project. Visitors could thus situate the exhibition as part of a larger movement whose evolution was also integral to the curation and lay out of the exhibition.

The long rectangle of the main room spun around the white dress Mejia-Krumbein had worn for the closing performance of "The Second Look"; the diaphanous "My Mother Your Mother # 2" stretched behind it like wings or a veil with its dangerous clothespins. On the window side of the gallery space, natural light illuminated a gorgeous, full-length gown with a heavily embroidered red circle on the belly: Monica Landeros's dramatic addition to the

electrocardiogram-embroidered children's clothes. Musicologist Elizabeth Stella's multi-color installation of dryer sheets and tiny graphs of the sound waves of a conversation about laundering diapers floated beside it, diffusing the scent of fabric softener into the room. It seemed to speak to the similar hues of the intricate patterns on the handmade paper of Carol Hendrickson's installation "Traje Suite," inspired by years of fieldwork on weaving in Guatemala. Anthropologist Anh Lyn's antique ironing board was strewn with "laundry" postcards and handwritten texts contributed by seminar members; visitors were invited to add their own story. The sinuous lines of Los Angeles artist Jimmy Centano's welded steel sculpture "Tendedero" was hung with personal relics. His personal memory artwork would become a partner for dancers; they moved amidst the sculpture's wires and poles and Centano's private notes, extending the collective reflection on secrets and revelations.

When performances commenced on opening night, the group of jazz musicians set up in front of an enormous quilt painting of a woman draped in a cloak, sheet, or blanket by Mejia-Krumbien. My "wind" paintings were grouped together to one side of it. It looked like they whirled and spun as the musicians began to play and people entered the gallery, viewed the art, chatted about washing clothes, and enjoyed snacks. The room grew silent when writer Deborah Durham stepped to the microphone to recount the gripping, tragic story of a Kentucky farm boy in the 1920s who fell into a boiling pot of laundry. Time stood still as Durham took on the voice of the boy's sister, telling of his agony and death three days later. Tears prepared us to experience the work of the dancers accompanied by a score composed of laundry stories.[7]

**FIGURE 4.2** Visitors viewing Monica Landeros' "Heart Beats" at "Hanging Out." Photograph by Anh Ly.

**88** Second wave

## Materials

The first two exhibitions were short on talk by design. Working with pen and ink, paint or cloth, the academics and students moved in new ways, or with media new to them. They responded with color, line, and moving images to explore alternatives to setting one word after another to form a sentence, an argument, or a story. The initial stages of *On the Line* focused on exploring anthropological questions about ecology, social life, memory, and sensation using paint, photographs, sound records or cloth. For "Hanging Out," words would become an essential medium. In the seminar, I asked everyone to remember their own laundry stories and then to record a laundry story of a friend, a family member, or a neighbor; transcribe it; and share it with the group. The dancers did the same. We recorded stories about clotheslines, washboards, Laundromats, launderettes, and washeterias. Like a pile of laundry in a basket, the stories came in many shapes, sizes, and colors; some were as vivid and detailed as scenes in romantic novels; others were short, poetic haikus. Many people spoke of deeply personal, emotionally charged memories, of love, resentment, fear, longing, jealousy – they were all there. And there was humor: "With all the research you've done, have you figured out how dryers make socks vanish?" This collection would be the basis for shaping critical practices across art and anthropology, music, and dance.

Consider how we worked with one of the most widespread research practices of social scientists: the interview. I have described how audiotaping interviews was nearly impossible for me when I did fieldwork in Morocco and how this led me to develop alternative modes of listening and recording, eventually leading me to the beauty salon. In twentieth-century America, on the other hand, the interview, the survey, and the life story are all widely occurring cultural forms. Anthropologist Charles Briggs's study of these has led anthropologists to think critically about them, and to other ways of producing talk during fieldwork.[8] The laundry stories we recorded included significant bits of biography. But we did not ask, "Who are you?" or "Where were you born?" We did not ask, "What did you see?" or "What is your opinion?" Unlike a marketing survey about a brand of soap or fabric softener, or an interview by a reporter, our goal was not to push a product, or collect perspectives on a particular event or issue. We simply asked interviewees to tell us anything that washing, drying, ironing, or folding brought to mind.

Memories of a grandmother or a country, socializing around the clothesline or at a Laundromat, expressing their love for their new digital dryer led to longer stories that did not follow the conventions of the interview or the life story. Starting with laundry brought out a different aesthetic. It allowed voices to catch on emotions and accents to suggest more particular attachments and identities than the categories of race, class, and gender that are standard, expected, and thus well rehearsed in standard social research situations. The tone, emotion, pace, and style of each voice added to the whole – but each equally exceeded generalization. Weaving them together could shape a context and produce art that held out the possibility of including everyone's voice and story. The work could remain emotion-laden and intimate, while also being part of the larger picture and collective experience.

## Social imaginations

The choreographers involved in the exhibition asked composer and musicologist Dhiren Panikker to develop a soundtrack with the collected laundry talk. "The result," they wrote, "was a score in which slivers of voices were sometimes distinct, sometimes covered by other sounds." As the dancers worked to "develop movement scores that complemented these shared-sound moments," they also had access to the original recordings and added their own stories to them.[9] This layered listening and collective reflection, added to and mingled with viewing the work of the visual artists since the start of the program, focused the dancers' attention on the rich gestural repertoire of ordinary tasks. They formed piles, like laundry in a basket. They hung their bodies like towels. They wrung each other out like wet sheets. And they added their own stories into their movement choices.

Watching the dancers rehearse to this score brought Philip Glass's opera "Einstein on the Beach" to my mind.[10] Glass composed the epic work in 1975, collaborating with Robert Wilson, who wrote the libretto with texts by Christopher Knowles, Samuel M. Johnson, and choreographer Lucinda Childs. Music critic Mark Swed wrote in the *Los Angeles Times* that

> The overall structure is rigorously laid out, with scenes of a train, a bed, a building, a field, a space machine. Two scenes in the field, one with a doughnut-shaped flying saucer in the distance and one closer-up, contain formal Childs' choreography, her dancers racing and whirling as if propelled by Glass' exuberantly Minimalist yet complex and virtuosic score.[11]

The five-hour-long opera creates an atmospheric, immersive experience. The audience is free to come and go within the concert hall as motifs also enter, exit, then return in the score. A refrain of counting "one, two, three, four" returned like "slivers" to produce sound eddies of Glass's epic work. It came to mind as I watched the dancers in the once-empty shop become a gallery and performance size.

In contrast to circling around a great man, and history, the word "slivers" were bits of recordings of unknown people telling their own stories about an ordinary chore. The opera is a complex and virtuosic composition on a grand scale, performed on proscenium stages in major performance halls. The sound/dance piece for "Hanging Out" was conceived for five dancers to be danced in a nondescript space, amidst an exhibition, for a public that sometimes interpolated them and sometimes physically intervened in the choreography.

Why bother to contrast the work of graduate students and young local dancers to a breakthrough piece in the classical music repertoire? While it's fine to make and present such work to "the community," why bring scholarly resources and reflection to bear on such work? A music historian might ask if I shouldn't simply set aside such an odd comparison.

Glass is, of course, well known for transdisciplinary collaboration and taking contemporary music to unexpected venues like airports. Likewise, anthropologists

are known for bringing complex intellectual theories to bear on the study of the ordinary, the everyday and the out of the way. But besides this, I make this comparison as an audience member: "Hanging Out" left a stronger mark on me than the grand opera. The opera impressed me with its brilliance; it evoked historical themes familiar to me. I lived through some of the events it evoked. It stimulated my memory and senses in a very general way. But epics are not composed to include the stories of ordinary people like me. The dance composition made of laundry talk, on the other hand, drew out a different social imaginary. It left a place not only for me to join the general flow of historical events as part of a country or world population, but as someone with my own stories. The voice score evoked things I had done, seen, and experienced. And it left room for my own and others' stories to be layered into it. Whereas the opera was enveloping and radiantly alerted my senses to the scintillating brilliance of a great mind, the minor work in the mall showed me how my life might be woven in concert with others.

The dancers worked simultaneously with the full interviews, the history of *On the Line*, the voice-score, and their own laundry memories to develop their movement. Added to more interviews, identifying data about the person or life histories, the stories could have been analyzed by a step-by-step contextualization of the laundry within a cultural setting or a life: that would have been the usual anthropological reflex. But instead, art opened possibilities for considering connections by way of practices or memory gestures that transcended any cultural context or particular community. A single bass voice speaking in a calm, wistful tone blended into the lighthearted laugh of a soprano. "Slivers" of exclamation in Spanish followed a step-by-step explanation of washing nylon stockings in English, which cut to an emphatic whisper in a language I did not understand: perhaps Chinese. The time of performance was both "once upon a time" or "right now."

**FIGURE 4.3**  Dancers Samantha Carlso, Rebekah JoAnn Guerra, Valerie Mendez, Erica Johnson, and Lindsey Casco performing "Laundry Stories." Photograph by Anh Ly.

A catch in the voice, a bit of a song, an accent, a tone: the movements by the dancers added to the shape and emotion of the soundtrack to convey a range of shifting emotions to the crowd. Slivered in the composition, each of these bits maintained their force, while gaining in emotion and meaning as they layered onto others. This feeling included the energies generated by being a part of the circle, of following the progression of the performance with others, shoulder-to-shoulder, eye-to-eye, in the space that had already artistically channeled our attention to laundry as a multi-vocal common denominator. That circle was ready to feel the dance in their own limbs, even as they imaginatively added their own stories to the fragments of voices on the soundtrack, joining in an embodied and personal social reflection. The subject was not a singular individual, or the tenor of our historical moment, but the possible texture of a social fabric, one in which all of these tones and accents could be woven together in shifting patterns.

Building on the previous components of the gallery work, in the midst of the exhibition that they enlivened, the musician and dancers created an affectively moving experience of a fluid and inclusive social fabric. It was not a vision or utopian projection, but an embodied experience, an enactment. I realized how relevant this work was for social theory as well as for artistic collaboration.

The "Hanging Out" performance responded to and expanded the circle Mejia-Krumbein formed to conclude "The Second Look," when we declared that we were "of the same cloth." Now, we did not simply hold the same message in our hands and read it, but produced an embodied, imaginative understanding of what a complex and multi-colored social fabric might actually sound like, move like. From a message of universalism and commonality, we developed a layered, overlapping, fluid way of bringing voices together, becoming confident in our own varied movements. And this was not all: in a final act, we would all become actors, not to tell the story of an exemplary figure, but to speak out together with the words of others.

**FIGURE 4.4** Audience members gathering for a performance of "Hanging Out." Photograph by Anh Ly.

## Others' stories

As the voices of the score for the dance performance softened and the last dancer slowed her movements and melted into the audience, someone began to pass around a basket. It held slips of paper with written words on them. I read mine "Big clouds were rolling in. I wasn't sure if the clothes I was hanging would dry," I think it said.

Panikker grabbed a baton and assumed the posture of a conductor. He gestured toward one section of the room; a few voices softly read the words on their "script." He pointed to another section: the sound rose as people gained confidence in speaking. Soon the entire room was buzzing with the sound of voices speaking others' words. As his hand moved down, the repeated lines grew softer. His hands rose: our voices grew to a fortissimo. He relied on the most basic knowledge of the conventions of Western musical performance to lead us in a spontaneous composition made of the fragments of laundry talk.

At first, I read my text without much emotion. I just tried to say the words in the correct order. But as I repeated it, I felt myself becoming bolder and more engaged. I wondered whose story this was. How did it end? Gradually, through repetition, I forgot about the narrative and made the words my own. I suddenly felt at one with the lines I was saying, and responsible for them. I tried to say or sing or whisper each word clearly or beautifully or with passion. I noticed what happened if I dissolved the words into their component syllables, blending into the rainbow of voices around me. I felt a sense of satisfaction from performing the words of a stranger in my voice. As the conductor gestured toward the floor, voices lulled to a whisper. A flick of his baton and the music ceased. We looked around at one another, smiling. A sense of awe at what we had done saturated the room.

## Pin the wind

The Art Council's temporary, pop-up gallery had no staff. If we wanted passersby to stop in, someone had to open the door. So, I served as receptionist. When someone entered, I would go to the closet-cum-video-room to turn on the power so that they could watch artist Josette Dacosta's video. It depicted an enormous, house-sized painting flapping on a line between two houses in the Basque country as a storm threatened. I thought about how video and music had animated my painting "Christo's Laundry" at "The Second Look" now reduced to a single panel, appropriately placed beside "Hang Dry." It was draped with the once lavender, now multi-colored linen dress I wore while painting it. I thought of Christo and Jeanne-Claude's wrapped buildings and curtains strung across vast landscapes.

The portraits of specific life-winds evoked life-sites as whirls, pressures, bodily sensations. They were perhaps traces also of the élan I brought to *On the Line*, and that made me paint. These were energies difficult to define. With my urban sensibilities, perhaps it was simply a reaction to what I felt as a slowness, a horizontality, and a monotony of life in suburbia. The wind was fast, forceful, and intense. Perhaps it matched my inner state, and way of talking: flowing, yet often quick, sometimes sharp.

**FIGURE 4.5** "Pin the Wind," oil on canvas, 72" × 60". Photograph by Nathaniel Goodwin.

"Pin the Wind" conveys a different mood. In contrast to the intensity and forceful movement of the life winds, it suggests a gentle breeze. Brush strokes on the right side of the canvas draw the wind in gentle curves. Two prominent orange forms suggest clothespins, but the sharp dangers of earlier work were now blended, softened. They "attach" a moving landscape in a way that recalls the orange "broaches" of "Tables et Tabliers," the paintings on paper that I wrote about in Chapter 2. In this new, larger painting, the "pins" are magnified to stabilize other forms and lines that move around them, suggesting actions of various amplitudes, or threads wound of assorted materials and thicknesses. What poles and kinds of attachments might expand this work into the open field? Would the design of *On the Line* hold if it was taken out of the gallery and suspended where winds and breezes could alter it?

I often have students experiment with movement to explore theoretical ideas. In prepration for their participation in the next and final stage of *On the Line*, I took my anthropology class out to a broad lawn, gave them each a plastic bag, and had them "catch the wind." How do we understand and theorize what we cannot see? What is the actor and what is acted-upon when you are a body in the wind? How does this change when a plastic sack is added to the coupling of body and breeze? I was not sure how the students would react to this kinesthetic exercise for which they had prepared by reading a difficult theoretical article about agency in social theory. The breeze certainly acted its part: it was gentle

**94** Second wave

but consistent, with puffs from time to time. They set out to catch them, some moving where the wind led them, others holding still, watching the bag fill and flutter, like laundry on the line.

## Preparations

It took two years to obtain the funding and agreements and permissions necessary to take *On the Line* to the open field. There were grant proposals and budgets, further laundry research and a new call for artists. Most important, the choice of site was necessary to define our action.

At first I thought of working within the context of existing public gatherings: perhaps the festive *Cinqo de Mayo* celebration, or the biannual "City of Arts and Innovation" fair; both take place in the historic downtown city center. Then, the possibility of working with the Riverside Public Library came up. Instead of setting our work into a context defined by existing events, we would conceive free-standing exhibitions tethered to these vital institutions that in addition to books and reading provide computers, job boards, and assistance for filling out administrative forms, among other social services.

To introduce the public to our project and upcoming events, we first set up mini-exhibitions at the Arlanza, La Sierra, and Casa Blanca libraries. "Pin the Wind" hung at the La Sierra library for many months. I remember watching a little girl with a long, black braid and pink tennis shoes inspect the painting, and then the bilingual leaflets about *On the Line* on the desk below it, announcing upcoming events at different libraries in March, April, and May. There were also colorful bookmarkers featuring some of the art from previous exhibitions. The girl slipped one of them into the book she was preparing to borrow and moved to the check-out desk. My mind wandered back to when I was the girl's age, perhaps nine, or ten? My sister Linda had recently reminded me of how we used to play "library" in the basement as children. Yes, she recalled, to the astonished laughter of my brothers-in-law, "there was a card catalogue, tags to mark due dates in the back of the books, all neatly stacked on a shelf, following the Dewey decimal system. We took turns playing the roles of librarian and borrower." We played in the same corner of the musty basement where I had created my "art studio." We shifted the stacks of paper, color pastels, charcoal, and watercolors to the floor to make the art table into the "check-out desk." In Riverside, the librarians similarly shifted their books and papers so that we could install our exhibitions and announcements.

As we packed the materials we needed to create a gathering place in a parking lot, on a hillside and in a park, I thought about Germaine Tillion's memoir of fieldwork in the Aurès region of Algeria. To prepare for her first fieldwork there in 1934, she packed her bags with:

> a naturalist kit that would allowed us to impale birds and small mammals, to preserve insects and dry plants; as well as the anthropologist's dynamometer, a Martin's scale for the eyes, another scale for hair and skin, a

Pachon (sphygmographic oscillometer) for blood pressure (not to forget the platelets for blood types); a device for the surveyor/geometer; and another for carrying out tests for drawing and patience.[12]

I went down our checklist:

> A toolkit, several widths of tape, assorted nails, many yards of cotton rope, twine, chopsticks to anchor ropes to the ground, drawing implements for children, poles, boxes of clothespins, nails and hammers and a small shovel, a portable umbrella clothesline, a foldable easel or two. There were small posters to identify each artwork and a program with the artists' bios. The *On the Line* story and catalogues of past exhibitions. A speaker and microphone; bottles of water and sandwiches. A flyer with the list of works and order of performances. Brooms to clear debris from parking lots; hats for when the air grew warm and the sun beat down, umbrellas if it looked like rain.

From preparing to collect specimens of insects and plants and measure people, to hiring a film crew to record our unfolding site-making, preparations for work in the field had certainly changed. And yet, one thing we had in common with Tillion was that our plan simultaneously included multiple objectives; some that we could not predict in advance. Once "in the field," we all had to be there, and be ready for anything, together.[13]

## In the field

The clouds were dark on the morning of the first outdoor event. It began to drizzle.

**FIGURE 4.6** "Untitled," 2016, by Danielle Giudici Wallis. Photograph by the author.

**96** Second wave

But Danielle Giudici Wallis was ready. She had set up her tent. Literally. It was part of her artwork which was inspired by a 1950s Girl Scout Handbook. She sat on a tarp, a figure in the installation. She had everything you might need for a campsite: logs and a folding cup and an orange cone to mark off her spot in the parking lot. Following the Girl Scout motto, she was prepared. At least this appeared to be the case. In fact, each of these objects was knitted, crocheted, or stitched with yarn, so that they, and she, would be soaked in a downpour.

Rebecca Guerrero's colorful artworks were conceived in media that were perfect for the site and situation. The rain animated the long swathes of Mylar, and then a single ray pierced the clouds to turn the line of paintings about her travels into a row of stained-glass cathedral windows. The wetness of the rain didn't alter the long metal tubes that sculptor Mike Grandaw would assemble to make "Tensegrity." The large sculpture conceived by Nathanael Dorent and Manja van de Worp was a perfect fit for our outdoor clothesline reflections. The metal tubes were held by tensed together by wires: it was their tautness that snapped the sculpture into place in a second. Having the delicate connecting lines become the subtle strength behind the form was theoretically spot on, but when Grandaw attached the cables for the first time, they sagged. For the sculpture/hanger/background/ stage/jungle gym, this first meeting was a rehearsal for coming events, when Grandaw used a different kind of cable, and the piece snapped into place, growing larger and more complex each time, in synchrony with the program as a whole.

In Southern California, when it sprinkles, people say, "We're having weather." They stay home. Nonetheless, curious library patrons came over to view the art and watch the dancers from under the eaves of the building. Already loyal *On the Line* supporters showed up. It seemed an inauspicious start, but being in the field in the rain together with a small audience gave us time to be together and share ideas about our work. The program was not simply intended to bring art to new publics or out of doors. The point was also to further our art/anthropology experiment. The rain actually forwarded that goal. It prepared us for upcoming events, when weather was good, and we were all engaged with visitors and the progression of the performances.

For the second event at La Sierra Library, a team of undergraduates stretched several parallel ropes across the grassy hillside beside the library, which was on the corner of a residential street and a large boulevard. The slope provided a natural stage. People driving by rolled down their windows to ask what was going on. Some parked and came to view the exhibition. It was a windy day. Landeros' latest work, long ribbons of cut out figurines with a hole in the belly, billowed behind the dancers as they leapt up the hill, or shaped piles of laundry on the sidewalk. With the breeze and the ambient sounds of traffic and planes flying into a nearby municipal airport, it was hard for them to hear the music. Deb Durham's voice was clear as she told her laundry story, microphone in hand. She used the mic as a cue to shift from performance to story circle. The microphone began to travel from person to person, story to story, as the voices floated one upon another in the open air, rising above the ambient street sounds.

**FIGURE 4.7** Rebecca Guerrero setting up her "Postales de mis viajes/Postcards from my Travels," 2016, at the Casa Blanca Library with the help of student Suzanna Vargas. Photograph by the author.

By the time we arrived to set up the exhibition in the beautiful garden behind the Casa Blanca library in May, visitors from previous events were being woven into the art in the exhibition. Some audience members returned time and again, to witness the evolution of the project. They became experts in our repertoire and its evolution. Like music fans talking about a favorite band's original hits, or a novel guitar riff in a well-known song, they both encouraged and helped us to further develop the work. One might figure them as amateur ethnographers; their view was certainly more holistic than those of us immersed in making things happen. And, much as happens in typical fieldwork, some of them became personally implicated in ways they had not originally imagined.

Some of them became subjects for Sandra Cisneros who painted portraits on white tee-shirt fabric and hung them on a clothesline in an ever-expanding gallery. Artist Carrie Ida Edinger could only travel to California from the East Coast for the first meeting, but she remained present through an interactive blog that culminated in a raffle at the final exhibition; the winner received laundry supplies.[14] For the outdoor exhibitions, I placed a wicker basket, a table, and a chair next to the "What Goes Unsaid" installation. I invited visitors to write their own "unsaid words" and drop them in the hamper. After each exhibition, I used walnut ink to write their words on silk. The anonymous authors could now read their words written in my hand in a long stretch of silk organza hung next to my "What Goes Unsaid." Words like those I coyly tucked into those gauzy envelopes were now on the surface of the cloth thanks to a process that mirrored the revoicing of laundry stories for the final "Hanging Out" performance.

**98** Second wave

I thought of how Roginski and Avaunt asked dancers during rehearsals: "Is there a secret that you would only share with a close friend?" This question inspired the individual solos that opened their piece. One of the dancers shared the hidden memory behind her movement – "a secret love affair in an outdoor garden."[15] Outside, the dancers explored and exposed secrets as they focused on the theme of hanging one's dirty laundry on the line. Working in the rain, on hillsides and sidewalks and finally in a garden, their movements obviously had to shift and change. Certain moment-themes carried through from site to site, but each place presented unique possibilities for setting the stage for the dance. Each provoked specific associations for each dancer's improvisations.

Landeros, who had found it impossible to talk about her art about losing a child at the exhibition in the Brandsater gallery, arrived at the final event wearing an enormous circular hat decorated with the same female figurines with their bellies cut out she had used in her latest pieces. She confidently spoke to the large audience about the development of her work over the course of the project, finding words to express her pain and tell her story. As always, a circle of people gathered to share their own "laundry stories." Artist-poet Cindy Rinne was among them: she read some of the poems she had composed for the personal poetry readings she gave to individual members of the public throughout the program. Among these, one in particular spoke to me about the sense of animating security I felt in the circle we had formed.

"She was Safe."

This dragon of blue scales,
Called *Water-carrier*,
Puts out fires
Instead of starting them. After the snow
Melted, she watered the fields—
> painting the earth green
> There was only
One of her. The people made sure
she was safe.
Someone might try to harm
*Water-carrier*, thinking she had
> breath of fire.[16]

Perhaps I saw myself in the sapphire dragon. Some people had thought I stretched laundry on the line in defiance of progress or to mark my difference: in fact, it was simply a "survival" from the past that was sustained because I'd lived in places where the practice was still usual. I had dared to elevate that practice to show its relevance in this new home of mine, where people marked my words because my crisp diction didn't jibe with the drawling ease of Southern California accents. Fires? They were there already. There was no snow: it had to be imagined before it could be melted to paint the fields and dance across them.

## Endings

We planned to continue beyond our performances at the library sites. We had set dates for a concluding exhibition and a series of performances at the Riverside Metropolitan Museum in fall 2016. We hoped to share our work with the public in yet another way; it would also helped us to reflect further on the large circle formed by eddies of smaller circles, lines, and exchanges. Sadly, the project was abruptly stopped due to budget cuts. The museum closed for major renovations. And then I was off to Berlin.

I did return to California from Germany in November 2016 for a final public discussion and screening of Rashaun Richardson's creative documentary film about our work with the libraries. I had not planned it, but the final get-together coincided with a visit to the Bay Area to spend time with my father; he was dying. My memory is surely hazy because of that circumstance. What I do recall is a warm sensation that spread out from my heart to encompass the whole theater as I listened to the artists speak about the way in which the program stimulated their work, while audience members reminisced about their role in the experiment. They brought to mind the original image of the vibrant expanding circle, but now, instead of an imagined, virtual form, it felt like an iridescent fabric covered the room, holding me in a tender embrace. The step-by-step widening of the circle had generated dozens of artworks, a warm network of relationships and shifts in practice to produce experiences that encouraged dialogue across lines of many kinds.

A sense of always forgetting someone or some important aspect of the project has followed me as I have written about this work-wave. Writing, I am forced to aggressively trim and clip the purposefully multifaceted experience. Still, stringing words into sentences line after line leads me to notice how we became new kinds of performers, to return to Ness's formulation of that idea earlier in this chapter. Writing, I can explain how fieldwork, developed to study meaning and social organization, can also be conceived to critically apprehend and heighten awareness of these in ways that generate new objects and new significations. Outlining the design process, I propose *On the Line* as a reference or a possible example for others.[17]

I thought about the power of example when I read cultural critic Doris Sommers's book *The Work of Art in the World*. She wrote that "Exemplary agents of change investigate the spirals of power and passion to locate cracks and weak points where alternatives can open a wedge," and she then listed some of these agents: "Schiller, John Dewey, Herbert Marcuse, Paulo Friere, Antonio Gramsci, Augusto Boal, Antanas Mockus and Jacques Rancière."[18] I tried to imagine the action of the agents she listed as a matter of locating the thin spots in a kind of frozen lake of power. One would need intuition (or a GPS) to locate the weak points in the crystalline structure. One would need great strength to pry it open and reach the flowing waters of alternatives below the surface. I tried but could only imagine passion vanishing, increasing, or changing tone – but not cracking.

**100** Second wave

So, I set passion aside and returned to the irritation the professor's words produced in me regarding power and example.

Institutions or nations may be broken. Power might shift hands. But every revolution has shown that habits and ways of doing things tend to persist: or, even after some interval of fervor for change, to return. Perhaps it was not "being" exemplary, but producing ideas, models, or designs that studied and engaged these habit-forming processes that was in order. Perhaps one might effect change by otherwise layering and playing with ordinary materials to get at alternatives. Perhaps dialogues that include multiple languages and mixed practices can be fostered through careful attention to movements anyone can learn and encounters anyone might become a part of. Indeed, some of the men on Sommer's list have said as much. But did that make them "exemplary"? Perhaps there is more potential for life-affirming change if we consider examples as actions one might follow, or concepts that can be passed on.

Whether the expanding circle of *On the Line* will serve as a model for others to adjust and adapt to their aims remains to be seen. But it is time to leave behind that vibrant wave started by a painting that blended distant landscapes. I turn now to a wave of work that began with concept and through art, created a community.

# Third wave

# 5

## MOVING SUBJECTS

If the first wave started with a counter-current move into a global meeting place, and the second developed by attending to a practice in all of its many meanings and implications for connection, this wave of work began with a concept.

Where does a concept come from? To begin to study this third wave of research I must step back to look forward, beginning with the experience of being welcomed "home" to a city I hardly knew at a moment of national crisis.

It was September 2001 and I was unpacking cartons of books in my new office at Georgetown University. Somewhere between Paris and Washington D.C. two boxes had burst at the seams. The post had bundled them back together, mixed up my Susan Sontag and Flannery O'Connor with a slew of workbooks for Christian home schooling. Welcome to America, I thought as I separated out the creationist textbooks from books by Ibn Khaldun and Edward Said I would use for my seminar at The Center for Arab Studies. I realized I still hadn't ordered those texts at the campus bookstore, so I walked down the hall to ask Liz, the administrator, how that was done. She answered, "A plane just hit one of the Twin Towers." It took a moment to sink in. I joined the stunned, silent crowd in the TV lounge and watched the second plane hit the south tower. We must have cried out in unison, but memory now shrouds the scene in silence. I recall a sensation of being knocked breathless; a sense of impact and a shock wave; one word flashed in red letters in my mind's eye: IRAQ.

It took over an hour to drive the few miles home across the bridge to Northern Virginia, to Crystal City. I lived in one of several large apartment complexes located above extensive underground shops and passageways; someone told me that they had been designed as a safe space in case of nuclear war. Still, on September 12th, when I ventured down to the basement mall, the thick cloud of smoke from the Pentagon blast that had snaked through the metro tunnel still filled the darkened corridors.

**104** Third wave

Welcome home. In Washington, people I hardly knew asked how it felt to be in my own country, after 20-odd years abroad. By then, I had experienced so many returns, but Washington D.C. was new to me. It seemed I was expected to move with easy familiarity in this foreign place due to nationality and upbringing. Still, like any returned migrant, I'd missed out on decades of popular culture. The words people used had changed nation-wide. And naturally, there were significant regional differences – Chicago in the 1960s, the Bay Area in the 1970s: these were my reference points for the USA. I had kept up with academic and art trends in the anglosphere, but my life was part of histories being made elsewhere.

Washington is of course full of people out of place: immigrants from across America and diplomats of all nations. On campus, students hailed from every state; there were many international graduate students. However, I noticed that apart from a few outlier intellectuals and trust fund kids whose future was assured, the student body seemed programmed to do what it took to get ahead. Ahead of what? I wondered. At the end of each term when grades were posted, I became accustomed to seeing a line of students outside my office door. Few of them argued that they had performed better than the grade I had assigned them; no, they simply *needed* the bump up to get into law school. They had worked so hard: indeed, I was sure that they had. I had observed how students seemed not to linger together, even at meals. They fueled their bodies quickly in the cafeteria or ate an "energy bar" and got back to studying or headed to an internship on Capitol hill. In the 1970s, there was "free" love: now I learned about "hooking up," a quick fix for bodily urges. One needed to save time and energy for advancing one's career. Marriage was back in vogue, but career stability came first. How might that moment of success be recognized? I wondered, thinking about my own move from a secure position in Paris for a temporary job in Washington. I had "returned" to the US capitol to see where two romances would lead: the first with a man, and the second with the country and academic world I had left behind so many years before. On the one hand, like many newly returned immigrants, I was out of step with the times. On the other, 9/11 brought conflicts associated with my area of regional expertise into the heart of current events and American history.

I have never been to Iraq. Still, when I landed at Kennedy airport coming from Casablanca after the first Gulf War in 1991, I'd been drawn aside and had my bags searched because the border police said I had been "over there" during the conflict. After 9/11 "over there" and the region I taught about seemed to grow larger all the time: it came to be known as "MENA," Middle East and North Africa, following the organizational units and activities of the US military. For my first US academic job, I taught about that vast region while the United States was pummeling Afghanistan with bombs. Those bombardments prepared the way for the eminently poised, courteous, seemingly reasonable Colin Powell to present trumped-up evidence about Saddam Hussein's nuclear capacities at the UN. So began a war that continues

to produce collateral damage to this day, including among Americans, in the United States.

The atmosphere on the Georgetown campus was very far from that of the "street" where ignorant gun owners shot people because they wore turbans or harassed women with head coverings. Yet it was tense. Many people did not quite know how to think about the attacks or what they meant for the future. There were seminars, debates, and discussions: the center where I worked was active, yet besieged; to study the Middle East implied a kind of identification with the "problem." In a tense political climate, the life of the mind was influenced by statecraft and realpolitik.

I argued and cried when my Egyptian-American boyfriend took the side of the Bush administration. We would eventually part ways. In the meantime, I made "*Asharq al-awsat*" with the remnants of the newspaper by that name. In English, the title means "The Middle East." In class, I spoke of the origins of this term, "middle," this close-by as opposed to the "Far East," as perceived from Europe. At home, I cut out the masthead of the newspaper and glued it across two canvases. Once it was dry, I tore the two apart, setting the green title into a sea of red and blue.[1]

The collage was shaped around printed text from the paper. I painted words: "Left" and "Right" written in English but facing opposite directions, as though in separate scripts. A wash of red, white and blue blends this layer into a turbulent sea or storm: it is overwritten with more words, scribbled with an indigo Bic pen – *awsat*, "middling," *moyen*; these and other words in Arabic, English and French on the canvasses suggest finding averages, moderation, or tepid emotions. They point to the difficulties of feeling betwixt and between. Along the seam

**FIGURE 5.1** "*Asharq al-awsat*," 2004. Acrylic, ink and paper on canvas, 13" × 22". Photograph by the author.

**FIGURE 5.2** Detail, *"Asharq al-awsat."* Photograph by the author.

where the two canvases meet, *le juste milieu*, the middle ground. It has been a long time since I have seen this painting in person: I'm not sure exactly where it is, or if it has survived. But my memory of making it on the back porch of a townhouse in Georgetown is vivid: the sense of frustration I felt with the "middleness" of what passed as reason in Washington, even in my own home still fires up my nerves when I look at this remnant of history. "With us or against us," the President said at the time.

An old friend laughed at how I now used "Arab" hand movements to underscore English phrases, sometimes mangled by French syntax, or a lilting "non?" at the end of my sentences. The way words were layered in the painting evoked how one language or gestural repertoire can shadow another. I pondered how each place I had lived had influenced my every movement and thought: but also, how these "influences" did not simply mix, like red and yellow make orange together on a palette. More like the painting, it seemed there were patterned or colored wisps of language, or clusters of body movements, that slid one atop another, coming together in particular ways according to some present situation or question at hand. In this way, life references were a bit like those one uses in academic research: the bibliography one draws on shifts depending on the project and the questions one seeks to pursue. Still, there must be a general direction, some momentum that defines these projects and these questions. To get at these, I turn to some personal archaeology and then to the questions of how concepts are made.

## Beyond between

In 2001, my parents were preparing to move out of the home where I'd lived in high school and returned to for holidays ever since I went away to college.

Moving subjects **107**

My sisters and I each gathered up the boxes of belongings we had stored in the garage over the years. Going through those objects that had stayed put, while I moved, I reflected on those shifts of residence. I also found a paper I wrote for Peter Brown's marvelous course on late antiquity that same year as I staged a performance to try to convey the ambiance of May 1968 for Martin Jay's class in Kroeber Hall. The essay offers clues to the direction of my future life. I argued the Anglo-Saxon Christian missionaries who traveled to what would become Germany in the eighth century to convert "the heathen" did so not only to serve God, but to feel part of a wider community with larger purposes than kin and kingdom. The letters between women and their brothers in religion especially intrigued me. At the time, I was writing a BA thesis about the idea of the "avant-garde" and the use of the new media of cinema among the cubists, futurists, and socialist political movements before WWI. I took note of how little the claim to be ahead of history included changing attitudes toward women among twentieth-century vangards.

I discovered a photo of the first time I left the United States. It was Christmas break, 1978. My friend Jeff in front of his beat-up red station wagon stands beside his mother, free-spirit Helen, and her baby daughter Sheila. We drove from Berkeley all the way to Cabo San Lucas. Along the way, I relished Helen's stories of moving to England with her two small sons when she was newly divorced, some 15 years earlier. England was as damp and chilly as everyone said; you had to pay for heat little by little, adding coins to the pay-as-you-go radiator. Her words returned to me later in the trip as I added coins to the dryer in a Laundromat on the outskirts of Ensenada. A storm so torrential that *The New York Times* wrote about it soaked our sleeping bags and left us stranded for a couple of days. I still have super 8 footage I took of the streams of people coming down from the usually dusty hills to see a parched arroyo transformed into a raging river full of tourists' stranded vehicles.[2]

A stash of old calendars also suggested how competence in housecraft also led me to enter into environments that helped me to imagine not only future travel, but desirable lifestyles.

The datebooks show that from 1977 to 1979, I made a weekly trek up into the Berkeley hills to dust and vacuum, mend, and wash dishes for Professor Gregory Vlastos. I knew the professor often wore a T-shirt with Plato's bust printed on it when we went for a jog. It was only later that friends told me of his eminence as a scholar of classical Greek philosophy. So, I wasn't daunted by his academic reputation at the time; I was in awe of the lifestyle his home and the objects in it suggested to me. As I vacuumed the bright carpets with their geometric forms, polished the blonde wood floor, or gathered clothes and linens to launder I carried out a kind of archeo-imaginative study of a form of life that I found exceedingly alluring. I observed the elongated hourglass shape of the glass coffee carafe. I sometimes took a break and rested in one of the simple, elegant modern chairs, pausing to observe the direction and intensities of the brush strokes on the expressionist paintings of boxers hung on the walls. When I picked up leftover hors d'oeuvres, emptied wine glasses and collected lipstick-ringed cigarette butts, I imagined the women whose

mouths had painted them. What fascinating conversations they must have had! I pictured elegant cocktail hours where guests exchanged well-chosen words, in accents that showed the complexity of their paths across the world. These fictional conversations appeared in my mind's eye like Calder mobiles come alive; each one had its own colors, qualities, and ways of moving.

Stitching the hem of the professor's trousers as my grandmother had taught me, I recalled her stories of being a teenage maid for "rich" families in Chicago. She showed me to iron, as older servants had taught her to do. She told me she imitated many of the American families' ways of doing things too. She was something like a fieldworker learning to participate in the life of "her" village, I told myself. Of course, the stakes were unimaginably high: an immigrant needs to get it right to make a life, not a thesis. I knew this to be true even for the sophisticated group I conjured at the professor's house. When I imagined pouring Burgundy from the svelte Bauhaus-style carafe to my own guests, I wondered if it poured its stories into the wine I served them? When the Staatliches Bauhaus closed its schools and dispersed because of the Nazis in 1933, its members dispersed around the world.

Back in Washington, I thought of that nearly forgotten excursion in household archeology. And I looked at my own modest yet light-drenched dining room. I took note of the embroidered tablecloth from Casablanca; little drips of indelible saffron had stained one corner at some forgotten dinner party. On the other side, the shadow of a wine glass never quite washed out. I imagined a spicy tagine spilled during a lively dinner when I spread the cloth out on a low round *mida* in Casablanca and a dozen people huddled hip to hip around the steaming platter. Was the wine stain a trace of a Rabat research meeting? I also made good use of the *nappe* in Paris where the open drop-leaf table entirely filled the tiny living room when guests visited.

## Dwelling in third places

A body can only move from one place to another. And yet the body is shaped much like the mind through accumulations and accretions that defy linear time. The figure of the immigrant is set between two homes: some have argued that this doubleness engenders is a particular form of suffering.[3] As a child, I did not understand why my great aunts wept as readily when my uncle hung out the American flag on the fourth of July as when I played the Polish national anthem on the piano. As a young woman in France, I came to understand the pull and tug of living as an immigrant, but then, moving on to Morocco, some said I became a cosmopolitan. Yet, this person of the cosmos did not feel like someone I could talk to. Later, I would write about conceptions of ethereal cosmopolitan lightness at length, sometimes with virulence. But only once I had created an alternative way of thinking about pushes and pulls, pains and joys, tugs and stretches between here and there as their meaning changes due to multiple, successive shifts of country.[4]

Confronted with the "cosmopolitan" and the "immigrant," I wondered what happened when the immigrant moved a second time, to a third location. What occurs when the immigrant's absences to herself are multiplied as she moves beyond a first migration? I was thinking about these questions when I made "*Asharq al-awsat*" in 2003. I have evidence of this because it was then that I submitted an article for the *International Journal of Migration* that proposed the concept of serial migration. I wrote

> moving to the third place involves a move out of the betwixt and between position. It introduces a very concrete third space, one that can be identified with a place on maps, with a language, with state institutions and bureaucracies; a place where the serial migrant lives among other people. The third move can lead to a distancing from the symbolic and practical confrontation of host to home that informs the experiences of migrants, students abroad, or anthropologists in the field, as noted in auto-biography, reflexive criticism, and sociological studies. Stepping into this third space does not make the preceding places of a person's life disappear. Indeed, places from the past can take on a new symbolic and strategic importance. For the researcher, exploring moves to the third place breaks the binary oppositions that have tended to inform how we think about migration, globalization, and our own work as social scientists in the field. We might see serial migrants as the perfect respondents for debates in political philosophy that urge the recognition not only of the "other" but of "others."[5]

Thus, I called for attending to paths of migration. Against the cosmopolitan, I called for recognition of the often-dramatic effects of borders and states and the shifting cultural milieu of the person on the move. I suggested that in fact, these shaped the person who migrated a second time as a particular kind of subject. Moving to a third country was transformational, I hypothesized. Repeating migration was a critical movement to study, I asserted. Understanding that experience from the perspective of the person or group on the move would unfold possibilities for understanding the forces that move some people and keep others stuck in place. The very power of the state and its grip on theoretical imaginations could tend to pose migration as a problem to be solved, immigrants as exceptional people whose difficulties needed to be understood and addressed. In fact, everyone is shaped by experiences of mobility. Urban studies had long drawn attention to how race, gender, and education levels affect mobility in cities, between cities, or from the countryside to urban centers. A more precise imagination of the interplay of mobility, power, and subjectivity could result by bringing that work together with research on migration.

I had observed how types of beauty salons were defined by different relationships to neighborhoods, cities, and the world; walking distance, near the office, wherever that famous hairdresser was working. I had studied how some women moved among several types of salons, and thus had access to several

**110** Third wave

forms of social life and being themselves. Others were confined to more limited experiences. People who had the opportunity to frequent different types of salons were introduced to different ways of being with others, alternative imaginations of social order, and alternative politics of conceiving, and eventually remaking themselves. That beauty salons could lead to different forms of embodiment and social imaginations had been demonstrated through fieldwork. How might I develop a field inspired by the idea of an always-moving background composed by the varied movements of everyone, without the mooring that Casablanca, Paris and Cairo had provided for the research triangle of my earlier research?

I could never do all of the research required to gather together stories of every path through the world, and how each was aided or impeded in particular contexts. I could not simultanesouly study "always at home" people, itinerant workers, and different kinds of immigrants. I could study a path that seemed to me particularly revelatory of how global regimes of truth and power pictured migrants as anomalous because their mobility challenged static assumptions about power, identity, and culture.

Regarding the relationship of self to self that the experience of oneself as another encouraged by serial migration creates, I often thought about philosopher Michel Foucault's analysis of the transformations of the late Roman Empire as they related to self-to-self relations. He wrote that

> whereas formerly ethics implied a close connection between power over oneself and power over others, and therefore had to refer to an aesthetics of life that accorded with one's status, the rules of the political game made it more difficult to define the relations between what one was, what one could do, and what one was expected to accomplish the formation of oneself as the subject of one's own actions became more problematic.[6]

What if disruptions are occasioned not only in a change in history, the fall of an empire, for instance, but by moves across places whose sense of unfolding collective narrative are shaped by different states, cultures, and societies? Working with serial migrants and reflecting on my own path, it would be possible to explore this question.

Foucault's attention to discipline also influenced the movement of my thoughts. For him, truth regimes are systems of ordered discourses and practices.[7] One could examine them broadly, for instance, to get at the production of the international migratory regime, including the way it divides the world into sovereign territories across which people become different kinds of subjects when they cross borders. One could study how particular states or agencies or events encourage them. Serial migrants have multiple experiences of being shaped by diverse regimes and global discourses and practices. In each new home, they are abruptly or delicately remade as they find ways of being themselves in the new

setting, with its new rules and expectations. At least, this was my hypothesis. How would I test it? The concept of serial migration and the imagination of a world made in motion was research-ready. But how might I do fieldwork with people who never gathered, who spoke diverse languages, and who were marked by no visible or audible characteristics? Whose identity as serial migrants was ignored by statistics and suspect for border police? Thinking about this today brings me back to the questions eminent professors asked me many years before when I first set out to study anthropology. How would I go about recognizing this population? What would set the boundaries of the field?

## A shared place

I started small. I set up a project that made the borders of my own third country, Morocco, a framework for contemplating serial migration. I invited serial migrant researchers and writers who shared the country as one of their homelands to a conference and seminar. Having at least one country in common meant we had a pool of shared references. We could literally and figuratively speak the same languages. This would make it easier to focus on the specifics of our shared paths of serial migration and how they shaped our lives in Morocco and elsewhere.

I sent out an invitation for a conference, followed by a closed working seminar on serial migration. It was to be held at Georgetown University in the spring of 2005. I wrote that

> The idea that introducing of a "third term" or yet another place, nation-state or language opens up new conceptual possibilities, has been discussed philosophically. Our work examines it from the perspective of actual encounters. We are not simply attempting to explore how such theories play out "on the ground." Our aim is to develop an approach to fieldwork that is appropriate to exploring issues of mobility because it is itself conceived in motion.
>
> Morocco has generally been studied as a place that people leave. By looking at the national territory as a space that people move to or pass through, we displace its identification as a "sending country" and see it as it in fact is: an ambiguous zone where nomads shepherd their flocks, holiday making sheikhs build palaces, and people from other countries settle.

Making the boundaries of Morocco the space of our common explorations, the group mingled those born there and those who moved there, reversing ideas of sending and receiving nations. Later, to introduce the edited book developed from this first project, I wrote

> While our engagement is a kind of research in action, it was conceivable only after the fact, after those involved in it had become serial migrants.

**112** Third wave

> Our work tries to give a name to an experience and mode of mobility that is otherwise unrecognized. It is a foray into a kind of social reflexivity involving attention to the scholarly event as a mode of interaction, and a moment of research on the theme being explored, as much as a forum for reporting research results. The participants in this event represented not only those they studied, but themselves.[8]

We brought our other homes and expertise as anthropologists, sociologists, socio-linguists, philosophers, and translators to our socially reflexive exchanges.

I leaned heavily on my friend Leila's arm as she guided me into the conference room. The event was nearly canceled when a routine eye exam revealed I had a detached retina. Without immediate surgery, I could lose sight in the right eye; even with an operation, it was not certain if my vision could be preserved. But a skilled surgeon, who learned his craft at the University of Cairo, was able to save much of my vision. I was exhausted: speaking to the large assembly on the first day of the conference was one of the most difficult and draining professional performances I have ever made. A closed session on the second day revived me. The intimacy of the smaller room and the informality and straightforwardness of the exchange gave me strength. As I shared thoughts and experiences with my friends, I noticed how "serial migration" helped to elucidate certain difficult-to-state things we shared.

As I listened and read the work of the others, I began to consider several options for forming a field. I thought of working by way of the complex imbrication of references and attachments, the allegiances of friends born in nations of the Arab world and in the Muslim faith. That would have been politically timely, and it would also make assumptions about who fit into each category. Those untied from "the community" by circumstance or choice would likely disappear from the research using this approach. The making of forms of subjectivity I was interested in exploring, for serial migrants, and for everyone, needed to be separated out to some extent from the weightiness of assumptions about ethnicity or nationality or religion so that the weight and meaning of these could actually be fully perceived in different settings. These differences were important to the individual migrants, and instructive about the different state and social regimes they lived through, and that played a role in making them who they were when I met them. What of the accumulation of these experiences of dissimilar disciplinary regimens: of state, of society, and of conceptions of the self in general, and the attributes of oneself in particular?

Another choice would have been to seek out people poised to move to a third country. Those on the verge of the transformational step might offer insights into its workings. It would also assume rather than investigate that the third move was any different than a first migration, or the kind of placeless existence of the worldly "cosmopolitan" that was the topic of abundant discussion in the academic literature at the time. To get a sense of the particularity

of the hypothetical third move, I needed to consider the long story, country after country. In Washington, I could have decided to study diplomats, for instance. I could have worked with global executives. However, when they shifted countries, they still move within a particular milieu. They experience new places, but the truths and powers that made sense of their lives remain stable, following along with them. Diplomats, military personnel, and ex-pats working for multinationals were not among those I would seek to engage. Stimulated by the collective reflection in Georgetown, I decided to focus on people whose moves were more uncertain, motivated by events or opportunities without an overarching institutional context. I defined serial migrants for the purpose of this research as people who had lived for at least three years each in at least three countries and whose lives were not tied together by such career continuities.

## Moving on

I began to collect life stories among serial migrants in Washington, and then moved to Houston. It was a temporary stop-over to teach for a year in the Rice anthropology department, well known for its hermeneutic and humanistic experiments and promotion of original forms of fieldwork design. George Marcus, a leading author in the "critical turn" that had originally attracted me to fieldwork, was on sabbatical in California. I rented his home for the year. Perhaps it was painting in his home office that led me to work as though I'd already read the yet to be written article in which he argues that the "critical turn" needs to be completed by expanding the range of media and modes of expression that anthropology can include, imagine, and create.[9]

There was no dedicated studio: I rolled up the Persian carpet in George's home office to paint. The large plate glass and sliding glass windows looked

**FIGURE 5.3** "Oil steal," 2004. Oil on canvas, 31" × 42". Photograph by the author.

toward the emerald green lawn; when I opened them to ventilate the room, cockroaches often snuck in. In that room that had seen so much writing, I used oil paint to trace a pink cockroach-like shape to reflect on the war raging in Iraq. Houston is dominated by the petroleum industry. In Moroccan Arabic, the cockroach is called an *ashrq ez-zit*, literally an "oil stealer." In French, the insect is a *cafard*, which also means having the blues. I gave the painting an English title: "Oil Steal." Before George and his wife Pat returned home, I rolled the carpet back and carefully inspected the room to be sure I had not left behind a brush or a fleck of paint. Who knows, perhaps a trace of linseed oil eluded me and its scent wafted for a while through the office, infusing George's future imaginings of where the critical turn might yet lead.

My next move was to London, where I convened an MA on global and transnational media at Goldsmith's College from 2005 to 2007. I was again thrilled to work with so many colleagues whose research had been a reference for me. Unlike in Houston, I felt exceptionally attuned to the campus life. The buildings were pleasantly run down. Work across disciplinary lines was not only encouraged, but the norm. The hems of the buildings and exchanges between theory and practice were frayed in a comfortable way, like a pair of old, perfectly fitting jeans.

For the first time, I was also able to scrape together the means to buy a flat: a first-floor walk-up above an Arab grocery store and organic food shop in Kentish town, Northwest London. When I read about a terrible accident during the haj at Mecca, I painted about the circle of life, death, and change. I had every intention of remaining, to paint more news-inspired pictures and complete the project on serial migration. However, the research topic seemed to dictate my destiny. By the autumn of 2007, I was on my way to a new job and home in California.

**FIGURE 5.4**  "Tragedy at the haj," 2006. Acrylic and newsprint on canvas, 31" × 42". Photograph by Ian Sam James.

## Storylines and subject forms

As I prepared the collected essays from the Georgetown conference for publication during this time I remained in dialogue with the authors. They introduced me to other serial migrants. I traveled to locations that attracted substantial numbers of migrants from around the world. Among these immigrants I could find serial migrants, but I needed to meet a lot of people and listen to countless life stories. Historian Elizabeth Shlala helped me finish up further story recording in London, while I spent time in Dubai, Montreal, Manama, New York, and Bahrain. I revisited Paris, Cairo, and Casablanca; I met many people who had changed careers multiple times. Their parents were or had been homemakers, farmers and herders, electricians and teachers, managers and engineers, and film directors; formal education ranged from none to a doctorate.

Had I once again entered into a period of spinning, a dizzying experience similar to the decade when I shifted among salons? Not exactly. I was not reweaving connections among recognizable places to explore transnational differences in what appears similar. I was working though immigration to untangle its different strands, seeking patterns in life narratives and outlook. Sometimes it was a whole family I met: other times, a group of friends or an individual. I spent time with people in their homes and places of employment. Fieldwork became a practice of catching the passing winds of others' journeys. It was about noticing their pauses and crescendos, and interpreting the way these conditioned the kind of ties they had to the lands they traversed, and how these attachments made them anew. I gathered tales of shifting countries in pursuit of safety, money, love, food, freedom, or adventure.

We tell our stories looking back from today: with present aims, environments, relationships, and interlocutors in mind.[10] I was intrigued by how individuals' accounts of their immigrations and motivations altered as we met over the course of the decade-long project. Some people moved during that time: as did I. I visited them in their new homes, adding to the research.[11] As I navigated the paths traced by life narratives, I paid particular attention to the critical moments that made some migrations and homes especially transformative. I noticed how countries became frames for life chapters. I became attentive to how people rooted in several soils compiled compendiums of references that often did not speak to one another, and yet came together in the actions and worldview of the subject on the move. Many people spoke of the same kind of presence/absence I identified in my own experience; the shadowed languages and gestures I had evoked with paint and pen in "*Asharq al-awsat*." Hani and Anissa, Guillermo, and many others complained that they were most often perceived as immigrants or returned natives; they were frustrated by static social imaginations that discouraged attention to their moves and the richness of their lives. It was not simply that they picked up cultural references or learned new job skills; they tended to see their experience in knowing how to move, even in difficult circumstances, as a kind of mastery worthy of notice.

**116** Third wave

How many conferences had I attended where academics and policy makers debated definitions of assimilation or integration? Serial migrants spoke otherwise. They considered how each home encouraged or impeded action with others. The opportunity to take part, to be of service, to participate; these were the possibilities the majority of serial migrants saw as desirable in a home and a successful life. Some locations offered more opportunities to work, to exercise this "project orientation" than others. And of course, every country offered more possibilities for some *kinds* of people than others. Noha, an Egyptian/Danish/British academic who was a particularly insightful woman, told me that when she considers moving to a new country, she asks herself what *kind* of foreigner she would be there. This consideration has to do with the potential for action, but also, with what each environment notices as pertinent features in people in general, and in one's self in particular. I listened to how, rather than focusing on how they were assimilated to some environment, they spoke of what each new home made of them as people.

What I found was not a shared worldview. Rather, there was a commonality made of a similar way of shifting environments, of repeated experiences of dwelling otherwise. It was very different from the "cosmopolitan" perspective that some scholars had associated with multiple moves, perhaps based on their experiences of field research or stays in institutes like the one I would later experiment in Berlin.[12] It was the *way* one reflected on politics or religion that was shared, not any particular ideology or belief. Commonalities came through in serial migrants' belongings, in their preoccupations with adaptability, in the way they could think through situations they faced with knowledge not only of what they had observed in other places, but of what each home had made of them and they had made of themselves by participating in it. The "subject form" of the serial migrant assumed no similarity in what their homes had allowed them to be and dream and accomplish. The "shape" of the serial migrant was a consequence of the path, a way of moving and associating multiple worlds and ways of being oneself.

Like me, the people I encountered sought to find continuity across the many versions of who they were, even as they became experts at anticipating the processes and travails of border crossing and settling in. They faced living with an accumulation of multiple, diverse ways of being oneself and the lack of transparency that produced for communication with others, no matter where they were. Feeling always partly hidden, addressing the accumulation of ways of being oneself became tantamount. How did one find consistency amidst all of these diverse versions? Barring serious psychological results of serial migration, people do not lose their own sense of continuity when they move from place to place: indeed, being differently defined can add to a sense of subjective cohesiveness and a sense of personal strength. Still, theorizing and rendering this sense of consistency in words was difficult. Fieldwork led me to realize again how serial migrant is, in a sense, a high-stakes experiment in the limits of the possibilities of hybridized or hyphenated cultures.[13]

## International life

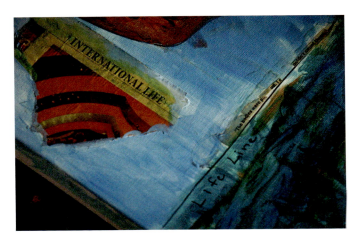

FIGURE 5.5  Detail, "International Life," 2009. Acrylic and newsprint on canvas, 5 panels, 10" × 30". Photograph by Ian Sam James.

FIGURE 5.6  Detail, "International Life." Photograph by Ian Sam James.

I began to study all of these stories I had recorded or written down; some had also been sent to me by email. There were dozens of them, and pages and pages of additional fieldnotes. I readily explored their similar narrative structures: how they used borders to write their life chapters in ways that overlapped with watershed moments of particular lives and cultural milieu. However, I pushed up

**118** Third wave

against the linearity of the stories, and the limits of words in the analysis. Facing a conundrum when it came to explaining subjective continuities that did not simply result from linear history, I spread out a series of canvases along a long low table. I made "International Life." Its multiple panels and extracts from *Asharq al-awsat, The Guardian, The LA Times*, and other papers were joined by lines and washes that suggested the sea or clouds, or some interior sense of flowing connection. Writing about the art, I was able to complete *Moving Matters Paths of Serial Migration*. This time, it was the editor who suggested printing the painting on the cover. The designer also used a detail from the piece as a background, adding yet another layer to the original artwork.

When the book came out in 2013, I followed the usual practice of readings in bookstores and lectures in universities. I also wanted feedback from people to those who had collaborated on the project, and other serial migrants. I recalled how "International Life" helped me overcome conceptual hurdles. I pondered the potential of the "project orientation" I'd identified as characteristic of serial migrants. And I invited a group of serial migrants to come together for a day-long collective "creative reaction" to the book on a warm day in late spring.

I imagined an appropriately mobile version of what art historian Miwon Kwon called an "ongoing invented community."[14] The group would explore migration and mobility by creating occasions and spaces for art made in the field. It would evolve by developing one site-specific intervention after another, in the image of the serial migrant. Each large or small event would develop a field to make art and simultaneously further shape and define the collective. The project would thus, I hypothesized, generate art and build community simultaneously. It would be a multi-modal experiment generated by site-by-site designs, an overall plan and an ever-emerging horizon of further research. We would present an exhibition or performance at each stop, adding to the ever-unfinished becoming of the collective as project, experiment, and community.[15] The whole would advance through collaboration with associations and institutions in each place. If the project worked, it would not depend on a set cast, but include different assemblies at each event. The *Moving Matters Traveling Workshop* could bring in new members at each stop, and be different things to different people.

It is obviously difficult to compare a real-life story full of travail with an art-derived engagement with diverse sites. Still, if the mimesis between individual and collective paths that I imagined for the *Moving Matters Traveling Workshop (MMTW)* might encourage auto-reflection and social critique. It might spark group feeling or consciousness through collaborative practices. It could create, at the very least, a laboratory for further self-reflexive research on serial migration.

For the first encounter, I sent a copy of the book to each participant; they were to select a passage to engage, critique, or amplify in their response. There were people I'd interviewed for the book, and others I'd met in Southern California. They were writers and researchers, visual artists, anthropologists, and performers who might draw out new aspects of our common experiences through art and scholarship.[16] We met in a dance studio with beautiful hardwood floors at the

Culver Center for the Arts in downtown Riverside. A couple staged a dialogue about their shared serial migration. Others discussed how serial migrants live through the diverse ways they are positioned by race, gender, and ethnicity and so many other factors. Some pointed to subjects I had not broached: death and migration, for instance. Participants presented photo-essays, bits of video; a journalist-turned-academic spoke of her experience of war and exile, and the serial migrant's "always-readiness." The desire to articulate and understand something we had in common was palpable.

And then a young woman with long blonde hair gathered in a braid entered from a side door, sat cross-legged on the floor, back to the audience, and began to sing.

# 6

# CONCEPT TO COMMUNITY

I could not understand the song: its harmonies were melodic to a Western ear. But that harmony was broken when the singer stopped short and twisted to look at us, the audience: NO! she cried out, then held a finger to her lips "shshssh."

She turned back to face the wall, then rose, moving to and fro, back and forth like a compass needle between two magnets. She did not want to go, she called out; the words were steady, matter of fact, yet her voice was muffled with emotion. The movements became faster, then something shifted: her gestures became fluid, graceful: she dropped to the ground, grabbed a pad of paper and a pencil, and looking right in our eyes, read aloud as she wrote: "Natalie, Natalia, Natalee ... an immigrant, a migrant, a legal alien, a student, a dancer, a scholar. I was born in Greece. My grandmother's German. I lived in England. I'm Natalie."

She ripped off the sheet of paper, scrunched it into a ball, slid to her stomach, and propelled her body across the floor with her arms, blowing the paper ball before her.

In *Moving Matters*, I ask readers to imaginatively contrast the back-and-forth step of the *pas de bourrée* to the three-stepped waltz to conceptualize the shift from immigration to serial migration.[1] By actually dancing, and associating her steps with song and word and writing, dance scholar and performer Natalie Zervou led us to think about our own critical transitions together. I can still hear the tense silence in the room as her dance progressed; when her arm stretched, I felt as though mine followed it. When she cried out, it brought back memories of leave-takings and border crossings. And when she wrote out who she was, I doubt I was the only one in the room whose mind flashed with their own names: Susan, Suzanne, Sawsan, Zuzanna, Suzan.

Zervou's emotionally charged and physically stirring performance, added to the other performances and artworks, ignited intense discussions around

**FIGURE 6.1** "MMTW Riverside Memory Book," 2015, by the author.

my book on that day in May 2013 in Riverside. Those led to imagining future meetings. I proposed to create *The Moving Matters Traveling Workshop* (MMTW). Five months later, several of us were on a plane together, heading to France.

Astonishingly, that first migration of the MMTW led me back to the city and street I had left for my own third move of country from France to Morocco. In 1988, I could see the then-derelict *Pavillon Vendôme* from the window of my then-newish public apartment complex.[2] Now it was my old building that was shabby, while the opulent Pavillon was newly renovated. Curator and art historian Guillaume Lasserre had been charged with turning the grand villa into a center for contemporary art.[3] Serendipity led him to hear about the MMTW. He bravely invited our untried collective to devise a performance related to the first exhibition he was curating in that newly majestic edifice: the theme was borders and migration.[4]

Once in Clichy, I set about research in the town with seven other participants. I had done part of my dissertation research there: there was a large Moroccan community in the city. Returning, I measured change not only by alterations in the built environment, but in how I now readily understood conversations among the town's Moroccan shopkeepers.[5] We studied the art; one piece in the extensive exhibition especially caught our attention. "Batgages" was made of helium filled, life-sized, paper replicas of the large plaid bags that many immigrants travel with because they are both inexpensive and resilient. Catalan artist Blanca Casas Brullet told us she made them to reference the invisible, immaterial, and yet essential cultural references any migrant carries with them. She had read my book, and she noted that for my research, I had defined a serial migrant as someone who has lived in three countries for at least three years.[6] She explained that growing up in Barcelona she experienced daily mind-migrations between Catalan and Castilian

**122** Third wave

worlds. Her quotidian border crossing was not exactly the same at that experienced by immigrants. But the at-home tug-of-war meant that when she migrated to France, her immigration experience was different from that of some other people. She made a cultural and political serial migration of the imagination, she said.[7] She quickly became an active member of the MMTW.

We used the floating bags to begin the performance in a large room, decorated with gilded mirrors that recalled the palace of Versailles. We walked one by one up a central aisle, carrying the bags, the public seated to each side, looking forward to the "stage." When we released the sacks they rose, bounced across the gold leaf of the ceiling, then settling into a new composition. Lasserre and I read excerpts from the book *Moving Matters* in French and English. These readings punctuated a series of individual performances. Anthropologist Alice Peinado invited us to listen to her field recordings of the stories of imprisoned Algerian migrants while watching a slide show of her own family's photo albums. The daughter of a Venezuelan diplomat, she asked us to contemplate privilege and its connections to scholarship. Erith Jaffe-Berg also presented family albums; these featured the houses in Los Angeles and Israel that her family shifted between throughout her childhood, before she moved to Canada. Her script was multi-lingual and included fantasy languages, or strange mélanges, similar to the "gremolo" of the *Commedia dell arte*; besides being an actress, Jaffe-Berg is a specialist in that form of Renaissance theater. Beatriz Mejia-Krumbein, the artist who played such a key role in the *On the Line* project, staged "Mi Tiempo, Mein Raum, My Map" to conclude the first portion of the performance.

> A door opens. Mejia-Krumbein enters in white dress with a red sash. She sings a children's song about a wolf in Spanish, then plays hopscotch across a large canvas spread on the ground. It is marked with four large circles of written words. She stands on one circle. "Mama, Papa, Tata Dolores, Gabriella, …." she calls in childlike sing-song. She pauses, looks at the audience and unties the belt from her waist. "Peter!" she calls out in the full-throated voice of a mature woman. Then, the scarlet ribbon comes alive in her right hand, leading her to a second circle. The soliloquy of names continues, this time in German accents: Frederich, Greta, Heinrich, Manfred … "Peter!" back to the point of departure, and a song and dance to "Pepita" reflected in an enormous, gilded mirror.
>
> She kneels and points at the words on the cloth beneath her: she reads them: "Heidi, Dylan, Yvonne, Tim, …" Her accent changes as she moves to different circle. Then, she calls my name and hands me the end of the long red ribbon. Together, we draw the sash across the space to shift the audience from their seats in the great room, into a smaller room where the performance continues.

In the second, darkened space, Nadine de Koenigswarter is making an artwork to the beat of a drum, rhythmically punching holes in a large length of black paper. Her hypnotic, meditative movements contrast to the focused attention produced by Nicola Mai's ethnographic film that dramatically visualizes cross-border identity shifts by enacting the story of Samira, who undergoes transitions between male and female and back again in order to collect an inheritance in Algeria.[8]

This was the first instance of what would become the MMTW's signature practices of using art objects as a basis for devising performance and literally getting the audience out of their seats. This first migration gave us time to think together about our individual stories. The interactions with the art and public and success of the individual-linked individual performances were encouraging. Now, it was time to test the relevance of my analysis of individual stories with respect to collective movements. What transformations, if any, would a migration to a third place bring about?

Olga Sezneva attended preparatory meetings in Clichy but had to travel before the performance. A sociologist at the University of Amsterdam, she had contacted the Allard Pierson Museum of Mediterranean Antiquities to see if they would be interested in welcoming the MMTW. By July 2014, a newly composed, larger group of serial migrant artists and scholars was on its way to the Netherlands.

**FIGURE 6.2** "MMTW Clichy Memory Book," 2016, by Guillaume Lasserre.

**FIGURE 6.3** "MMTW Amsterdam Memory Book," 2015, by Blanca Casas Brullet.

## Collective transformation

"Objects in/of Migration" conceived the museum as a site for exploring the relationship of mobility to value and materiality. Does movement add to an object's value? To that of a person? What cherished objects do migrants carry with them in their travels? What things are cast by the wayside by a serial migrant or by history? We explored these and related questions in relation to the museum's collections to prepare art for an exhibition, which would in turn inform an on-site performance.

In Riverside and Clichy, I had appeared as author and organizer. Now, we set my book aside and I worked with everyone else as an artist-scholar-performer. I was naturally motivated by the "Mediterranean" setting and interested in how that region was conceived in the northern European museum. In contrast to the heavy statues and sarcophagi of its galleries, my art had to travel to play a role in the exhibition. It had to be light. Perhaps inspired by Natalie and Beatriz, I worked with paper, white cloth, words, names, and red ribbons. Once more I turned to sewing silk organza as a way to reflect on history, this time not my own, but that of the Mediterranean region that was so meaningful to me.

"My Mediterranean Sea Scroll" is a long length of champagne-tinted silk organza. It is inscribed with bits of Ibn Battuta's travelogue and Herodotus' history and words Sappho is reputed to have penned. These and many other canonical texts cover the surface of this diaphanous manuscript, sail, peplos. When it is stretched, hung, or draped, its waves of writing conjure voices of bards and novelists, philosophers, and librettists joining in an ethereal hymn of their contributions to a shared Mediterranean civilization. Viewed from Amsterdam, perhaps the Mediterranean appears flowing and peaceful. Historian Fernand Braudel

**FIGURE 6.4** Detail, "Sea Scroll," 2014. Photograph by Ian Sam James.

figured the sea a protagonist of history; a natural replacement for the nation, empire, or dynasty. The "scroll" includes a passage in which he warns against reomanticizing the "Middle Sea." The Mediterranean has been a theater to countless wars. It is subject to unpredictable, violent squalls. What sunken ships and lost objects never made it to museums? Which destruction did the smooth surface of the literature on "Sea Scroll" help people to forget? I wrote on the silk as though it had no seams.

I could have tried to make the surface of the sea scroll inclusive, in the manner of historians who rewrite history to include women and marginalized, or persecuted peoples. I might have etched indigo marks into the sea scroll, like the chin tattoos women from the Moroccan countryside scrimp and save to erase. However, mingling blue drawings with the sepia scripts of great literature would have blurred what actually happens in the museum. I wanted to get at how including them in the main storyline would sideline that setting aside. So, I had sewed deep folds and smaller creases into the scroll, underneath its smooth surface. I wrote the names of immigrants lost at sea on bits of sheer velum. I added charred matches: a reference to the *haraga* – the Maghrebian word for "burning" used to designate people who destroy their ID papers and scorch their previous lives to cross unpredictable seas as migrants. I added tiny replicas of ordinary objects; a coin, a vase. Then, I placed all of that in the folds of the scroll, which I hung from the ceiling. The sides of the pockets are open. Some of the matches and names and lost treasures spilled out onto the floor. Thus, I contrasted the smooth Mediterranean of High Culture to the torn historical realities.

There were a few strips of paper in the folds of the installation that said "gather wood, gather words" in different languages, a reference to my paintings inspired by women at work and tragic events in Morocco's North.

I made a second installation on wood and words, pondering labor so habitual one never notices it being done, or who does it. I studied the museum collection, thinking about what we collect and what is destined to be lost to history. I made new "bundles" of sticks of words, and tied them with red twine. Then, I placed seven bundles in a vitrine accompanied by individual notices, in keeping with usual display practices. Each of the seven texts laid out under the glass was historically accurate, yet factually fanciful. They included references to scholars who study the region, but their specializations and their names were mixed up. I arranged them chronologically, from ancient Phoenicia to present-day Tangier. *Gather Wood*: the daily tasks of maintaining life. *Gather Words*: the power to set down the truth and to stop the movement of the world in its tracks. Wood: a metonym for materials that cannot be animated by the voice of the judge. Words: the media I work with as a scholar, that I layer and veil and set in motion in the installation. Viewing a photo of the installation today, my thoughts unfurl: wood pulp made into paper to print words upon words; words detached from paper, marching across the screen as a tap on a computer keyboard; the museum's persistent emphasis on objects and materiality in our time of digital promiscuity: I love the way the photograph captured the museum staff meeting in their glass office, behind the installation, their papers spread on the table.

FIGURE 6.5  "Gather Wood, Gather Words: What Goes Up in Smoke," 2014. Photograph by the author.

## Dancing with Gods

When the MMTW meets, we always take video and photos of ourselves at work as well as during public representations. The collective store of memory materials is available to all MMTW participants and others who might want to work on or with them. Everyone is simultaneously an analyst and an actor. No one is required to produce a sculpture, or write an article or perform, but everyone finds a role to play. After the Amsterdam workshop in 2014, Casas Brullet edited a short film that shows us developing the performance that would follow the path our exhibition traced through the museum. It illustrates how roles and practices shift: watch it and observe how theater writer and director Rickerby Hinds plays his professional role for a while, and then steps aside as a visual artist proposes a song, or a choreographer adds to the script of evolving, impromptu collective invention.[9]

In Amsterdam, the group worked and lived together for nearly a week. It was intense.[10] Museum visitors sometimes stopped by to see what we were up to. In the hushed halls, it sometimes seemed that the ancient objects spoke to us. Indeed, for the performance, three of us would become a golden horse, the hairpin of a princess, and a plastic water bottle: this last inspired by Alejandro Ramirez's introduction of ordinary objects that migrants would need to cross the Mediterranean today among the ancient, commonplace articles in the museum vitrines.

Choreographer and scholar Priya Srinivasan began the performance, dancing on the table of the museum cafeteria. She told stories as she moved to the music-filled museum entrance, and then up a flight of stairs. As Stephen James read a poem about forced migration, she continued ascending, to a gallery where she encountered statues of ancient Greek and Roman gods, newly attired, and video – enlivened by our art. She danced with a goddess and told us about how Ganesh the Hindu deity always accompanied her on her migrations; from India to Australia, to America and China and beyond. After an encounter with a customs agent whose voice rang from above "What do you have to declare?," she led the public into a large room to the sound of Andrea Puente playing the most ancient Greek recorded song on the harp. Srinivasan wrote about the experience:

> Although I performed in traditional proscenium stages, conferences, and the occasional museum, my encounter with the MMTW made me realize the importance of doing site-specific performance work, and particularly what a focus on collaborating between live embodied-performance and visual artists and their objects might enable.[11]

Like Srinivasan, Amsterdam would add to my ability to conceive an exhibition as a scene for bringing together performance and art making. My experiential trajectory moved in the opposite direction; it was performing on stage that was entirely new to me.

## Stepping out of oneself

In her 1966 memoir of fieldwork, anthropologist Hortense Powdermaker recounts how dancing played an unexpected but critical role in her research among the Lesu people of what is now New Guinea. She wrote about panicking when she was expected to participate in a ritual dance, imagining what her family would say to see her dancing with "savages."

> I wondered if I would not collapse on my way to the open clearing which served as the stage. But there I was in my proper place in the circle; the drums began; I danced. Something happened. I forgot myself and was one with the dancers. Under the full moon, and for the brief time of the dance, I ceased to be an anthropologist from a modern society. I danced. When it was over, I realized that for this short period, I had been emotionally part of the rite. Then out came my notebook.[12]

At the Allard Pierson Museum, during the performance, I took out the stained tablecloth I'd set on my table for so many years in Casablanca, in Paris, and then in Washington. Now I used it to conjure memories. I inspected the coffee and wine and saffron shadows on the red-and-white fabric and told stories about the people who made them.

**128** Third wave

In rehearsals, I was nervous. Magically, my fright vanished once I stepped on stage. I followed the outlines of the traces of my past with my hands and voice, sensing the support and aspirations of the other artists welling through me like a current of expectation. Powdermaker danced among people defined as others from the first; the feeling of being a part of the performance was strange if elating. It did not "make her one of them." In contrast, I was on stage to explore my own path with others who shared it in very different ways. Performing felt like a homecoming.[13]

I gathered the old tablecloth up and stepped aside so artist Gluklya Pershina could play the role of the museum janitor.[14] I again became an audience member and hummed along as she sang the "International" in Russian as she dusted the precious golden horse (Sezneva) and hairpin (Alexandru Balasuscu). She finished as Ramirez entered as the water bottle. He struck up a conversation with the other museum objects about the issues of value, identity, and movement that had motivated the event. They looked down on him for his relative newness and asked for his credentials for being at the museum. What was his catalogue number? The performance ended with a first rendition of what would become a leitmotif of the collective. We all walked in chaotic circles, forming a kind of vortex as we read out random numbers to the rhythm of a video of our ID cards.

The third workshop marked an important threshold in our collaborative creation and a shift from recognizing a common path toward becoming something like a community. Indeed, my intention had been to shape the MMTW not as a closed set of people, but as a dynamic collective subject that was not dependent on any single person or a cluster of particular individuals. The MMTW could in this way project itself into the future as a community whose existence grew with each new on-site endeavor, while welcoming additional participants. Re-examining my notes on our post-performance meetings and the video, films, and texts others have published about the MMTW, I observe how the individual transformations initiated by settling into a third homeland could be transposed to understand our collective movement.

## Story, history, installations

Setting up house in one place after another involves finding appropriate institutional partners, submitting grant proposals, seeking donations, or going after crowd funding. It requires arrangements for lodging and rehearsal spaces. Someone has to coordinate and carry out these plans. When we don't have sufficient funds, someone has to solicit MMTW contributions to help others in the group pay for travel or lodging. I generally took on this role in collaboration with the person or persons from the MMTW who had initiated the collaboration with our local partner. In July 2015, Alexandru Balasescu and Ioana Paun took leading parts in developing the next large workshop with the *Tipographia Gallery* in Bucharest. The gallery was a former factory on the outskirts of the city. It was built in 1962 to house the printing presses of the Ceausescu regime. The site inspired the theme. "My Story, Your History" would ask how migrants' personal histories jibe with national or other historical narratives.

I decided to see how my "Mediterranean" scroll might be reconfigured to explore personal memories of history making.[15] I remade it as a personal tribute to my friend, socio-linguist Nabiha Jerad, who was active in the movement against Tunisian dictator Ben Ali, with whom I'd begun a research project in the wake of the "Arab Spring." The project was never finished because Nabiha died after a hit-and-run accident on a deserted country road near her family home on the Kerkennah Islands in August 2012. A photograph in which Nabiha appears as a witness, perhaps also as an icon of the Revolution, was central to the new version of the work. The image is repeated amidst the flow of words in different scripts. As a linguist, the verb was everything to her. The Arabic alphabet has no vowels. "Vocalizations" are small diacritical marks that indicate how to read a text. I thought of Nabiha as that kind of active, verbal breath. She took what was in front of her and breathed life into it. She gathered people of every opinion around her table, creating possibilities of finding a language to channel collective energies in a hopeful direction. It was perhaps my sadness at her passing that also prompted me to develop a second installation that pondered life and death by staging a historical and personal memory – encounter by way of the poppy flower.

The *papaveraceae* family is described by botanists as "cosmopolitan." The species of this genus can be violet or white or pale pink. The golden California poppy can excite with its spring abundance, but it is the scarlet *Papaver somniferum*, native to the Eastern Mediterranean, that stirs the greatest yearnings. Its cultivation has been spread far and wide thanks to human thirst for visions, and a desire to make a profit from those for whom wakeful dreaming has become a compulsion.

To make this new piece, I read about opium wars and the opioid crisis in the United States. I studied how the flowers rise besides stalks of grain, or above carpets of tiny blue florets that form a soft carpet below their flamboyant taller sisters. Poppies grow in clusters. The taller they are, the more supple. In the wind they bend, kiss the earth, and then stand up again. Cut them back, they sprout anew the following year. The poppy is delicate yet tenacious.

On the left, there were images of me sprawled on my back in a bright California field, surrounded by wild, floral flourishes of orange paint on velum; joy, abandon, "flower power," Jefferson Airplane, LSD? To the right of this pulsating field, the eye met a patch of white wall, and then lowered to view a long row of A4-sized photos. It was the image of me in the poppy field, now printed black and white on red-stained paper. In the English-speaking world, the red poppy is worn to honor veterans. The crimson images were set in a long line, four feet above the ground. A parallel line of A4 leaves of paper was aligned on the floor. These were printed with the texts of broken peace treaties. Blue cornflowers mark remembrance of the war dead in France. I brushed the treaties with cerulean paint as though to erase them, then scattered red petals on top of the papers on the floor. Looking at the way the lines of photos on the right spelled out something final, dead, or eternal, I wondered if it was Deleuze and Guattari's famous book on difference and repetition that influenced my imagination.[16] Or did that philosophical work appeal because it corresponded to my style of making things of my vulnerability to history?

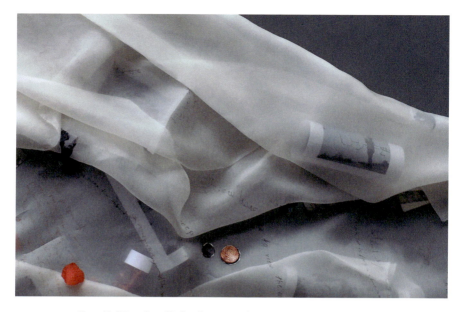

**FIGURE 6.6** Detail, "Sea Scroll # 2," 2015. Photograph by the author.

**FIGURE 6.7** MMTW discussion in Bucharest, with "Dans les bras de Morphée" and "Sea Scroll" in the background, 2015. Photograph by the author.

Besides such theoretical matters, there were matters of life or death at play in my family at that time. I had to leave Bucharest before the final performance. I imagined based on our exchange up until that time, it would be similar to the one we developed in Amsterdam. Instead, the group invented the "MMTW Map Quest" to bring the public into the process of making art.

The artists traced a huge world map on the slate floor. Then, they distributed multilingual papers to visitors. Where were you born? Where would you have liked to be born? Draw a picture of how you traveled. Who did you travel with? There was multi-colored chalk scattered around the room. Everyone drew their responses on the same map with the chalk. Later, in Riverside, Chicago, London, and Santa Monica, we would print the maps in a variety of formats. We would change up the questions depending on the site or participants. We edited questions to encourage people to converse and explore drawing. "Draw hearts where your loved-ones live" led to exchanges about how love was defined. The question "Who have you wanted to travel with but could not?" drew out issues of passports, visas, and resident status. The question "Where do you want to die?" led one group of strangers to discuss preferences for cremation or burial, and another to debate the advantages of dying in the cold Arctic Ocean or the comparatively warm waters of the Mediterranean Sea. We collected the large and small maps with their sketches of their traces of migrations, travels, and longings.

*Mapquest* is a portable and malleable way of getting people to think about mobility, desire, and their own lives.

**FIGURE 6.8** "Mapquest," Bucharest, July 2015. Photograph by Guillaume Lasserre.

## Return

In 2016, we returned to Riverside. This time we occupied the central atrium and screening room of The Culver Center for the Arts and our performance coincided with a conference at the Center for Ideas and Society on the campus. It would be a review of the MMTW up until that time. It was an opportunity to study what we had made together in greater detail than we do in our post-event meetings. One thing was clear to the scholars we invited to comment on our work: we were a tight-knit community. One commentator found this off-putting; another found the format an interesting model for creating solidarity. Either way, it was clear to me that our experiment had gelled: the MMTW further proved the viability and usefulness of the concept of serial migration: what's more, its design had generated a community that transcended any single event.

At the second Riverside meeting, Balasescu curated a show of art made for Amsterdam and Bucharest at the university so conference-goers could get a firsthand view of some examples of our art. I wrote a script for a performance using elements from work we had previously developed. From "Map Quest," to a poetry duo, a hip-hop theater sketch and dance improvisations, the action flowed until a group formed to shape a line, creating a border with signs in many languages declaring, "no boundaries." Sezneva, wearing a mock Soviet army uniform loudly informed everyone that they had to leave *all* of their belongings on the floor; it was a reminder of a recent Danish injunction that required undocumented migrants to leave their few valuables with the police. The actress-sociologist then read down a list of the names of everyone who had ordered a (free) ticket, "You may enter!" she called out. One by one, the audience walked through the line of "protestors" or "guards" up the short flight of stairs to a movie theater. But some people hadn't registered. Couples were separated. Friends were split up. These separations caused considerable consternation. A few MMTW members took on the roles of "passeurs," or "coyotes" to sneak the "unregistered" members of the audience into the screening room for the completion of the event with Paulo Chagas' musical composition video and Jaffe-Berg's new rendition of the performance she first developed in Clichy.

Following the path of the MMTW with others, we now reflected on how each workshop site had added to the program by bringing our questions into a new environment. Making each site a temporary group-home led us to probe our own stories of migration and our commonalities in new ways. It tightened our connection to one another but also to the project. Serial migrants live with the task of making themselves from accumulated versions of who they are and what they could become in their various homes. This struggle with accretion makes them ideal subjects for experimenting with unfamiliar practices, or novel combinations of modes of inquiry. A feeling of being opaque, the sense that there is some important aspect of themselves that is never quite "here" for others anywhere, that I'd observed in my solitary fieldwork, was shared by the MMTW members. Identifying ourselves as serial migrants in our public exhibitions, performances, and lectures made us feel more fully present, if not entirely legible to our audiences and ourselves.

Balasescu noted that the MMTW is "a structure that allows [him] to experiment and transform [his] anxieties into a form of expression that may be easier to perceive than the raw emotions themselves. Although, it is true, a few times things were very emotionally charged, especially in the periods of limbo when I didn't know where I'd be living next." His "deep anxiety regarding the rise of nationalism and populism, a rhetoric that has at its basis an anti-migration and anti-free movement politics of fear," inspired his work with the MMTW.[17] Kayde Anobile concurred, the MMTW has made her "more aware of the privileges she has enjoyed in her own migrations, and helped her to better understand the migratory experiences of others as well as herself."[18]

I recall one participant telling me that being a part of the MMTW gave her a sense of comfort with herself. She said, of being with others who shared her path, "it made me less resentful of the stay-at-home people who couldn't 'get' me. Since I have been a member of the MMTW I began to feel empathy for them." Some attendees at the Riverside conference came to the event thinking it would focus on the experience of cosmopolitans and what their perspectives might mean for the global condition. They listened to MMTW artist/scholars speak about what they had endured in the course of their migrations: imprisonment, exile, exploitation, abuse, but also, new horizons, exciting educational prospects, love, and with the MMTW, the joy of working together.

Our solidarity was visible, palpable. It was time to consider how we could move on to reflect on other forms of movement and migration, other experiences of mobility besides our own.

## Further migrations

The idea that experiences of mobility shape everyone, whether they stick to their neighborhood, or close to their village, or travel the world on a regular basis, was integral to the imagination that led me to study serial migration. It was the moving background to that research. It would be important to explore this mobility diversity topically, and by associating people whose paths diverged from ours for the next workshops. What imaginative horizons might arise if we included various paths in our reflection on how moving shapes each subject? How might we work with the horizon of a polity that could include this diversity in its very constitution?

In fact, this process of diversification had already begun. Already in 2014, Los Angeles-based members of the MMTW had met with the Son of Semele Ensemble (SOSE), an experimental Los Angeles theater company. Jaffe-Berg had spoken about work with the MMTW to the director of the theater ensemble Matthew McCray. He arranged the meeting to see if SOSE might develop a play based on my book using the methods of the work of the MMTW. The actors were interested in our methods of collaboration and intrigued by the concept of serial migration. Many of them had grown up and lived only in Southern California. Could they relate to the serial migrant? I explained that our projects focused on serial migration, but that this was only one path: everyone has a

**134** Third wave

mobility profile. SOSE then developed a collaboratively written play in three phases that substantially added to thinking about other paths than those I had studied and the MMTW had worked on up until that time.

The play revolved around a much talked of but never seen protagonist who was soon to be married. Her peripatetic work for global causes had led her to leave New York to live in several African countries. She met her White, Zimbabwean fiancée in the course of this work. The play explored how family members' outlooks and feelings related to their experiences of moving or staying in one place. The immigrant sister-in-law, the homebody sister, the international commuter; the characters were conceived to draw out how staying and moving, dwelling or traveling through shaped them. "Sea Seed" created motion-filled scenes for experimenting with the broad theoretical horizons that prefaced the study of serial migration from its inception.

I began this book with a description of "Sources," a painting on silk I made for a month-long exhibition on WALLS in Berlin in June 2017. Some three dozen MMTW artists took part in that exhibition and a series of performances, conceived in collaboration with Lisa Strehmann and the office for refugees of the East Berlin Protestant Dinary, and with the support of Pastor Thomas Jeutner and the docents of the *Kapelle der Versöhnung*.[19] The month-long program naturally addressed politically pressing themes of borders and freedom of movement. It also layered these with the double means of "walls" in English, which, unlike German, uses the same word for those borders and divides and the protective, nurturing walls that shelter and create a home.[20] This site of world memory was fertile ground for exploring movement, confinement and displacement in relation to something like a global audience. Nearly 30,000 people from dozens of countries and all walks of life experienced the MMTW exhibition.[21]

This time, after hanging the artworks, MMTW members living in Berlin attended a pre-workshop seminar on voice and movement led by Uthra Vijay and Srinivasan at the *Wissenschaftskolleg*: it was also open to the scholars in residence at the institute. Then, as though to warm up the often chilly *Kapelle* for the rest of us performers, Inge Mandos and Schwadron joined Vijay and Srinivasan for an opening quartet performance that drew Indian and Jewish women's songs and laments and traditional dance movements into haunting, sometimes dramatic, always subtle communication. Which walls had listened to those voices?

The second set of performances required me to step up my game as travel agent, organizer, producer, and participant. With 20-some artists, it was the largest gathering yet. And the one most inspired by both the art that lined the inner circles of slatted wall of the chapel, and observations of the many people who viewed it while we were developing the performance. The relationship of walls, viewing, and surveillance proved a major theme in the art for WALLS. Of course, walls incite people to scale them. Kayde Anobile's embroidered ladder, "Breach," and a colorful painted ladder I made, called "Over the Rainbow," were favorites for visitors seeking photograph opportunities in the exhibition.[22] As we began to prepare the larger performances, we found a wooden ladder in a storage area. We tried to climb it all together. It turned out that dancers Ghulamsakhi Alizada

and Schwadron were able to dangle themselves and spin it around like gymnasts who had invented a new apparatus. These elements set the stage for the rest of the performance, which began with a slow walk for half the group in the park. We all held white umbrellas because when I saw the forecast for rain I rushed to buy these at the Euro Store. They proved to be an effective prop as well as protection; they caught the eyes of passersby who wondered what was happening in the chapel. Some decided to follow us.

As those of us in the park approached the church, the arms of other performers reached out to us from within, through the slats of the open to the air exterior wall. From outside, I saw Casas Brullet stretching, alone, embracing the clay wall behind our imprisoned partners. She was performing a pantomime that illustrated the emotional state of the others who had no way out. There was no way in for us; until I "found" a passage and led the public into the covered corridor of the chapel. Everyone gathered to watch as a bevy of MMTW artists tried to climb the ladder together: they scored a victory when they managed to hoist eight-year-old Bernadette Faller Richardson high above them, as though she had scaled some imaginary boundary.

Next, the ladder became a dance partner for the acrobatic Alizada and Schwadron. From the thrill of their movements high above us, calm set in as Lorenza Manfredi, gently, slowly poured water over sand castles with a bright pink water can, melting them; walls dissolve and are built once more, sometimes with their shards and remainders, like the inner wall of the edifice. This quiet interlude prepared us to enter the warm inner sanctum. The ladder followed. Artists climbed up and down its rungs recounting slips of stories about walls they had known, trading voices at times and asking, "Who has the right to tell my story?" The performance ended in a silent circle, all of us facing inward to with a bow to one another first, and then a turn outward, to acknowledge the audience.

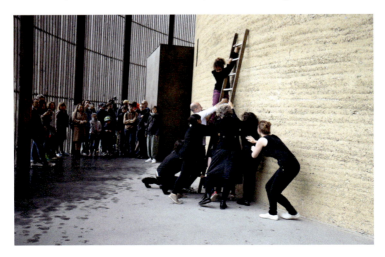

**FIGURE 6.9** "WALLS," MMTW performance, June–July 2017, *Kapelle Der Versöhnung*/Berlin Wall Monument. Photograph by Guillaume Lasserre.

**136** Third wave

That September, a smaller contingent traveled to Barcelona to explore issues of migration and mobility in the midst of philosophers assembled for a conference on competence and capitalism.[23] In the midst of enormous demonstrations for Catalan independence, we held a boisterous debate about the advertised "round table" discussions: how could that be done in a room furnished with four-cornered desks? Perhaps in response to the tense political context, or the seriousness of the other participants, the MMTW performance took on burlesque aspects for the first time.[24] I hid behind a curtain and did a skit about competence in riding an elevator based on a true story. A couple of months earlier, I'd entered a crowded elevator on the ground floor of a California medical building. When I asked someone to push the button for the first floor, everyone looked at me as though I was insane. Later in the raucous performance, Sezneva, "since she was Russian," was instructed to lead us all in a ballet lesson. Schwadron danced, but when she opened her mouth to sing, it was Felip Jufresa-Marti's deep bass song that came out. When Casa Brullet hid under a square table and refused to come out, we agreed to a compromise. She would rejoin us but only if we showed our competence in a new skill. We had to learn to pass the microphone from one to another person without using our hands. The performance ended with the audience joining us in this activity, inspired by the theater of the absurd and the realities taking place around us in streets, police stations, and parliaments.

In 2018, Priya Srinivasan, Olga Sezneva, Dennis Thompson II, and Uthra Vijay conceived a new program for Amsterdam. "Traverse Heritage: Voice, Body, Movement" engaged with Srinivasan's research and performance work on colonialism and decolonization.[25] The performance was developed in collaboration with two choirs from the city's suburbs that Thompson directed: the Sannas choir and the DoreMimi choir. It was staged at Amsterdam's elegant Hermitage Museum in the "Portrait Gallery of the Golden Age," a gallery composed of several small rooms and one large hall that featured enormous group portraits of white-collared pale men.

Vijay, in Australia, and Thompson, in Amsterdam, worked for months by Skype and Zoom to set up the musical program in preparation for intense on-site development over a period of a week. Meanwhile, Sezneva set about working with Surya Nahumury, recording the migration stories of the choir members, many of whom hailed from former Dutch colonies. Barbara Bernardi and Katarzyna Puzon composed a soundscape of these voices, mixed with stories from MMTW artist-scholars. On site, the MMTW attended rehearsals with the choirs. Sezneva and I prepared an installation for the room about "trade" that substituted new labels for the exhibiting ones, telling of the ravages of the Dutch East India Company in each place they set up shop around the world.

The performance began with us MMTW members sitting in a circle, listening to the recordings, playing the role of researchers. The public walked up long flight of stairs, listened and watched us listening. After six minutes, an eternity, Vijay's voice rang out. She beckoned with her hand, and everyone followed her into a small gallery focused on notable Amsterdamers of the 17th century.

**FIGURE 6.10** "Traverse Heritage," pre-performance filming at the Hermitage Museum, Amsterdam, May 17, 2018. Photograph by the author.

We looked in awe as several women struck poses in front of paintings in the darkened room. As lights illuminated their brown eyes and faces, they replaced the once prominent men (and a single wealthy woman) in the paintings. The stories that accompanied the paintings had also been replaced by Bernardi and Puzon's soundtrack. The voices of that recording faded as we moved next to the "market" room with its usual sound scape of bustling commerce. The audience read the new labels that Sezneva and I had composed to explain the cost in lives and livelihood and humanity that this trade entailed in the colonies. Vijay guided us into a further room; in the dark, we listened to Surya's reflections on recording the interviews with the choir members and thoughts about her own family's migration to the Netherlands, from Surinam and Morocco. Finally, Vijay took us into the vast main gallery space. Hundreds of eyes looked down on us from the paintings, and now, for the first time, those of the choir members and the MMTW looked down on us as well. A film about Rembrandt's "Night Watch" usually plays on a large screen in the center of the hall. Now, a video portrait of the choir and MMTW members drew the eyes of all who entered.

Vijay sang a phrase: Thompson struck a chord and the choir members formed groups to sing. The songs were from Indonesia, Surinam, South Africa, and India: countries colonized by the Dutch, places where many of the choir members or their parents were born. The music attracted people from around the museum: some listened and watched from windows in galleries on the floor above us. The singers formed a circle around Vijay and Sandhya Sanjana, who sang a duet and Srinivasan and Indu Pandy, who danced in front of the group video. Their confident, emotionally charged improvisations relied on their long and expert practice of Indian art forms: their fine art enlivened the museum hall with

**138** Third wave

heretofore untold stories that opened political as well as aesthetic horizons for the present. The singers and dancers rejoined the chorus members, split into two groups on either side of the room. While singing, one group moved slowly toward the other, until we formed a single corps. The performance ended with the entire cast walking in a large circle around the room, singing the "Shanthi Nilava Vendum" song for peace Uthra had taught us the previous year in Berlin.

Only months after the performance, rewriting the history of the "Golden Age" became global news. A new inclusive narrative of the past could make it possible to create the conditions for equality in the present-day city.[26] "Traverse Heritage" showed how this could happen with grace and emotion, in peace.

## Horizons

In 2014, Johanna Drucker wrote in the future tense:

> The critical design of interpretative interface will push beyond the goals of "efficient" and "transparent" designs for the organization of behaviors and actions, and mobilize a critical network that exposes, calls to attention, its made-ness — and by extension, the constructedness of knowledge, its interpretive dimensions. This will orchestrate, at least a bit, the shift from conceptions of interface as things and entities to that of an event-space of interpretive activity.[27]

At the same time she was writing, the MMTW was putting these ideas into action. Ours was not simply an application of theoretical speculation, but a compelling form of experiment in its own right. Working with a design led by a concept that helped us to critically and newly apprehend hitherto unremarked aspects of how moving made us, the project unfolded in response to the algorithmic powers and state discplines that shape the globe.

The "artificial" nature of the community we developed from a common experience of serial migration is significant for anyone interested in exploring possibilities for emerging modes and temporalities of engagement with a place, culture and state. With climate change, and existing demographic trends, the need to accommodate people on the move will increase. Social and political forms the world will need to adjust to a new situation will require imagination and a willingness to experiment. The city will not simply need to provide shelter and sustenance. The imagination of the polity will have to evolve to include not only people of diverse backgrounds, but also people shaped by diverse experiences of movement and belonging.

I imagine the MMTW continuing to experiment with enacting this utopian dreamed city. These could not be "everyday" utopias of the kind sometimes associated with community art rooted in single sites. It requires too much conscious work at bring distant or unlike people and things together.[28] Thanks to its concept-driven fieldwork design, the MMTW generates spaces with variable

"outcomes" and "goods" for diverse participants, audiences and disciplines. Is it art? Is it scholarship? Is it social action? The variegated and multi-scale field-creation of a project like the MMTW is all of these, yet it is also something else entirely. What this something is may not yet have a name.

It is good to offer refuge or promote coexistence. It is even better to develop political forms and social imaginations that include people on different paths by right and in principle, giving everyone the opportunity to make their unique contributions to the city and thereby belong. There is much yet to explore with regard to the outlook for *The Moving Matters Traveling Workshop*. But this book is drawing to a close.

# CONCLUSION

In these pages, I have associated images with words to reflect on the shifting fields I have shaped, sown, labored, and harvested. I have followed the paths I have taken across anthropology and art to make new things, not for innovation's sake, but with the prospect of better coming to terms with the world as it is, and shaping what it might yet be. With this book, I invite others to extend and expand the movements I have made, to shift my designs to their questions. To work as I have, one need not collect wood or story slivers or sprinkle poppy dust on silk. The broad cloak of references I have worked with and sometimes traced on translucent organza is adjustable. So are the disciplinary and state lines that have marked my path, and the histories that have shaped my ways of being, working, making.

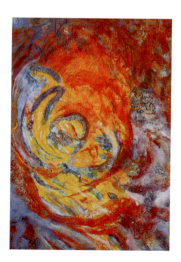

**FIGURE 7.1** Detail of "Conclusion." Photograph by Ian Sam James.

Conclusion  141

History will always offer unexpected occasions to relate to and work on and with our vulnerability. Indeed, it has renewed that offering even in the short interval between the moment I sent off the manuscript for this book, and when I edited it in quarantine, in the midst of a global pandemic. In the quiet of confinement, I returned to ancient sources too often set aside in the rush of the contemporary. I read an idyll by Theocritus, to Demeter, goddess of fertility and the harvest, and of poppies.

> All by Demeter's shrine at harvest-home?
> Beside whose corn stacks may I oft again
> Plant my broad fan: while she stands by and smiles,
> Poppies and corn sheaves on each laden arm.[1]

A wide world awaited me in the garden; I scattered seeds and waited for the flowers to bloom. What dreams and desires will their seeds and sap stir in the future? What new things will people make of them? "Looking forward," I wrote in my notebook, "it is the goddess of these mingled fields that I will take as my inspiration and my guide."

The Santa Ana winds came up: they raged in concert with the storms of change in human worlds. They blew the roof off my house, just as I was packing my bags to travel. I would return to Paris, yet again. But not before repairing the roof and finishing a painting to conclude this project of reflection and remembrance.

**FIGURE 7.2** Detail of "Conclusion." Photograph by Ian Sam James.

**142** Conclusion

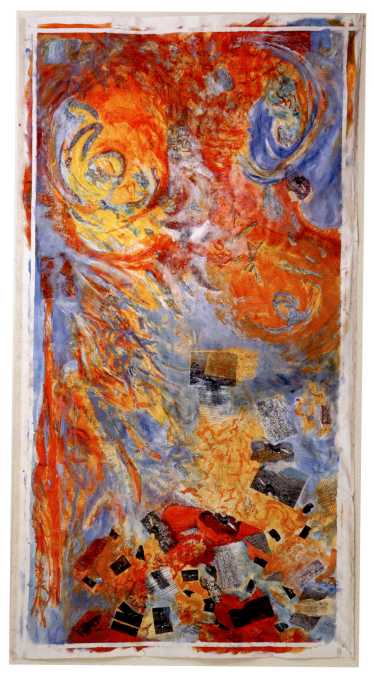

**FIGURE 7.3** "Conclusion," 2020. Acrylic, ink, and tissue paper on linen, 72" × 145". Photograph by Ian Sam James.

# NOTES

## Prologue

1  This is a broad overview. There were anthropologists in the first decades of the twentieth century who were concerned with indigenous histories, such as Germaine Tillion, whose work and memoir of fieldwork in the 1930s I reference in the coming pages. Tillion, *Il était une fois l'ethnographie*, 2000.
2  Levi-Strauss, *Tristes Tropiques*, 43.
3  For a more detailed examination of my early family life in relation to anthropological dispositions, see Ossman, *The Places We Share*, 2007.
4  See Ossman, *L'anthropologie*, 2014.
5  Fabian's *Time and the Other*, 1983 was a most influential critique of the "ethnographic present."

## Introduction

1  It was part of a *Moving Matters Traveling Workshop* exhibition and performance project on WALLS that I discuss in Chapter 6.
2  Ceramic artist Martin Rauch led this process organized by Open Houses, a charity that preserves buildings in Eastern Germany. The *Kapelle* was designed by architects Rudolf Reitermann and Peter Sassenroth. The *Kapelle* opened in 2000.
3  Some people also make it from rose petals.
4  Levi-Strauss, 2018, 43. All translations of Levi-Strauss are my own.
5  Ibid., 44.
6  Bourdieu's warning about the illusions of autobiography hold true for memoir: indeed, for practically any writing-based personal engagement, Bourdieu, "L'illusion." I do give an "account of myself" but one that is overwritten by efforts to explain the shape my work has taken.
7  Zagorska-Thomas, "The Fabric of Fieldwork," 2015.
8  Johnson, "How the World," 2019.
9  Wood, *The Magician's Doubts*, 1994, 27.
10  I draw on Foucault, *History of Sexuality*, vol. 3, 1988 (original French 1984) and Faubion, *Anthropology of Ethics*, 2011, for a discussion on ethics and anthropology. For more on portraits across text and image, see, for instance, Wrona, *Face au Portrait*, 2012.

**144** Notes

11 Sociologist Andrew Abbott has written of "lyrical" sociology that it is characterized by engagement with the object, and communicates by way of emotion. Interestingly, he seems to make irony the zero-sum position, since he calls the stance of lyrical sociology "non-ironic." He emphasizes the author's effort to communicate an emotion with respect to the object, rather than an explanation; Abbott, "Against Narrative." By emphasizing my lyricism, I do not assume these distinctions. Rather, I tend to think that lyricism can include irony and other rhetorical displacements. See Menocal, *Shards of Love*, 141 on this inclusive aspect and on how lyrical poetry can be deeply political. See also my analysis of the synthetic qualities of the image in a political analysis of imagery of Morocco's monarchy, Ossman, *Picturing Casablanca*, 1994.

12 Contrast to Geertz, "An Inconstant Profession," 2001.

13 To speak of "Art Worlds" in an academic book might bring to mind. Becker, *Art Worlds*, 1982. To engage sociological currents of the study of art worlds and art fields is important, but would set me adrift from the direction I have set for this book.

14 In this case, the opposition between studio and office added to the potential for alternative ways of working otherwise scholarly materials. It set me up for daily shifts between fields of reference. For more on the importance of offices and studios, see Pusetti, "Ethnography," 2018.

15 The exhibition as a whole can be viewed on the print or e-book version of the exhibition catalogue: Lambe, Ossman, and Puzon, *Wissen/Schaffen*, 2018. See also the photo-essay I published on *Allegra Lab*; Ossman, "Wissen/Schaffen."

16 It is interesting to compare my approach with that of artist Raul Ortega Ayala. He noted that he seeks to "immerse himself" in a context "without any a priori idea." He stops the project

> When I feel I'm becoming the thing I'm studying—my interest is art and at some point I have to step back and make the actual work … After spending some ten years assuming a participant–observer role in many of my projects, I began wondering what would happen if I somehow inverted this methodology, I wanted to see what the consequences would be in my own work if I distanced myself from the subject matter, as opposed to being a participant observer.
>
> Ortega-Ayala, "Immersions," 100–101

I was indeed immersed in the life of the institute, but my double field included the *altertnativ* space of the studio. That doubling set in motion a dynamic of reflection and making that helped me to understand and parse the environment.

17 Füssel, "A Struggle for Nobility," 2013.

18 Clark, *Academic Charisma*, 2005.

19 Charles Taylor pointed out the particular modernist stance of (anti-Romantic) modernism that Mann develops

> under a Schopenhaurian influence. Hans Castorp's epiphany in the 'Snow' section of *The Magic Mountain* shows how the harmonious beauties of the sunlit classical world are built on the horrors of old age, decay and human sacrifice. And in 'Death in Venice' what irresistibly attracts Gustav von Aschenbach, that highly controlled and disciplined craftsman, admirer of Frederick the Great, to the effortlessly incarnate beauty of Tadzio is also drawing him ineluctably toward disease and death. The epiphanies of being for Mann have this profoundly ambiguous character.
>
> (Taylor, *Sources*, 1989, 459)

20 The theme of light, lightness, color, and abstractions of Enlightenment as related to the modern body, but also the mind, is one I have explored at length. See, for instance, Ossman, *Three Faces*, 2002, 5–63.

21 Puzon, *Wissen/Schaffen*, 6, 2018. Dr. Puzon also organized a viewing of the exhibition by members of the Centre for Anthropological Research on Museums and Heritage (CARMAH) from Humboldt University.

Notes **145**

22 Anna Laine writes of how social research is deeply imbricated in the global system of border control. She argues that work across art and anthropology can be especially proactive in reflecting on and displacing these borders. I entirely agree with her that "a transgressive way of working that positions the issue of investigation above disciplinary belonging" is needed. Laine, *Practicing Art*, 2018, 15. As she reminds us in her writing and her art, these transgressions are not simply those set out by states or dominant cultures, but fundamentally part of the research and evaluation processes of academia and the art world.

23 Habermas, *The Structural Transformation*, 1991. Like many others, I have benefited from engaging and disputing Habermas's theorization. See particularly Ossman, *Three Faces*, 2002, 73–74.

24 Bourdieu considers the academic "game" as one of one-upmanship overdetermined by one's class position and habitus; Bourdieu, *Homo Academicus*, 1984.

25 This point was made most clearly by Sadiyya Sheik, one of the fellows at the institute in her year-end summing up for the 2016–17 *Wissenschaftskolleg* yearbook, 193.

26 This shift of the object into a new setting might be compared to the study of human subjects who move, or who have the ground moved from under their feet. See, for instance, Dimitra Gefou-Madianou's writing on how the building of the new Athens international airport moved people into a new environment in ways that altered their relationships to one another and their self conceptions. Gefou-Madianou, "Ethnography in Motion." Her work as well as recent research on infrastructure provides a welcome antidote to the idea of the airport as a non-place, a term Marc Augé popularized in the 1990s, Augé, *Non-Lieux*, 1992. For a different mode of adaptation to the extension of the Tokyo airport, view and listen to anthropologist Rupert Cox and sound artist's Angus Carlyle's marvelous "Air Pressure" project, 2011.

27 Cultural theorist Caroline Levine draws attention to how genre theory in literary studies "could benefit from more attention to the portability of forms. For many critics, the terms *form* and *genre* are synonymous or near synonymous," Levine, *Forms*, 2015, 13. As will become clear in the coming pages, the kind of "portable shifting" of form she writes about is one that I have both drawn into fieldwork as a productive venture, and one that I have had to figure out as a shifting and evolving kind of subject.

28 The swan is an important creature in Greek mythology and European cultures. There was quite a group of dedicated opera-goers among the Wiko residents, and so Wagner's *Lohengrin* and *Parsifal* also came to mind as I noticed how fairytale and myth were brought to life by the birds in the lakes around us.

29 At the *kolleg*, I had the privilege to get to know historian Gina Pomata and read her insightful account of the shifting place of observation and the movement of the case study from the marginalia of research to its center. That work offers food for thought considering present-day possibilities for pertinent shifts, Pomata, "Observation Rising."

30 On the idea of art as a conversation object, see Kester, *Conversation Pieces*, 2013, and Cantarella, Hegel and Marcus, "A Week in Pasadena," 2015. This will come up again in Chapter 4.

## Chapter 1

1 All spoken forms of Arabic differ from the standard written version of the language. Geographic proximity and media production affect assessments of whether one or another colloquial is more or less easily understood.

2 I do not speak any of the Amazigh languages.

3 Geertz, *Interpretations of Culture*, 1973.

4 The list of books by and about the experience of disappearing or being confined as a political prisoner is a long one. Anthropologist Susan Slyomovics, *Performance of*

**146** Notes

*Human Rights*, 2005, is especially enlightening with regard to the people I encountered during my fieldwork in the 1980s and 1990s.

5 Barthes, *Le degré zéro de l'écriture*, 1953.

6 This was a shifting that mimed historical and ongoing debates about which practices or substances, be they tea or coffee or wine, were permissible under Muslim law.

7 I had naturally read Khatibi's reflections about calligraphy and its engagements in everyday practices like tattooing. One need not adhere to his semiological take on Islam to imagine that his work might have influenced such art-notes. Some of his work has recently been translated into English, for instance, Khatibi, *Plural Maghreb: Writings on Postcolonialism*, 2019.

8 Indeed, reflections on this fact are central to the analysis of the image and the political work of the monarchy in my first fieldwork. The work I did with charcoal and pastels was obviously important to my anthropological analysis. However, the conceptual work and art it produced was invisible and unmentionable, like so many of the objects of political and social censoring I analyzed for dissertation fieldwork.

9 I am, of course, referencing Magritte's painting "Ceci n'est pas une pipe."

10 This again brings up the issues of proximities and overlaps of lyrical prose and poetry.

11 See Marcus, "Ethnography in/of," 1995, for a summary of experiments in new forms of fieldwork at the time. Related discussions of issues of setting contexts in fieldwork design were later central to the authors included in Gupta and Ferguson, *Anthropological Locations*, 1997. Further reflections on context in fieldwork include Melhuus, "Issues of Relevance," 2002 and Dilley, "Problem of Context," 2002.

12 My book *Picturing Casablanca* (1994) proposes an analysis of the work of media in shaping the nation and daily life of the Moroccan monarchy. Censorship naturally plays an integral role to keeping people in line, but so too does the positive production of images of the nation and the king that "fill the sight" of citizens in ways that also discourage the elaboration of alternative conceptions of the polity to those developed by the state.

13 Contrasts of male to female, men's to women's spaces and how they map onto public and private spaces are an ongoing subject of discussion worldwide, and particularly in areas like the Muslim world where gendered spaces can be very clearly marked. I cannot delve into the abundant literature here. Most specifically on Morocco in the 1990s, Bouchra Boulouiz reflects on Moroccan urban society and gender during the period between the late 1980s and early 1990s in her novel *Rouge Henné*, 2012.

14 Ossman, "Salons," 1991.

15 Gonzalez-Quijano and Ossman, "Nouvelles Cultures," 1991.

16 I think, in particular, of Roger Silverstone and David Morely's work at the time.

17 Augé, *Pour un anthropologie des Monde Contemporains*, 1994.

18 Needless to say, at talks in the United States, I was taxed with being a "post-modernist" because I cited as yet untranslated or "incomprehensible" French authors. See Barth, Gingrich, and Parkin (eds.), 2005, for more on diverse traditions of anthropological scholarship. For a recent discussion about writing in English and linguistic impacts on concept formation, see Law and Mol, *Words to Think With*, 2020.

19 See, for instance, Adida et al., "Identifying Barriers," 2010, for a study of the reception of "Muslim-identified" CVs. Also see Deeb and Winegar, *Anthropology's Politics*, 2016 on Middle East politics and US anthropology.

20 One of the quirky and fascinating aspects of becoming a French citizen is that you receive not only a certificate of naturalization but also a new birth certificate.

21 De Certeau, *The Practice of Everyday Life*, 1984.

22 Thus, while I worked in contemporary fields, I was influenced by the work of historians like Natalie Davis who not only wrote women into history, but explored multi-sited methods and lives through archival research, for instance, in Davis, *Women on the Margins*, 1995.

23 I explore this further on in the book with regard to my efforts to piece together statistical sources for the project on beauty salons.

Notes **147**

24 A number of now well-known scholars contributed to that seminar. Significantly, when I contacted the French scholarly journal *Terrains* to see if they might be interested in publishing a special edition of our papers, the editor in chief told me that she would be very interested in having me send in *my* article for review: but how could our Maghrebi colleagues offer anything of quality as a group? Knee-jerk colonialism was alive and well even among anthropologists. Many of the people who would have been contributing authors to our collective publication published their articles individually in other well-known international journals. The ongoing influence and impact of fieldwork and anthropology in Morocco are apparent in a long and ever-growing list of academic works, and the prominent place of fieldwork in research-action projects by NGOs or international agencies.

25 Rabinow, *Reflections on Fieldwork in Morocco*, 2007.

26 Anthropologists like artists have, of course, long recognized the importance of play. Still, becoming playful in the field or in one's writing about it can be perceived as problematic by people who confuse dry, brittle prose with scientific objectivity.

27 Indeed, there was no class on how to actually do fieldwork at Berkeley when I studied there. Today, such courses are common in the United States. Faubion and Marcus, *Fieldwork Is Not What It Used to Be*, 2009, reflect on teaching fieldwork with some of their students. While they and others propose new approaches to teaching and conceiving fieldwork, institutional factors still limit not only what is possible for research, but the way individual endeavors fit into the making of knowledge and careers. See Shapin, *Never Pure*, 2010, for further reflections on science, career, and bodies (which are surprisingly absent in much of the anthropological discussions about fieldwork design).

28 For an American-trained humanistic anthropologist of that era, the "laboratory" brought to mind positivism, behaviorism, and scientism. See Debaene, "A Case of Cultural Misunderstanding," 2013, for further discussion of French and American takes on science among anthropologists.

29 See Ossman, "S.O.S. Racisme," 1989, for more on the organization.

30 Communications scholar Yves Winkin played a key role in introducing these currents in the Francophone milieu. He took part in the program and gave seminars on these topics at the IRMC.

## Chapter 2

1 See Aouchar, "Pratiques Vestimentaires," 1998, in particular for considerations of the development of dress in rural Morocco.

2 This resulted in a conference and a special issue of the journal *Hermès* in 1998. Contributors were Stéphane Bornhausen, Marie Carcasonne, Jean-Noël Darde, Simone Davis, Jean-Noel Ferrié, Jean-Paul Fischer, Annie Gentes, François-Bernard Huyghe, Alain Jauvion, Deborah Kapchan, Dominique Pasquier, Jean-Baptiste Perret, Monique Sicard Roger Silverstone, Jacky Simonin, Michèle Sinapi, Yves Winkin, Adeline Wrona, and Christoph Wulf.

3 Contributors to Ossman, *Miroirs Maghrébins*, 1998, were Amina Aouchar, Jamaa Baida, Gilbert Beaugé, Rabia Bekkar, Habib Belaid, Omar Carlier, Larbi Chouikha, Hannah Davis-Taieb, Jean-Noel Ferrié, Yves Gonzalez-Quijano, Mohammed Kenbib, Abderrahmane Lakhsassi, Hadj Miliani, Abderrahmane Moussaoui, Abdellah Saaf, Marc Schade-Poulsen, Yves Winkin, and me. Chapters on cities and trade routes as arteries of changing forms of media and dress in the nineteenth century, Ramadan television-watching, the attraction of Moroccan women to McDonalds, the role of sport or religion in creating ideal body images, and many other topics including my own contribution on beauty salons.

4 Larbi Chouikha's studies of the specificities of Ramadan soap opera, its rhythms, and its audiences particularly alerted me to this. Chouikha, "La modernité," 1998.

**148** Notes

5 Oakley and Callawy, *Anthropology and Autobiography*, 1992, 8.
6 Ossman, *Three Faces of Beauty*, 2002, 133–4.
7 Thus, I developed my work from a different starting point from a sociologist like Pierre Bourdieu. His subjects were always striving to advance; too often held back by the habits and *habitus* of their birth class and position.
   My writings about beauty engage in particular his work on taste and social distinction: Bourdieu, *La Distinction*, 1979.
8 In *Three Faces of Beauty* I entertained imaginary discussions with Marcel Mauss about this idea of "habitus" in relation to his famous essay, "Techniques of the Body," 1950.
9 Weiss, "Review of *Three Faces*," 2003.

## Chapter 3

1 The vendor is selling *habilles* (clothing), the *sharia'* is a boulevard, the *zenqa* a street.
2 It may have seemed I was reliving tropes of feminist commentary on cleaning practices set in motion by artist Mierle Laderman Ukeles' "Maintenance Manifesto," 1969. Some of the work did focus on "exposing the gendered symmetry of 'the Everyday'." Jackson, *Social Works*, 2011, 89. However, my narrowed attention to laundry instigated not only individual performances, or collective work done by or for women, but also feminist models for collective experiment and collaboration that might be adopted by everyone.
3 Besides "Hang-Dry," I painted a dozen or so other canvases with oils while in Morocco. I gave most of those to friends as gifts. Others are still stored with family in France.
4 See Ossman, painting, "Making Art," 2011.
5 The case was the object of numerous reports in the Moroccan and European press and provoked a large movement for legal reform in the kingdom. Filmmaker Abdelkrim Derkaoui produced a film called "Les Griffes du Passe" (*The Claws of the Past*) based on the tragedy. Articles in English include Kristen McTighe's article in *The New York Times*, https://www.nytimes.com/2012/04/06/world/africa/death-of-rape-victim-in-morocco-sparks-calls-for-legal-reform.html.
6 These are topics that anthropologist-artists Carol Hendrickson and Lydia Nakashima-Degarrod have addressed in depth over the years. See, for example, Hendrickson, "Visual Fieldnotes," 2008; Nakashima-Degarrod, "Making the Unfamiliar Personal," 2013.
7 Glen Bowman, Rupert Cox, Carol Hendrickson, and George Marcus who have played important roles in creating meeting points of art and anthropology were among the participants in this fieldwork experiment.
8 Zagorska-Thomas, "Fabric of Fieldwork," 2014.
9 I thought of Paul Rabinow's suggestion that "today resolute and ardent untimeliness is an important practice to foster," Rabinow, *Marking Time*, 2008, 49. Indeed, to his mind, "if one is committed to untimely anthropological work then being a bit late may well be timely, and being ahead of things, or slightly beside the point, is worth our while," ibid., 50.
10 Laine, *Practicing Art*, 2018, 92. See Laine's introduction for further discussion about the Renaissance as a benchmark for art history and criticism. Laine also discusses Corine Kratz's exhibition of her photographic portraits of Okike people and communities that was also showing simultaneously at the gallery, and describes how she and Katz's work engage with a kind of "prototyping" in the sense George Marcus uses the terms to describe a prototype that is fluid and open to revision (p. 93). I will have occasion to come back to her discussion and Marcus's as I follow later developments of the "Gather Wood, Gather Words" project.
11 Laine, *Practicing Art*, 2018, 6–11, offers an excellent and more detailed account of why it is difficult even for the best-intentioned efforts and individuals to overcome deeply engrained assumptions in both fields.

Notes **149**

12 In the meantime, I had also had the pleasure to exchange ideas about triviality with Yves Jeanneret, who, inspired by Barthes, argued for a more open semiology, and attention to how objects become meaningful thanks to the creative circulation. Jeanneret, *Penser la Trivialité*, 2009.
13 On skill in art, see Sansi, *Art, Anthropology and the Gift*, 2015, 123–5. His analysis and discussions of the role of practice in the arts more generally suggest the building of skills in fieldwork that occurs over multiple projects.
14 Reflecting on hanging out my own dirty laundry resonated with the way that scholars were increasingly interested in the marginalia of their research.
15 In his popular book about doing fieldwork, anthropologist Harry F. Wolcott used the example of laundry to discuss intimacy in the field; Wolcott, *The Art of Fieldwork*, 2005, 72–73.
16 These texts accompanied the exhibition and appear in a slightly modified form here.
17 Balderama, "On the Line," 2013.
18 Lave cited by Ingold, *Making*, 2013, 13.
19 I wish that Andrew Causey's *Drawn to See: Drawing as an Ethnographic Method*, 2017 had been available to guide and reassure the students as they sketched.
20 I thank Mejia-Krumbein for sharing her personal notes taken during the project with me.
21 Personal communication, Beatriz Mejia-Krumbein, 2013.
22 My situation was not that of the curator. Graduate student Astara Light was given that role by the artist/scholars, and Mejia-Krumbein guided her.
23 *Artist-scholars*: Ken Crane, Beatriz Mejia-Krumbein, Tim Musso, Katherine Parsons, Christina Schwenkel, Duncan Simcoe. *Students:* Audrey Coleman-Macheret, Lisa DeLance, Danae Gmuer-Johnson, Robert Finch, Erin Gould, Celso Jaquez, Jared Katz, Astara Light, Joshua Liashenko, German Loffler, Shahab Malik, Kara Miller, James Phillips.
24 While the idea of working through art was challenging to some of the students, the range of possible reactions to my work was, I think, generally less intimidating than having to critique a professor's prose writing and arguments in a seminar. Instead of having to respond point for point, they could work closely with an artwork, a section of the exhibition, or one of the general themes.
25 Following Hooper-Greenhil, Nakashima-Degarrod draws attention to how the gallery shapes a space to "depict what they were feeling and recalling, expressed through the communal sharing of feelings and stories about injustice. The gallery offered the physical space and the cultural setting to share their emotional reactions," Nakashima-Degarrod, *When Ethnographies Enter Art Galleries*, 2009, 139.
26 See the interviews with Landeros in Rashaun Richardson's 2016 film, "On the Line" and with Patrick Brien in the *Press Enterprise*, the newspaper of the Inland Empire region of California, https://www.pe.com/2016/03/03/artist-spotlight-textile-artist-monica-landeros/.

## Chapter 4

1 Although Geertz popularized the expression in a 1988 article for the *New York Review of Books*, anthropologist Renato Rosaldo is credited with first using the term in relation to ethnographic research methodology. See Clifford, "Anthropology and/as Travel," 1996. With regard to the arts and anthropology, see Walmsley, "Deep Hanging Out," 2015.
2 Anthropologist Liisa Malkki has compared the improvisatory work of the ethnographer to that of the jazz musician, noting how the anthropologist in the field is constantly rewriting her "script," Cerwonka and Malkki, *Improvising Theory*, 2007, 180–4. In our case, working with a growing number of people, we had to have a kind of band leader for this process; that is, me. The design needed to take into account

**150** Notes

that people did not all start the project knowing the same "melodies" or "chord progressions" that would be required to improvise.

3 Ness, *Choreographies of Landscape*, 2018, 12. Ness suggests that we might remedy this by attending to under-studied elements in the work of philosopher and scientist Charles Sanders Pierce. I will not enter into dialogue with her important contributions to the understanding of lesser-known parts of his work here.

4 Murphy, "Design and Anthropology," 2016, 435. Also Suchman, "Anthropological Relocations," 2011 for reflections on the dynamics of field design.

5 Ibid.

6 Participants were Jimmy Centano, Josette Dacosta, Deborah Durham, Danae Gmuer-Johnson, Erin Gould, Shelly Guyton, Carol Hendrickson, Erica Johnson, Rebekkah Johnson Guerra, Kylie Kruger, Anh Ly, Beatriz Mejia-Krumbein, Stephanie Miller, Reuben Munoz, Dhiren Panikker, Francisco Ramos, and Elizabeth Stela. The project was developed thanks to the support of the Riverside Arts Council, notably Patrick Brien and Rachel Dzikonski.

7 Whatever the limitations of the *On the Line* experiment, it illustrated the potential for field design to be a leading practice not only for understanding what can be made in social art projects, but for other kinds of social action as well. On the first, see, for example, Finkelpearl, *What We Made*, 2013.

8 Briggs, "The Epistemological Pitfalls of Communicability," 2007, 558–61.

9 Avaunt and Roginski, "When Choreography and Secrets Collide," 2015.

10 Los Angeles Opera in October 2013.

11 Mark Swed, *Los Angeles Times*, October 13, 2013. https://www.latimes.com/entertainment/arts/culture/la-et-cm-einstein-on-the-beach-review-20131014-story.html.

12 Tillion, *Il était une fois l'ethnographie*, 2000, 17. My translation, including the formal name for the device that Tillion familiarly referred to as the "Pachon."

13 "On the Line 2016" participants were: *choreographers* Casey Avaunt and Sue Roginski; *dancers* Val Carnahan, Erica Johnson, Rebekah Johnson-Guerra, Kylie Kruger, and Tracy Tom-Hoon; *engineer* Manja van de Worp; *ethnographers* Frank Ramos and Stephen James; *filmmaker* Rashaun Richardson; *musicians* Gabriel Hartman and Jeff Zahos; *visual artists* Zoe Bray, Jimmy Centano, Sandra Cornejo, Nathanael Dorent, Carrie Ida Edinger, Mike Grandaw, Rebecca Guerrero, Danielle Giudici Wallis, Anh Ly, Monica Landeros, Barbara James, Megan James, Beatriz Mejia-Krumbein, Susan Ossman, and Cindy Rinne; and *writers* Juliann Allison and Deb Durham. In addition, students from UC Riverside and Encore Arts High School exhibited their selected work at the final event in a dedicated exhibition space at the Casa Blanca library.

14 See http://www.carrieida.com/UnfoldingOnTheLine.html.

15 Ibid.

16 Rinne, *Listen*, 2017, 31.

17 The work thus responded to calls for multimodal approaches to anthropology in ways that also engaged appeals for emotional and affective work of humanist anthropology and currents of participatory, collaborative, and activist art. See Bishop, *Participatory Hells*, 2013; Jackson, *Social Works*, 2011.

18 Sommer, *The Work of Art*, 2014, 146.

## Chapter 5

1 See Ossman, "Painting Art," 2011 for a different interpretation of this painting.

2 "Baja California Area Flooded," Dec. 21, 1978, section A, page 8. https://www.nytimes.com/1978/12/21/archives/baja-california-area-flooded.htm.

3 Sayad, *The Suffering of the Immigrant*, 2004.

4 Beck, *Cosmopolitan Vision*, 2006, and my response to it, Ossman, "Beck's *Cosmopolitan Vision*," 2006.

Notes **151**

5 Ossman, "Studies in Serial Migration," 2004.
6 Foucault, *Histoire de la sexualité*, vol. 3, 1984, 84.
7 Foucault, "The Political Function of the Intellectual," 1976.
8 Ossman, *The Places We Share*, 2007.
9 Marcus, "The Legacy of *Writing Culture*," 2012.
10 For more on Oakeshott's attention to how each member in a series "comments" on another, and how I developed this idea in fieldwork and analysis, see Ossman, 2013, 100.
11 Paul Ricoeur and Hayden White were particular guides for this analysis.
12 Ossman, *Moving Matters*, 2013, 19–35.
13 Ossman, *Moving Matters*, 2013, 12–13.
14 Kwon, *One Place after Another*, 2004, 130.
15 Thus, the MMTW's form inherently poses some of the same questions about what is finished and what is not as in Biehl and Locke, *The Anthropology of Becoming*, 2017. At the same time, it engages theories of engagement and reception, since the work it does is both a self-reflexive social exercise on itself, and a work for a given audience, the imagination of which is part of the research carried out to prepare for each workshop.
16 For more on the diagnostic and other analytics in anthropology, see Faubion, *An Anthropology of Ethics*, 2011.

## Chapter 6

1 Indeed, the metaphor of dancing pervades the book. This is not surprising given its themes, but perhaps also a sign of my admiration for the art and an intimation of how it might serve as a powerful accompaniment to further reflections on mobility generally. While some anthropologist colleagues have questioned the use of the term "choreography" for this, saying it suggested a kind of set script, working closely with choreographers and dancers introduced me to the flexibility of that practice, which can embrace substantial improvisation.
2 Ossman, *Picturing Casablanca*, 1994, 71–79.
3 Unfortunately, the art center at the Pavillion Vendôme is no more. A new mayor came to office in 2015 and decided that contemporary art was not what his town needed. An office for tourism replaced it.
4 "Au-delà de cette frontière, votre billet n'est plus valable" was the title, "Beyond this border, your ticket is no longer valid." September 13, 2014–January 5, 2015.
5 I moved from Clichy to Casablanca in September 1988. See Ossman, *Picturing Casablanca*, 1994, 71–72.
6 See Ossman 2013 for further details on how I developed this working definition for that stage of the research, and also, for accounts of the variety of forms of mobility that include, for instance, the displacement of people who "move" from one country to another without ever actually moving house due to shifting borders or the dissolution of states.
7 For a similar argument, see Jerad, "From the Maghreb to the Mediterranean," 2007.
8 Mai has discussed this film about Samira in Mai, *Mobile Orientations*, 2018. His work with actors offers fascinating perspectives on the role of the ethnographer as an intermediary for art making.
9 Also see Suchman, "Anthropological Locations," 2011, who questions the limits of design. Naturally, there are always limits, but one cannot know what they are unless one pushes up against them.
10 One of the current projects of the MMTW is to develop a collectively authored digital book. The audio-visual materials could thus give rise to varied interpretations. Readers/viewers would also have access to significant parts of the collection, so they might analyze our work, too.
11 Srinivasan, "Some Thoughts on Movement and the MMTW," 2017.

**152** Notes

12 Powdermaker, *Stranger and Friend*, 1967, 112.

13 For further details on the performance and workshop, see Balasescu, Alexandru, and Olga Sezneva, "When Anthropologists Act as Artifacts," 2017. Sezneva continues to reflect on theses of possession and dispossession of objects from the perspective of research on the presently Russian, formerly Soviet, and longtime German city of Koenigsburg. Sezneva, "Of Trophy and Triumph," 2019.

14

> "In discussions on collaboration in philosophy (Stengers 2011), anthropology (Lassiter 2005; Sanjek 2015) and art (Ravetz, Kettle, and Felcey 2013), what characterizes collaboration is a certain equality or mutuality of the participants involved. However, we found that for the flow of learning and creativity to occur, the persons involved needed to allow themselves to disappear in some sense. In many ways this surrender was necessary for those moments of work that were most collaborative. We consider how such surrender, which enables a deep mutuality, can occur but not descend into the creation of unequal or hierarchical relationships? For it is precisely in hierarchical relationships that what is erased is the specificity of what the subjugated party has to offer; that party's presence is obscured."
> Ang and Gatt, "Collaboration and Emergence," 2017–2018, 70

15 This is a topic that has led to extensive conversations with respect to both other evolving artworks, particularly Blanca Casas Brullet's plastic sacks, and the motifs we work with in performances.

16 Deleuze and Guattari, *Différence et Répétition*, 1968.

17 Balasescu, "Adopt a Canadian," 2017.

18 Ossman, "Elective Anxieties," 2018. This online article also presents an account of the site-by-site development of some visual works of art.

19 See Schwadron, "I, Thou, and the Sphere of Betweenness," 2018.

20 Faller, "The Moving Matters Traveling Workshop," 2017. In German, there are two words for the single English "walls" that distinguish between these two: "Grenzen" and "Mauren."

21 For an interview with Lisa Strehmann, co-curator of the exhibition and administrator with the Refugee Office of the East Berlin Protestant Dinary about the exhibition and project, see Ossman, "Is Berlin Done with Walls?" 2017.

22 For photos of these works and more, see Ossman, "Elective Anxieties," 2018.

23 Philosopher and MMTW member Felip Marti-Jufresa organized the meeting.

24 Schwadron has written extensively on dance, gender, and Jewish "joke work" in the United States. Perhaps it was under her influence as well as the ambient political situation that the performance also took this tone. Schwadron, *The Case of the Sexy Jewess*, 2018.

25 Srinivasan, "Decolonising Moves: Gestures of Reciprocity as Feminist Intercultural Performance," 2019, proposes further reflections on decolonizing performance from a feminist perspective. See also Srinivasan, *Sweating Saris*, 2011.

26 The effects of this work and that of other artists and scholars have changed how the Netherlands is viewing and debating its colonial history. For one of the many news accounts, see Daniel Boffey, "End of Golden Age: Dutch museum bans term from exhibits," September 13, 2019, https://www.theguardian.com/world/2019/sep/13/end-of-golden-age-amsterdam-museum-bans-term-from-exhibits.

27 Drucker, *Graphesis*, 2014, 178.

28 Cooper, *Everyday Utopias*, 2014, offers an overview of utopian art projects along with concrete examples.

## Conclusion

1 Theocritus, *Idylls*, 49. Also see Frazier, *The Golden Bough*, 47.

# BIBLIOGRAPHY

Abbott, Andrew. "Against Narrative: A Preface to Lyrical Sociology," *Sociological Theory* 25(1 March) (2007): 67–99.

Abu-Lughod, Lila. *Veiled Sentiments, Honor and Poetry in a Bedouin Society*. Berkeley, University of California Press, 1986.

Adida, Claire L., Laitin, David D. and Marie-Anne Valfort. "Identifying Barriers to Muslim Integration in France," *Proceedings of the National Academy of Science of the America* 7(52) (2010): 384–390.

Affergan, Francis. *La Pluralite des mondes, Vers une autre anthropologie*. Paris, Albin, 1997.

Allison, Juliann and Susan Ossman. "Making Matrice: Intersubjectivity in Ethnography and Art," *Collaborative Anthropologies* 7(Fall) (2014): 1–25.

Anderson, Benedict. *Imagined Communities: Reflections on the Origins and Spread of Nationalism*. London, Verso, revised edition 1991.

Ang, Gey Pin and Caroline Gatt. "Collaboration and Emergence: The Paradox of Presence and Surrender," *Collaborative Anthropologies* (Fall-Spring) (2017–2018): 66–93.

Appadurai, Arjun, ed. *The Social Life of Things: Commodities in Cultural Perspective*. Cambridge, Cambridge University Press, 1986.

———. *Modernity at Large: Cultural Dimensions of Globalization*. Minneapolis, University of Minnesota Press, 1996.

Asad, Talal, ed. *Anthropology & the Colonial Encounter*. Ithaca, NY, Ithaca Press, 1973.

Augé, Marc. *Non-Lieux, Introduction à une anthropologie de la surmodernité*. Paris, Le Seuil, 1992.

———. *Pour une anthropologie des mondes contemporains*. Paris, Flammarion, 1994.

Bachelard, Gaston. *La poétique de l'espace*. Paris, Presses Universitaires de France, 1957, trans. *The Poetics of Space* by Marie Jolas. Boston, MA, Beacon, 1981.

Balasescu, Alexandru. "Adopt a Canadian," *Allegra Lab*, November 17, 2017. https://allegralaboratory.net/adopt-canadian-short-story/

Balasescu, Alexandru and Olga Sezneva, "When Anthropologists Act as Artefacts," *Allegra Lab*, May 18, 2017. https://allegralaboratory.net/when-anthropologists-act-as-artifacts-a-conversation-between-an-ancient-hairpin-alec-balasescu-and-a-gold-horse-olga-sezneva/

**154** Bibliography

Balderama, Jaqueline. "On the Line, a Painting Exhibition by Susan Ossman," *The Highlander* 13(February) (2013).

Balendier, Georges. *Le Désordre, éloge du Mouvement*. Paris, Fayard, 1988.

Barth, Fredrik, Andre Gingrich, Robert Parkin, eds. *One Discipline, Four Ways: British, German, French, and American Anthropology*. Chicago, IL, University of Chicago Press, 2005.

Barthes, Roland. *Le degré zéro de l'écriture*. Paris, Le Seuil, 1953.

Bateson, Gregory. "Style, Grace and Information in Primitive Art," in *Steps to an Ecology of Mind*, New York, Ballatine Books, 1972.

Battaglia, Debbora, ed. *Rhetorics of Self-Making*. Berkeley, University of California Press, 1995.

Beck, Ulrich. *Cosmopolitan Vision*. London, Polity Press, 2006.

Becker, Howard S. *Art Worlds*. Updated edition. Berkeley, University of California Press, 2002.

Behar, Ruth. *An Island Called Home: Returning to Jewish Cuba*. New Brunswick, NJ, Rutgers University Press, 2007.

Behar, Ruth and Deborah A. Gordon, eds. *Women Writing Culture*. Berkeley, University of California Press, 1996.

Benhabib, Seyla. *Situating the Self: Gender, Community and Postmodernism in Contemporary Ethics*. Oxford, Polity Press, 1992.

Benjamin, Walter. *Illuminations*. New York, Schoken Books, 1969.

———. "Doctrine of the Similar," trans. Knut Tarnowski, *New German Critique* 17, Spring 1979 (original 1933), 65–69.

Berger, John. *Ways of Seeing*. London, Penguin, 1972.

Berman, Marshall. *All That Is Solid Melts into Air. The Experience of Modernity*. New York, Penguin, 1982.

Bhabha, Homi. *The Location of Culture*. London, Routledge, 1994.

Biehl, Joao and Peter Locke, eds. *Unfinished: The Anthropology of Becoming*. Durham, NC, Duke University Press, 2017.

Bishop, Catherine. *Artificial Hells, Participatory Art and the Politics of Spectatorship*. London, Verso, 2012.

Boffey, Daniel. "End of Golden Age: Dutch museum bans term from exhibits," *Guardian Online*, September 13, 2019. https://www.dw.com/en/dutch-museum-bans-golden-age-from-exhibitions/a-50423426

Boltaniski, Luc and Laurent Thévenot. *De la Justification. Les économies de la grandeur*. Paris, Gallimard, 1991.

Borneman, John and Abdellah Hammoudi, eds. *Being There. The Fieldwork Encounter and the Making of Truth*. Berkeley, University of California Press, 2009.

Boulouiz, Bouchra, *Rouge Henné*. Harhoura, Fondation Rosselli Maroc, 2012.

Bourdieu, Pierre. *La Distinction*. Paris, Editions de Minuit, 1979.

———. *Homo Academicus*. Paris, Editions de Minuit, 1984.

———. "L'illusion biographique," *Actes de la Recherche en Sciences Sociales* 62(63) (1986): 69–72.

Braudel, Fernand. *Le Méditerranée et le Monde Méditerranéen à l'Epoque de Philippe II*. Paris, Armand Colin, 1982.

Bray, Zoe. "Anthropology with a Paintbrush: Naturalist–Realist Painting as 'Thick Description'," *Visual Anthropology Review* 31(2 Fall) (2015): 119–133.

Brecht, Bertold. *Brecht on Theater. Selected Notes and Essays*, trans. John Willet. New York, Methuen, Hill and Wang, 1964.

## Bibliography    155

Briggs, Charles L. "Anthropology, Interviewing, and Communicability in Contemporary Society," *Current Anthropology* 48(4 August) (2007): 551–580.

Brodine, Maria, et al. "Ethnographic Terminalia: An Introduction," *Visual Anthropology Review* 27(1) (2011): 49–51.

Brown, Peter. *The Body and Society – Men, Women, and Sexual Renunciation in Early Christianity.* New York, Columbia University Press, 1988.

Büscher, Monika and John Urry. "Mobile Methods and the Empirical," *European Journal of Social Theory* 12(1) (2009): 99–116.

Caillois, Roger. *Les Jeux et les Hommes.* Paris, Gallimard, 1958.

Calhoun, Craig. "Belonging in the Cosmopolitan Imaginary," *Ethnicities* 3(4) (2003): 531–568.

Cantarella, Luc, Christine Hegel and George E. Marcus. "A Week in Pasadena: Collaborations toward a Design Modality for Ethnographic Research," *Field* (Spring) (2015): 53–94.

Carlier, Omar. "Le café maure. Sociabilité masculine et effervescence citoyenne (Algerie XVII-XXeme siècle)," *Annales ESC* 4 (1990): 975–1004.

Causey, Andrew. *Drawn to See. Drawing as an Ethnographic Method.* Toronto, University Toronto Press, 2017.

Certeau, Michel de. *The Practice of Everyday Life*, trans. Steven Rendall. Berkeley. University of California Press, 1984.

Cerwonka, Allaine and Liisa H. Malkki. *Improvising Theory. Process and Temporality in Ethnographic Fieldwork.* Chicago, IL, University of Chicago Press, 2007.

Cesara, Manda. *Reflections of a Woman Anthropologist: No Hiding Place.* London, Academic Press, 1982.

Chernysheva, Liubov and Olga Sezneva. "Commoning beyond 'Commons': The Case of the Russian '*obshcheye*'," in Law, J. and Mol, A. *On Other Terms, The Sociological Review Monographs*, 68(2) (2020).

Chin-Davidson, Jane. "Performance Art, Performativity and Environmentalism in the Capitalocene," in *Oxford Research Encyclopaedia of Literature*, 2019. doi: 10.1093/acrefore/9780190201098.013.93

Clark, William. *Academic Charisma and the Making of the Research University.* Chicago, IL, University of Chicago Press, 2006.

Clifford, James. "Anthropology and/as Travel," *Etnofoor Jaarg* 9(2) (1996): 5–15.

Cohen, Shana. *Transforming Social Action into Social Change. Improving Policy and Practice.* London, Routledge, 2018.

Coleman, Simon and Peter Collins, eds. *Locating the Field: Space, Place and Context in Anthropology.* Oxford, Berg, 2006.

Cooper, Davina. *Everyday Utopias. The Conceptual Life of Promising Spaces.* Durham, NC, Duke University Press, 2014.

Cox, Rupert, ed. *The Culture of Copying in Japan, Critical and Historical Perspectives.* London, Routledge, 2008.

Cox, Rupert, Andrew Irving and Chris Wright, eds. *Beyond Text? Critical Practices and Sensory Anthropology.* Manchester, Manchester University Press, 2016.

Crapanzano, Vincent. *Imaginative Horizons. Literary-Philosophical Anthropology.* Chicago, IL, University Chicago Press, 2004.

Crehan, Kate. *Community Art, An Anthropological Perspective.* London, Berg, 2011.

Damish, Hubert. *L'Origine de la perspective.* Paris, Flammarion, 1987.

Dattatreyan, E. Gabriel and Isaac Marrero-Guillamó. "Introduction: Multimodal Anthropology and the Politics of Invention," *American Anthropologist* 121(1) (2019): 220–228.

**156** Bibliography

Davis, Genie. "Susan Ossman, Her Moving Matters Gives Prescient Insight," *Diversions LA* 9 (January) (2019). http://diversionsla.com/susan-ossman-her-moving-matters-offers-prescient-insight/

Davis, Hannah, Rabia Bekkar and Jean-Claude David, eds. *Espace Public, parole publique dans le Monde Arabe.* Paris, L'Harmattan, 1997.

Davis, Natalie Z. *Women on the Margins: Three Seventeenth-Century Lives.* Cambridge MA, Harvard University Press, 1995.

Debaene, Vincent. "A Case of Cultural Misunderstanding: French Anthropology in Comparative Perspective," *Cultural Anthropology* 284 (2013): 647–669.

Deeb, Lina and Jessica Winegar. *Anthropology's Politics, Disciplining the Middle East.* Stanford, CA, Stanford University Press, 2016.

Deleuze, G. and Félix Guattari. *Différence et Répétition.* Paris, Presses Universitaires de France, 1968.

Dewey, John. *Art as Experience.* New York, Paragon, 1934.

Dilley, Roy M. "The Problem of Context in Social and Cultural Anthropology," *Language & Communication* 22 (2002): 437–456.

Drucker, Joan. *Graphesis. Visual Forms of Knowledge Production.* Cambridge, MA, Harvard University Press, 2014.

Fabian, Johannes. *Time and the Other: How Anthropology makes Its Object.* New York, Columbia University Press, 1983.

Falasca-Zamponi, Stefania. "Review: *Picturing Casablanca: Portraits of Power in a Modern City,*" *Contemporary Sociology* 25(3) (1996): 409–410.

Faller, Helen. "The Moving Matters Traveling Workshop: An Interview with Susan Ossman," *Allegra Lab,* April 12, 2017. https://allegralaboratory.net/interview-moving-matters-traveling-workshop/

Faubion, James D. *Modern Greek Lessons: A Primer in Historical Constructivism.* Princeton, NJ, Princeton University Press, 1993.

———. *The Anthropology of Ethics.* Cambridge, Cambridge University Press, 2011.

Faubion, James D. and George Marcus. *Fieldwork Is Not What It Used to Be. Learning Anthropology's Method in a Time of Transition.* Cornell, Cornell University Press, 2009.

Ferrié, Jean-Noel. "Culture publique et lieux intérieurs au Maroc," *Politix* 31 (1995): 187–202.

Ferrié, Jean-Noel and Gilles Boetch. "La Formation de l'aire Culturelle méditerranéenne par les anthropologues européennes du XIX siècle," in *Antropologia Contemporanea,* 15(1) (1992): 75–81.

Finkelpearl, Tom. *What We Made. Conversations on Art and Social Cooperation.* Durham, NC, Duke University Press, 2013.

Foster, Stephen W. "On Listening: Polyphony and the Vagueries of Representation," *Anthropology and Humanism* 44(2) (2019): 248–259.

Foucault, Michel. "The Political Function of the Intellectual," *Radical Philosophy* 17(13) (1977): 126–133.

———. *Histoire de la sexualité,* 3 vos. Paris; Gallimard, 1984.

———. "L'éthique du souci de soi comme pratique de la liberté." In *Dits et écrits II, 1976–1988,* Paris, Gallimard/Le Seuil, 1527–1548.

Francastel, Pierre. *L'Image, la Vision et l'Imagination, de la Peinture au Cinéma.* Paris, Denoël/Gonthier, 1983.

Frazer, Sir Thomas. *The Golden Bough,* vol. 7: Spirits of the Corn and the Wild. Cambridge, Cambridge University Press, 1912 (third edition).

Füssel, Marian, "A Struggle for Nobility: 'Nobilitas literaria' as Academic Self-Fashioning in Early Modern Germany," in *Scholarly Self-Fashioning and Community in the Early*

*Modern University*, ed. Richard Kirwan, 103–120, Farnham, Surrey and Burlington, VT, Ashgate, 2013.

Ganim, John and Shayne A. Legassie, eds. *Cosmopolitanism and the Middle Ages*. New York and London, Palgrave, 2013.

Gatt, Caroline and Tim Ingold. "From Description to Correspondence, Anthropology in Real Time," in *Design Anthropology, Theory and Practice*, eds. Wendy Gunn, Tom Otto and Rachel Charlotte-Smith, London, 139–158, New York, Bloomsbury, 2013.

Gebauer, Gunter and Christoph Wulf. *Mimesis: Culture, Art, Society*, trans. Don Reneau. Berkeley, University California Press, 1994.

Geertz, Clifford. *The Interpretation of Cultures*. New York, Basic Books, 1973.

———. "Deep Hanging Out," *The New York Review of Books* 45(16) (1998): 69–72.

———. "An Inconstant Profession: The Anthropological Life in Interesting Times," *Annual Review of Anthropology* 31 (2001): 1–19.

Gefou-Madianou, Dimitra. "Ethnography in Motion. Shifting Fields on Airport Grounds," in *Ethnographic Practice in the Present*, eds. Marit Melhuus, Jon P. Mitchell and Helena Wulff. New York and Oxford, Berghan Books, 2010.

Giordano, Cristiana and Greg Pierotti. "Getting Caught: A Collaboration On- and Off Stage between Theater and Anthropology." *The Drama Review* 64 (1) (2020): 88–106.

Goffman, Irving. *The Presentation of Self in Everyday Life*. New York, Anchor, 1959.

Gonzalez-Quijano, Yves and Susan Ossman. "Les Nouvelles Cultures dans le Monde Arabe'," *Les Cahiers de l'Orient* 21 (1990): 161–167.

Goodman, Nelson. *Ways of Worldmaking*. Indianapolis, Hackett, 1978.

Goody, Jack. *The Logic of Writing and the Organization of Society*. Cambridge, Cambridge University Press, 1986.

Gratton, Johnnie and Michael Sheringham, eds. *The Art of the Project. Projects and Experiments in Modern French Culture*. New York and Oxford, Berghan Books, 2005.

Grewal, Inderpal and Caren Kaplan, eds. *Scattered Hegemonies: Postmodernity and Transnational Feminist Practices*. Minneapolis, University of Minnesota Press, 1994.

Grosz, Elizabeth. *Volatile Bodies: Toward a Corporeal Feminism*. Bloomington, University of Indiana Press, 1994.

Gupta, Arjun and James Ferguson, eds. *Anthropological Locations: Boundaries and Grounds of a Field Science*. Berkeley, University of California Press, 1997.

Habermas, Jurgen. *The Theory of Communicative Action, vol. 1, Reason and the Rationalization of Society*, trans. Thomas McCarthy. Boston, MA, Beacon, 1984.

———. *The Structural Transformation of the Public Sphere*, trans. Thomas Berger and Frederick Lawrence. Cambridge, MIT Press, 1991.

Heidegger, Martin. "Building Dwelling Thinking," in *Poetry, Language, Thought*, trans. Albert Hofstadter. New York, Harper and Row, 1971.

Heinich, Natalie. *Le Paradigme de l'art contemporain. Structures d'une révolution artistique*, Paris, Gallimard, 2014.

Hendrickson, Carol. "Visual Fieldnotes: Drawing Insights in the Yucatan', *Visual Anthropology Review* 24(2) (2008): 117–132.

———. "Drawing in the Dark: Seeing, Not Seeing, and Anthropological Insight." *Anthropology and Humanism* 44 (2) (2019): 198–213.

Hogan, Susan and Sarah Pink. "Routes to Interiorities: Art Therapy and Knowing in Anthropology," *Visual Anthropology* 23(2) (2010): 158–174.

Ibn, Khaldun. *The Muquaddimah: An Introduction to History*, trans. Franz Rosenthal, N.J. Dawood. Princeton, NJ, Princeton University Press, 1967.

———. *Le Voyage d'occident et d'orient*, Introduction and French translation by Abdessellam Cheddadi. Paris, Sindbad, 1980.

## 158 Bibliography

Ingold, Tim. *Lines, a Brief History*. London, Routledge, 2009.

———. *Making. Anthropology, Archaeology, Art and Architecture*. London, Routledge, 2013.

Jackson, Sharon. *Social Works, Performing Art, Supporting Publics*. Abingdon/New York, Routledge, 2011.

Jeanneret, Yves. *Penser la trivialité. Volume 1: La vie triviale des êtres culturels*. Paris, Hermès-Lavoisier, 2008.

Jerad, Nabiha. "From the Maghreb to the Mediterranean. Immigration and Transnational Locations," in *The Places We Share: Migration, Subjectivity and Global Mobility*, ed. Susan Ossman. Lanham, MD, Lexington Press, 2007.

Johnson, Jacqueline Bell. "How the World and Time Intersect: Visiting the Studio of Susan Ossman," *Art and Cake*, March 11, 2019. https://artandcakela.com/2019/03/11/how-the-world-time-intersect-visiting-the-studio-of-susan-ossman/

Kapchan, Deborah, ed. *Theorizing Sound Writing*. Middleton, CT, Wesleyan University Press, 2017.

Kester, Grant H. *Conversation Pieces, Community and Communication in Modern Art*. Berkeley, University of California Press, 2013 (2nd edition).

Khatibi, Abdelkebir. *Plural Maghreb: Writings on Postcolonialism*, trans. Yalim, Burcu. London, Bloomsbury, 2019.

Kilito, Adefettah. *La Querelle des images*. Casablanca, Eddif, 1995.

Kwon, Michelle. *One Place after Another. Site-specific Art and Locational Identity*. Cambridge, MIT Press, 2004.

Laine, Anna. *Practicing Art and Anthropology: A Transdisciplinary Journey*. London, Bloomsbury, 2018.

Lambe, Claire, Susan Ossman and Katarzyna Puzon. *Wissen/Schaffen, an Exhibition by Claire Lambe and Susan Ossman*. Printed by the authors, 2018.

Langer, Susan. *Feeling and Form, A Theory of Art*. London, Routledge and Kegan Paul, 1953.

Laroui, Abedellah. *The Crisis of the Arab Intellectual, Traditionalism or Historicism*, trans. Diarmaid Cammell. Berkeley, University California Press, 1976.

Law, John and Annemarie Mol. "Words to Think With: An Introduction," *The Sociological Review Monographs* 68(2) (2020): 263–282.

Leveau, Remy. "Quel avenir pour la présence culturelle française dans le monde arabe," *Esprit/Cahiers de l'Orient* 172 (1991): 108–132.

Levi-Strass, Claude. *Tristes Tropiques*. Paris, Pocket, Terre Humaine poche, 2018 (original 1955).

Levine, Caroline. *Forms, Whole, Rhythm. Hierarchy and Network*. Princeton, NJ, Princeton University Press, 2015.

Lurhmann, Tanya. "What Counts as Data," in *Emotions in the Field: The Psychology and Anthropology of Fieldwork Experience*, eds. J. Davies and D. Spencer. Palo Alto, CA, Stanford University Press, 2010.

MacGregor, Arthur, ed. *Naturalists in the Field: Collecting, Recording and Preserving the Natural World from the Fifteenth to the Twenty-First Century*. Leiden and Boston, Brill, 2018.

Mai, Nick. *Mobile Orientations: An Intimate Autoethnography of Migration, Sex Work, and Humanitarian Borders*. Chicago, IL, University of Chicago Press, 2018.

Marcus, George E. 1995. "Ethnography in/of the World System: The Emergence of Multi-Sited Ethnography," *Annual Review of Anthropology*, 24 (1995), 95–117.

———."Affinities: Fieldwork in Anthropology Today and the Ethnographic in Artwork," in *Art and Anthropology*, eds. A. Schneider and C. Wright. Oxford, Berg, 2011.

———. "The Legacy of *Writing Culture* and the Near Future of the Ethnographic Form, a Sketch," *Cultural Anthropology* 27(3) (2012): 427–445.

Mauss, Marcel. *Sociologie et anthropologie*. Paris, PUF, 1950.

McLean, Stuart. *Fictionalizing Anthropology. Encounters and Fabulations at the Edges of the Human*. Minneapolis, University of Minnesota Press, 2017.

Mejia-Krumbein, Beatriz. "Dwelling Among Walls, An Artist Prepares for MMTW Berlin," *Allegra Lab*, March 2017. https://allegralaboratory.net/dwelling-among-walls-an-artist-prepares-for-mmtw-berlin/

Melhuus, Merit. "Issues of Relevance, Anthropology and the Challenge of Cross-Cultural Comparison," in *Anthropology by Comparison*, eds. Andre Eingrich and Richard G. Fox. London, Routledge, 2002.

Menocal, María Rosa. *Shards of Love: Exile and the Origins of the Lyric*. Durham, NC, Duke University Press, 1993.

Mernissi, Fatima. *Dreams of Trespass: Tales of a Haram Girlhood*. Reading, MA, Addison Wesley, 1994.

Miller, Susan. *Disorienting Encounters: Travels of a Moroccan Scholar in France in 1845–86*. Berkeley, University of California Press, 1992.

Minh-ha, Trin T. *Woman, Native, Other*. Bloomington, Indiana University Press, 1989.

Mondzain, Marie-Jose. *Image, icone, économie. Les sources byzantines de l'imaginaire contemporain*. Paris, Le Seuil, 1996.

Morely, David. *Home Territories. Media, Mobility and Identity*. London, Routledge, 2000.

Murphy, Keith M. "Design and Anthropology," *Annual Review of Anthropology* 45 (2016): 433–449.

Nakashima-Degarrod, Lydia. *When Ethnographies Enter Art Galleries, Museum Immaterialities, Objects, Engagements, Interpretations*, ed. S. H. Dudley, 128–142. London, Routledge, 2009.

———. "Making the Unfamiliar Personal: Arts-based Ethnographies as Public-engaged Ethnographies," *Qualitative Research* 13(August) (2013): 402–413.

———. "Atlas of Dreams. Unveiling the Invisible in the San Francisco Bay Area," *Visual Anthropology Review* 13(1 Spring) (2017): 74–88.

Narayan, Kirin. "Ethnography and Fiction: Where Is the Border?" *Anthropology and Humanism* 4(2) (1999): 134–147.

Ness, Sally Ann. *Choreographies of Landscape: Signs of Performance in Yosemite National Park*. New York, London, Berghan Books, 2016.

Noland, Carrie A. and Sally Ann Ness, eds. *Migrations of Gestures*. Minneapolis, University Minnesota Press, 2008.

Oakeshott, Michael. *Experience and Its Modes*. Cambridge, Cambridge University Press, 1995 (original 1933).

Oakley, Judith and Helen Callaway, eds. *Anthropology and Autobiography*, ASA monographs. London, Routledge, 1992.

O'Neil, Paul. *The Culture of Curating and the Curating of Culture(s)*. Cambridge, MIT Press, 2012.

Ong, Walter. *Orality and Literacy: The Technologizing of the Word*. Ithaca, NY, Cornell University Press, 1977.

Ortega Ayala, Raoul. "Immersions: Raul Ortega Ayala in Conversation with Chris Wright," in *Anthropology and Art Practice*, eds. Arnd Schneider and Chris Wright. London, Bloomsbury, 2013.

Ossman, Susan. "S.O.S. Racisme: Studied Disorder in France," *Socialist Review* 88 (Spring) (1988).

———. "Salons de coiffures au Maroc," *Les Cahiers de l'Orient* 21 (1990).

———. *Picturing Casablanca: Portraits of Power in a Modern City*. Berkeley, University of California Press, 1994.

———. "L'ailleurs est nulle part: Remarques sur les mouvements de personnes à partir du Maroc," in *L'influence des migrations internationales sur le Maghreb*, eds. Lawrence Michalak et al. Tunis, Presse de l' Université de Tunis I, 1997.

## 160 Bibliography

———. "La Manifestation de sentiments, des slogans marocains contre la guerre du Golfe," in *Espace Public, Parole Publique au Maghreb et au Machrek*, eds. Davis- Taïeb, Hannah, Rabia Bekkar, Jean-Claude David. Paris, Maison de l'Orient/L'Harmattan, 1997.

———, ed. *Miroirs Maghrébins, Itinéraires de soi et Paysages de Rencontre*. Paris, CNRS Editions, 1998.

———, ed. *Mimesis: imiter, représenter, circuler. Hermès*, 22, Paris, CNRS Editions, 1998.

———. "Parcours et partages: pérégrination sur le savoir pratique des anthropologues," in *Parcours d' Intellectuels Maghrebins*, ed. A. Kadri. Paris, Karthala, 1999.

———. "Cucina, Lugares de restauration y formas de poder en Marruecos," in *Cocinas del Mundo. La politica en la mesa*, eds. Francisco Letamandia and Christian Coulon. Madrid, Editorial Fundamentos, 2000.

———. "Out of the Blue Room: Space and Kin in a Split Level House," in *The Ethics of Kinship*, ed. James D. Faubion. Boulder, CO, Rowman and Littlefield, 2001.

———. *Three Faces of Beauty: Casablanca, Paris, Cairo*. Durham, NC, Duke University Press, 2002.

———. "Media, Bodies and Spaces of Ethnography: Beauty Salons in Casablanca, Cairo and Paris," in *Media/Space: Place, Scale and Culture in a Media Age*, eds. Nick Couldry and Anna McCarthy. London, Routledge, 2004a.

———. "Studies in Serial Migration," *International Migration* 42(4 October) (2004b): 111–121.

———. "Beck's *Cosmopolitan Vision* or Plays on the Nation," *Ethnos*, 71 (4) (2006): 559–568.

———. "Cinderella, CVs and Neighborhood *Nemima*: Announcing Morocco's Royal Wedding," *Comparative Studies of South Asia, Africa and the Middle East* 27(3 November/December) (2007a): 425–439.

———, ed. *The Places We Share: Migration, Subjectivity and Global Mobility*. Lanham, MD, Lexington Press, 2007b.

———. "Making Art Ethnography: Painting, War and Ethnographic Practice," in *Art and Anthropology*, eds. A. Schneider and C. Wright. London, Berg, 2011a.

———. "Seeing Princess Selma: Transparency and Transnational Intimacies," in *Circuits of Visibility: Gender and Transnational Media Cultures*, eds. R. Hegde and A. Valdivia. New York, New York University Press, 2011b.

———. *Moving Matters, Paths of Serial Migration*. Stanford, Stanford University Press, 2013a.

———. *On the Line*. Exhibition Catalogue, printed by author, 2013b.

———. "Anthropologie Visuelle," *La Vie des Idées*, October 2014.

———. "On the Line: A Report on Shifting Collaborations around Clotheslines," *Critical Arts* (June) (2016): 446–463.

———. "Is Berlin Done with Walls? An Interview with Lisa Strehmann," *Allegra Lab*, June 22, 2017. https://allegralaboratory.net/is-berlin-done-with-walls-mmtw/

———. "Wissen/Schaffen; a Photo Essay," *Allegra Lab*, January 26, 2018a. https://allegra laboratory.net/wissenschaffen-fieldwork-exhibition-photo-essay/

———. "Elective Anxieties: Migrating Art with the Moving Matters Traveling Workshop," *Europe Now*, July. https://www.europenowjournal.org/2018/07/01/elective-anxieties-migrating-art-with-the-moving-matters-traveling-workshop, 2018b.

———. An Exhibition in Fieldwork Form, *HAU Journal of Ethnographic Theory*, in press 2021.

Pandian, Anand and Stuart McLean, eds. *Crumpled Paper Boat*. Durham and London: Duke University Press, 2017.

Pandolfo, Stefania. "'The Burning': Finitude and the Politico-theological Imagination of Illegal Migration," *Anthropological Theory* 7(3) (2007): 329–363.

Petch, Alison. "Notes and Queries and the Pitt Rivers Museum," *Museum Anthropology* 30 (2007): 21–39.

Pink, Sarah, and David Howes. "The Future of Sensory Anthropology/The Anthropology of the Senses." *Social Anthropology* 18 (3) (2010): 331–340.

Pomata, Gianna. "Observation Rising: Birth of an Epistemic Genre, 1500–1650," in *Histories of Scientific Observation*, eds. Lorraine Daston and Elizabeth Lunbeck. Chicago, IL, University of Chicago Press, 44–80, 2011.

Powdermaker, Hortense. *Stranger and Friend, The Way of the Anthropologist*. New York, Norton and Company, 1967.

Pusetti, Chiara. "Ethnography-based Art. Undisciplined Dialogues and Creative Research Practices. An Introduction," *Visual Ethnography* 7(1) (2018): 1–12.

Rabinow, Paul. *French Modern: Norms and Forms of the Social Environment*. Cambridge, MA, MIT Press, 1989.

———. *Reflections on Fieldwork in Morocco*. Berkeley, University of California Press, 2007 (2nd edition).

———. *Marking Time, On the Anthropology of the Contemporary*. Princeton, NJ, Princeton University Press, 2008.

Rabinow, Paul, G. George Marcus, James D. Faubion and Robias Rees. *Designs for an Anthropology of the Contemporary*. Durham, NC, Duke University Press, 2008.

Rappaport, Joanne. "Beyond Participant Observation: Collaborative Ethnography as Theoretical Innovation," *Collaborative Anthropologies* 1 (2008): 1–31.

Ricoeur, Paul, *Temps et récit*, Tome I: *L'Intrigue et le récit historique*. Paris, Le Seuil, 1983.

———Tome II : *La Configuration dans le récit de fiction*. Paris, Le Seuil, 1984.

———Tome III : *Le Temps raconté*. Paris, Le Seuil, 1985.

———. *La mémoire, l'histoire, l'oubli*. Paris, Le Seuil, 2000.

Rinne, Cindy. *Listen to the Codex*. Littlerock, CA, Yak Press, 2017.

Roginski, Sue and Casey Avaunt. "When Choreography and Secrets Collide, A Collaborative Art Project Seeks to Turn Community Memories Into Dance," *Zocalo Public Square*, December 16, 2015.

Sanjak, Roger, ed. *Field Notes. The Making of Anthropology*. Ithaca, NY, Cornell University Press, 1990.

Sansi, Roger. *Art, Anthropology and the Gift*. London, Bloomsbury, 2015.

Sayad, Abdelmalik. *The Suffering of the Immigrant*, trans. David Macey. London, Polity, 2004.

Schneider, Arnd. "Appropriations Across Disciplines: The Futures of Art and Anthropology Collaborations," in *Beyond Text? Critical Practices and Sensory Anthropology*, eds. Rupert Cox, A. Irving and Chris Wright. Manchester, Manchester University Press, 2016.

Schneider, Arnd and Chris Wright, eds. *Between Art and Anthropology*. London, Berg, 2010.

———. *Anthropology and Art Practice*. London, Bloomsbury, 2013.

Schwadron, Hannah. *The Case of the Sexy Jewess: Dance, Gender and Jewish Joke-Work in US Pop Culture*. Oxford, Oxford University Press, 2018.

———. "I, Thou, and the Sphere of Betweenness: Dancing Difference in One Direction," *PARtake: The Journal of Performance and Research* 2(1) (2018): 1–19.

Schwenkel, Christina. *Building Socialism, The Afterlife of East German Architecture in Urban Vietnam*. Durham, Duke University Press, 2020.

Sezneva, Olga. "We Have Never Been German: The Economy of Digging in Russian Kaliningrad," in *Practicing Culture*, eds. Craig Calhoun and Richard Sennett. London, New York, Routledge, 2007.

**162** Bibliography

———. "Of Trophy and Triumph: Affective Attachments and Proprietary Feelings in Koenigsberg/Kaliningrad, 1945–1950," in *Spatial Justice in the City*, ed. Sophie Watson. London, Routledge, 2019.

Shapin, Stephen. *Never Pure: Historical Studies of Science as If It was Produced by People with Bodies, Situated in Time, Space, Culture, and Society, and Struggling for Credibility and Authority*. Baltimore, MD, Johns Hopkins University Press, 2010.

Sharman, Russel Leigh. "Style Matters: Ethnography as Method and Genre," *Anthropology and Humanism* 32(2) (2007): 117–129.

Slyomovics, Susan. *The Performance of Human Rights in Morocco*. Philadelphia, University of Pennsylvania Press, 2005.

———. *How to Accept German Reparations*. Philadelphia, University of Pennsylvania Press, 2015.

Sommer, Doris. *The Work of Art in the World. Civic Agency and Public Humanities*. Durham, NC, Duke University Press, 2014.

Sperber, Dan. *La Contagion des idées*. Paris, Editions Odile Jacob, 1996.

Srinivasan, Priya. *Sweating Saris, Indian Dance as Transnational Labor*. Philadelphia, Temple University Press, 2011.

———. "Some Thoughts on Movement and the MMTW," *Allegra Lab*, May 15, 2017. https://allegralaboratory.net/some-thoughts-on-movement-and-the-mmtw-priya-srinivasan/

———. "Decolonising Moves: Gestures of Reciprocity as Feminist Intercultural Performance," *South Asian Diaspora*, 2019: 209-222.

Stoller, Paul. *The Taste of Ethnographic Things, The Senses in Anthropology*. Philadelphia, University of Pennsylvania Press, 1989.

Strathern, Marilyn. "On Space and Depth," in *Complexities: Social Science of Knowledge Practices*, eds. John Law and Annemarie Mol. Durham, NC, Duke University Press, 2002.

Sublet, Jacqueline. *Le Voile du nom: Essai sur le nom propre arabe*. Paris, PUF, 1991.

Suchman, Lucy. "Anthropological Relocations and the Limits of Design," *Annual Review of Anthropology* 40 (2011): 1–18.

Svasek, Maruska. *Anthropology, Art and Cultural Production*. London, Pluto Press, 2007.

Taylor, Charles. *The Sources of the Self*. Cambridge, Cambridge University Press, 1989.

Taussig, Michael. *Mimesis and Alterity; A Particular History of the Senses*. London, Routledge, 1993.

———. *I Swear I Saw This: Drawings in Fieldwork Notebooks Namely My Own*. Chicago, IL, University of Chicago Press, 2011.

Terrio, Susan J. *Judging Mohammed. Juvenile Delinquency, Immigration and Exclusion at the Paris Palace of Justice*. Stanford, CA, Stanford University Press, 2009.

Theocritus, *Idyll VII*, translated by Charles Stuart Calverly, London, George Bell & Sons, 1892.

Tillion, Germaine. *Il était une fois l'ethnographie*. Paris, Le Seuil, 2000.

Turner, Victor. *From Ritual to Theater: The Human Seriousness of Play*. New York, Performing Arts Journal Publications, 1982.

Urry, John. *Mobilities*. Cambridge, Polity Press, 2007.

Vendler, Helen. *Poets Thinking. Pope, Whitman, Dickson, Yeats*. Cambridge, MA, Harvard University Press, 2004.

Veyne, Paul. *Sur L'individu*. Paris, Le Seuil, 1987.

Walmsley, Ben. "Deep Hanging Out in the Arts: An Anthropological Approach to Capturing Cultural Value," *International Journal of Cultural Policy* 24(2) (2015): 272–291.

Waterston, Alisse. "Intimate Ethnography and the Anthropological Imagination: Dialectical Aspects of the Personal and Political, in *My Fathers Wars*," *American Ethnologist* 46(1) (2019): 7–19.

Weiss, Brad. "Review of *Three Faces of Beauty: Casablanca, Paris, Cairo*," *American Ethnologist* 30(1 February) (2003): 184–185.

White, Hayden. *Figural Realism: Studies in the Mimesis Effect*. Baltimore, MD, Johns Hopkins University Press, 1998.

———. *The Content of the Form: Narrative Discourse and Historical Representation*. Baltimore, MD, John Hopkins University Press, 1999.

*Wissenschaftskolleg zu Berlin*, Yearbook, 2016–2017.

Wolcott, Harry F. *The Art of Fieldwork*. Oxford, Altamira Press, 2005 (second edition).

Wood, Michael. *The Magician's Doubts. Nabakov and the Risks of Fiction*. Princeton, NJ, Princeton University Press, 1994.

Wrona, Adeline. *Face au Portrait. De Sainte-Beuve à Facebook*. Paris, Hermann, 2012.

Zagorska-Thomas, Natalia. "The Fabric of Fieldwork," *Fashion, Style & Popular Culture* 1(1) (2013): 137–141.

Zumthor, Paul. *La lettre ét la voix: De la "littérature" medievale*. Paris, Le Seuil, 1987.

# INDEX

Note: Page numbers followed by "n" denote endnotes.

accumulation and serial migration 112, 116
"Ah W Noss" song 64
Ajram, Nancy 64
Al Filali, Amina 67
Alizada, Ghulamsakhi 134–135
Allard Pierson Museum of Mediterranean Antiquities 123, 127
"almost writing" 31, 56
American University of Paris 47, 52
analysis of knowledge making through art 52–54
anthropology 36–38; career trajectories for xviii; in different countries 36
Arabic, alphabet 129; language 29; script 31; "vocalizations" 129
"Arab Spring" 129
Arlanza library 94
art, immediacy of 76; overcoming the linearity of writing 117–118
art as leading practice in fieldwork 6–7
art making 3–4, 29, 62, 66–67, 71–72, 84, 105–106, 117, 124–125
art scene 86
"*Asharq al-awsat*" 105, *105, 106*, 109, 115
audience 89, 97, 123; *see also* "Publics"
Augé, Marc 34
autobiography 5
autographic art 205
auto–reflection and social critique 118
Avaunt, Casey 83

backward-looking analysis 23
Baida, Jamaa 41
Balasescu, Alexandru 128, 133
Balderama, Jacqueline 74–75
Barthes, Roland 30, 51
Bauhaus 108
Bekkar, Rabia 41
Belaid, Habib 41
Bellaoui, Fatima 36
Ben Ali, Zine el-Abedine 43
Berber *see Imazigen*
Bernardi, Barbara 136
Berque, Jacques 36
"Bibliography" 18–19
Bischoff, Elmer xvi
Blanche, Francis 64
Boas, Franz xiv
Bourdieu, Pierre 39, 59, 163, 165, 168, 174
Brandstater Gallery, La Sierra University 64
Braudel, Fernand 124
Brien, Patrick 84
Briggs, Charles 88
Brown, Peter 107
Brunei Gallery, School of Oriental and African Studies 67
Bush administration 105

cable TV channels 52
*Cahiers de l'Orient* 56
Cairo 23; academic importance 51; as media center 33; visits for fieldwork 48–51

Calder, Alexander 108
call and response method 64–65, 77, 84–85
Camau, Michel 35
capitalism 22, 136
Carlier, Omar 41
Casablanca xviii, 29–31; as starting point 33–34, 65
Casa Blanca Library 97
Casas Brullet, Blanca 121, 126, 135, 136
Catalan independence Movement 136
"Catch the Wind" 93
CEDEJ (Centre d'Études et de documentation Économiques, Juridiques et Sociales) 49, 52
CELSA, Université Paris IV 47
censors 30
Centano, Jimmy 87
Center for Arab Studies, Georgetown University 103
Centre Jacques Berque 43
de Certeau, Michel 36
Chagas, Paulo 132
"Chergui" 83
Chicago xvi, 104, 108
Chillali, Aicha 50
Choukiha, Larbi 41
choreographers 89, 127
choreography 89
Christo and Jeanne-Claude 92
"Christo's Laundry" 77, 92
Cisneros, Sandra 97
civil society concept 39
classical fieldwork: ahistorical methods of xviii
Clichy 121
climate change 138
CNRS/CELSA program 47, 54
coffee, and knowledge production 14–15; as art material 15
collaborations 15, 16, 23, 49–51, 128, 152n14
collectives 14–17; intentional 10, 38; multi-site 23; public events 39; reflection 89, 113; serial migrant artists 24; shadowing 54; shaping 42; transformation 123; transnational 38
colonialism, and ethnography xvii; Dutch 136–137; French xvii, 29, 36
commonality 22, 14, 24, 91, 116, 119
communication 37
community 89, 112, 138; artificial or invented 118
cosmopolitan 108, 116, 129

"creative reaction" 118
"critical turn" 113, 114
cultural studies 51
cultural style 30
Culver Center for the Arts 132

dance composition 89, 90
Dacosta, Josette 92
"deep hanging out" 84
Delacrois, Eugène xiv
Demeter 141
Denes, Agnes xvii, xix
design 6, 18, 19, 23, 24, 38, 57, 68, 69, 84, 85, 88, 93, 99, 113, 118, 132, 138, 140, 146n11, 149n3, 150n8
Désir, Harlem 39
Des Plaines xvi
dialogue as aim 70, 76, 84, 89
dialogue between anthropology and art 68–69
disappearing practices 62
domestic labor 44, 67; and "labor-saving" devices 64
Domogała, Malgorzata 49
Dore Mimi Choir 136
Dorent, Nathanael 96
Drucker, Johanna 138
Durham, Deborah 87, 96
Dutch "Golden Age" 138

East Berlin Protestant Dinary Refugee Office 134
Edinger, Carrie Ida 97
education: and embodiment 52; and notions of equality 57
Egypt: cinema and music 48
"Einstein on the Beach" 89
emotions 91; collective 91
encounters 39–41
English 29, 35; hegemony in the academy 51
environments 7–13
epistemology 41
equality, education and notions of 57
ethics and mobility 55
ethnographic present xv, xvii, 26
ethnography 56, 84; multi-site 23, 37–38; team 86
ethnography as "ground knowledge" 36
ethnomethodology 41
exemplary people and actions 99
exhibitions 69, 70, 71, 86, 91, 96, 97; concept of 73–74; as proposal 73; as scenes for performance 127

**166** Index

experience-based research xiv, 57; and
  memoir xv
experience-distant data-driven
  approaches 36

"The Fabric of Fieldwork" 67, 70, 76
Faller Richardson, Bernadette 135
fashion magazines 48
"fast" salon 47
feminine-gendered spaces 33, 44
Ferrié, Jean-Noël 49–50
fieldwork memoir xv, xvii, xviii; through
  art 127
*Fieldworks across Anthropology and Art*
  conference 68
Foucault, Michel 41–42, 52, 110
French academic networks 51
French research institutions 38, 47, 52
Füssel, Marian 10

Ganesh 127
"Gather Wood, Gather Words" 65, 66, 67,
  125, 126
Gauguin, Paul xiv
Geertz, Clifford 30, 37
Gellner, Ernest 37
gender and forms of scholarship and art
  74, 85; perceptions of the researcher 88;
  salon 49; and space 33, 44, 146n13; and
  work 6, 73–74
genre shifting, as critical practice 18,
  22, 85
Georgetown University 103, 111
German universities as models 10
Gitlin, Todd 59
Glass, Philip 89
globalization 23, 33, 57, differences
  produced by 42, 54, 133
Goffman, Irving 41
Goldsmith's College, University of
  London 114
Gonzalez-Quijano, Yves 32
Grandaw, Mike 96
Guerrero, Rebecca 96
Guiducci Wallis, Danielle 95

Habermas, Jurgen 14, 56
habit-forming processes 100
hammam 32–33, 61
"Hang Dry" 23, 62, 64, 65, 81, 85, 86, 92,
  148n3; and blended geographies 63
"Hanging Out" 84, 87, 89; performance
  of 91
Hendrickson, Carol 87

Hermitage Museum, Amersterdam 136
Hinds, Rickerby 126
*History of Everyday Life* 36
Houston 113
"human sciences" 38
Hussein, Saddam 104

Ibn Battuta 123, 144
Ibn Khadoun 123
ICE (Immigration and Customs
  Enforcement) 85
"ideal speech situations" 14
imaginative renovation 85
*Imazigen* 30
"Immersion" xvii, 9, 144n17
immigrant 108, 109
immigrant experience 24, 122
"impressionism" 36
"Index Cards" 22
Indian art forms 134–135
individual research and art process 38;
  informed by collective, and collaboration
  15, 23, 55
influential models, movement of 33
Ingold, Tim 76
Institut de Recherche sur le Maghreb
  Contemporain (IRMC) 35, 37,
  64; research program on cultural
  practices 39, 47, 49; reference for
  further work 84
intimacy and collective research 41
intimacy and development of *On the Line*
  artwork 73, 74, 78, 97
Iraq War 103–104
Iron Curtain 2

Jaffe-Berg, Erith 122, 132
James, Stephen 127
Jay, Martin xvi, 107
Jeanneret, Yves 70
Jefferson Airplane 129
Jewish music 134
Jufresa-Marti, Felip 136

*Kapelle der Versöhnung*/Berlin Wall
  monument 2–3, 9, 24, 134
Katz, Jared 78
Kenbib, Mohammed 41
de Koenigswarter, Nadine 123
Kroeber Hall xvi, xix
Kwon, Miwon 118

*Laboratoire Communication et Politique* 47
ladder, as art and prop 134–135

Laine, Anna 68–69
Lambe, Claire 7
Lamzal, Fedwa 49
Landeros, Monica 78, 86, 96
Lark, Sylvia xvi
Lasserre, Guillaume 121–122
laundry stories 81, 87
layered attention 46
Levi-Strauss, Claude xvi, 4, 5, 30
life stories, conventions of 88; limits
    of 138; serial migration fieldwork
    110, 115
"liveliness" 84
local/national cultural styles 52
Loffler, German 78
Lyn, Anh 87
lyricism 6

Maghreb, transregional research 36
Mai, Nicola 123
Malherbe, François 29
Malik, Shahab 77
Malinowski, Bronislaw xiv
malls 85
Manfredi, Lorenza 135
"MapQuest" 131
Marcus, George 113
Mauss, Marcel 78
media environments and fieldwork 52;
    and ethnography 7; and fieldwork
    design 33
media studies xvii
Mediterranean, ashistorical actor 124;
    migrations 3, 125
Mejia-Krumbein, Beatriz 64, 76, 80, 86, 91,
    122, 124
"MENA" (Middle East and
    North Africa) 104
menu-driven fast-salon 52
migration studies, state-centered
    approach 110
Miliani, Hadj 41
*Mimesis* 23, 46, 47–48, 118
"Mimesis and Mediations" 47
mimetic process 77
"MiTiempo, Mein Raum,
    My Map" 122
Mitterrand, François xvii
mobility 24, 133, 134; and
    fieldwork 111
mobility diversity 133–134
modern body 32
Monet, Claude xiv
El Monfalouti, Mustapha 29

Morocco xvii, 23, 24, 65, 111, 125;
    and anthropology 30; foreign
    cultural centers 36; perception of in
    US 104
Moroccan community in France 121
Moussaoui, Abderrahmane 41
*Moving Matters Paths of Serial Migration* 118,
    120, 122
*Moving Matters Traveling Workshop (MMTW)*
    24, 118, 121, 122, 131
multi-modal 18, 78, 118
multi-site ethnography 23, 37–38
multi-site international research 38
Murphy, Keith 85
music 88, 136
musical composition 78
"Muslim" names and discrimination in
    France 34–35
Muslim scholarship 19
Musso, Tim 78
"My Mediterranean Sea Scroll" 124
"My Mother Your Mother" versions 1 and
    2 71, 86
"My Story, Your History" 128

Nabiha Jerad 129
Nahumury, Surya 136, 137
names, religious identity 50; spoken and
    written 35
narrative structures 83, 117
nationalism 133
Ness, Sally Ann 84, 99
North Africa 30, 38; *see also* Maghreb

O'Connor, Flannery 103
Officina 6, 26
"Oil Steal" 114
"On the Line: A Second Look" 65, 70, 71,
    81, 91, 93, 99; individual artworks 78;
    mimetic process of 77; performance
    of 86

paint by numbers 64
Pandy, Indu 137
Panikker, Dhiren 89, 92
Paris: migration xvii-iii; and contact with
    anglosphere 52; everyday life 48; returns
    to 43, 141
participatory artworks 81, 93, 99, 131
Pascon, Paul 37
Paun, Ioanna 128
Pavillon Vendôme 121
pedagogy 86; active 93; and
    disparities 55

**168** Index

*Picturing Casablanca: Portraits of Power in a Modern City* (Ossman) 35, 146n12
Pienado, Alice 122
"Pin the Wind" 93
"La pince a linge" (The Clothespin) 64
politics and community 17; ideology 19; protest 39
politics of the everyday 36, 39, 70
poppies (*papaveraceae*), types and effects and symbolism 129
populism 133
post-disciplinary terrains 69
Powdermaker, Hortense 127–128
Powell, Colin 104
professionalism 52
"proximate"/neighborhood salons 42
publication, moments of 77–78
Puente, Andrea 127
Puzon, Katarzyna 12, 136

Rabat 23, 62–63, 71, 84
Rabinow, Paul xviii
race xvi, 71, 85
Radi, Souad 49
Ramirez, Alejandro 126, 128
references 18–21, 39, 41, 51–52, 70, 115, 125
relationships 23, 34, 99, 110
Rembrandt 137
"Return Migration" to unknown city 104
Rice University 113–114
Richardson, Raushaun 94
Rinne, Cindy 98
Riverside, California 62
Riverside Arts Council 94
Riverside Metropolitan Museum 99
Riverside Public Library 94
Roginski, Sue 83
roles: anthropologist, artist, artist-scholar-performer 124

Said, Samira 51
salon: conversation-circle type of 52; custom-designed style 52; hairdresser 52; menu-driven fast-salon 52; owners *vs.* workers 55; type of 47, 52; women's movements 52
Sanjana, Sandhya 137
Sannas choir 136
"Santa Ana" 83, 141
scenes, for collective research 38
Schneider, Arnd 68
"script" for fieldwork 34, 92
Schwadron, Hannah 134, 135, 136

"Sea Seed," process of composing 133–134; and mobility diversity 133
"self as art" salons 47
self-mimesis 47
self-reflexive process 37
self-reflexive writing 35
self-to-self relationship 110
self-transformations 51
semi-autonomous community 6
semiological and structuralist ideas 84
sensory ethnography 12, 57, 83
September 11, 2001 (9/11) 103, 104
serial migrants: definition 113; discussions of the concept with the MMTW 24, 118, 123, 132; project orientation 111, 118; and subjectivity 115–116
Sezneva, Olga 123, 136
shadowing 54–55
"Shanthi Nilava Vendum" song 138
shape and evolving script project 34
shifting genres 22
Shlala, Elizabeth 115
La Sierra Library 94, 96
Simcoe, Duncan 77
single salon-form 53
social imaginations 89
socialist political movements 107
social mobility 55
social reflexivity 112
solitary and collaborative fieldwork 23
Sommers, Doris 99
Son of Semele Ensemble (SOSE) 133
Sontag, Susan 103
S.O.S. Racisme xviii, 39
"Sources" 2–5, 24, 134
sound slivers 89; and interviews, as composition 91
Southern California 85, 96; laundry 62–63; social divisions 85; weather 96
Srinivasan, Priya 127, 134, 136
*Steeped in History, Knowledge, Place* 7, 8, 11, 12
Stella, Elizabeth 87
Students for a Democratic Society (SDS) 39
style 5, 22, 30, 39, 42, 51–54, 81
subject form 115–116
subjectivity 24, 53, 54, 109, 112
Swed, Mark 89

"Tables et Tabliers" 44, 55, 67; compared to "Pin the Wind" 93
"Table Tress" 44, 45, 55, 57
Tate Modern Museum 68
"Tendedero" 87

"Tensegrity" 96
Theocritus 141
theoretical speculation, "application" of 138
"thick description" 30
Thompson, Dennis II 136, 137
*Three Faces of Beauty: Casablanca, Paris, Cairo* 56, 57
"three-world" model 52, 57
Tillion, Germaine 94
Timbuktu 3
"total social fact" 78
transdisciplinary collaboration 89
trans-Maghreb research 36
transnationalism 35
*Tristes Tropiques* (Levi-Strauss) xvi, 4–5, 30
"triviality" 70
Tuareg 3
Turkish bath 32
Turkish Osmanli dynasty 35
Typographia Gallery 128

United States 35, 51, 105, 107; cable TV channels 52
University of Amsterdam 123
University of California, Riverside 64, 84, 85, 150n14
University Village Mall 86

van de Worp, Manja 96
Vijay, Uthra 134, 136, 137
Virolles-Souibes, Marie 41
virtuosic performance 89
visual fieldnotes 29, 30, 31, 37, 65, 67, 68
Vlastos, Gregory 107

WALLS exhibition and performances 2, 134–135
Washington D.C. in the 2000s, and notions of home 104
"web of meaning" 30
Wessie Ling/WESSIELING 65, 67, 69
Westermark, Edvard 36
Western musical performance norms 92
"What Goes Unsaid" 70–71
"Window #1" 29, 31, 37, 65
Winkin, Yves 139
"Winter Wash" 75
*Wissen/Schaffen* exhibition 19
*Wissenschaftskolleg zu Berlin* (Wiko) 6–9, 10, 11, 12, 14, 22, 134; cross-disciplinary mission 19, 69
Wolton, Dominique 47
women 32, 34
women's movements 52
Wood, Michael 5
*The Work of Art in the World* (Sommers) 99
working-class struggles 64
Wright, Chris 68
writing and art 5, 6, 30–31, 35, 55–56, 118, 144n23, 145n26
writing sensations 30–31, 56
writing process 56–57

Years of Lead 30

Zagorska-Thomas, Natalia 69
Zervou, Natalie 120, 124
Zola, Emile 64

# Taylor & Francis eBooks

www.taylorfrancis.com

A single destination for eBooks from Taylor & Francis with increased functionality and an improved user experience to meet the needs of our customers.

90,000+ eBooks of award-winning academic content in Humanities, Social Science, Science, Technology, Engineering, and Medical written by a global network of editors and authors.

## TAYLOR & FRANCIS EBOOKS OFFERS:

- A streamlined experience for our library customers
- A single point of discovery for all of our eBook content
- Improved search and discovery of content at both book and chapter level

## REQUEST A FREE TRIAL
support@taylorfrancis.com